Panoramic photography

Arnaud **Frich**

Panoramic photography

From Composition and Exposure to Final Exhibition

Translated by Alan Greene

ELSEVIER

AMSTERDAM • BOSTON • HEIDELBERG • LONDON • NEW YORK • OXFORD • PARIS
SAN DIEGO • SAN FRANCISCO • SINGAPORE • SYDNEY • TOKYO

Focal Press is an imprint of Elsevier

Acquisitions Editor: Diane Heppner
Developmental Editor: Valerie Geary
Publishing Services Manager: George Morrison
Project Manager: Kathryn Liston
Assistant Editor: Robin Weston
Marketing Manager: Christine Degon Veroulis

Focal Press is an imprint of Elsevier
30 Corporate Drive, Suite 400, Burlington, MA 01803, USA
Linacre House, Jordan Hill, Oxford OX2 8DP, UK

Library of Congress Cataloging-in-Publication Data

Frich, Arnaud.
 [Photographie panoramique. English]
 Panoramic photography : from composition and exposure to final exhibition / Arnaud Frich.
 p. cm.
 Includes bibliographical references and index.
 ISBN-13: 978-0-240-80920-5 (pbk. : alk. paper)
 ISBN-10: 0-240-80920-3 (pbk. : alk. paper) 1. Photography, Panoramic. I. Title.
 TR661.F7513 2007
 778.3'6—dc22
 2006100489

British Library Cataloguing-in-Publishing Data
A catalogue record for this book is available from the British Library.

ISBN 13: 978-0-240-80920-5
ISBN 10: 0-240-80920-3

For information on all Focal Press publications,
visit our website at www.books.elsevier.com

07 08 09 10 11 10 09 08 07 06 05 04 03 02 01

Printed in China

Working together to grow
libraries in developing countries

www.elsevier.com | www.bookaid.org | www.sabre.org

ELSEVIER BOOK AID International Sabre Foundation

Acknowledgements

To the photographers who agreed to participate in this project, I express my gratitude.

Writing this first book has been a real honor, a unique experience, and a real team effort.

Above all, I am extremely grateful to Stéphanie Poisson, my editor, for her encouragement and kindness, her critical but just attention, and her valuable work in proofreading. Without her, this book would not be the same.

Most sincere thanks to my French publisher, éditions Eyrolles, notably Éric Sulpice, for giving me the chance to write this book and for allowing me real freedom of choice.

Thanks to all the people behind the scenes at éditions Eyrolles, who have helped me in the realization of this work and who have allowed its publication; special thanks go to Isabelle de Robillard, production head, in this regard.

Many thanks to the graphic design team Nord Combo, Ludovic Févin in particular, for the remarkable work they have done. They have known how to listen to my concerns and made this book more elegant.

Warmest thanks Alain Quintin, Loïc Blevenec, and the team of MMF-Pro for their material aid and support, ever since my first beginnings in panoramic photography.

Thanks to the different equipment and software makers for their help, notably Catherine Gautier of Manfrotto France, Gilbert Morin of the Panavue company, and Dominique Massot and Patrick Dumas of the Realviz company.

Thanks as well to the stores Le Grand Format (particularly Daniel Gadat) and Le Moyen Format, and AMC. All three are located in Paris and have allowed me to create photographs of their equipment.

Thanks very much to Emmanuel Bigler and Yves Colombe for their technical explanations and specific knowledge of optics with regard to the method of joining photographs.

Thanks to my teacher of color management, Gérard Miemetzky. My long training with him has been very valuable, both before and during the realization of this book.

Thanks to the Internet surfers whose remarks and warm, friendly messages on my Web site have given me the energy to write this book. I am equally grateful to many members of various discussion groups for their exchanges on panoramic photography and color management.

I am most grateful to the photographers whose work inspires me each day, notably Ansel Adams, who has influenced my manner of viewing since I was an adolescent.

Warmest thanks to all the people who have taken an interest in my work and have been so very kind, particularly Vincent Luc and Jimmy Peguet.

Thanks very much to Nadine Beauthéac-Bouchart for having granted me permission to publish the photographs of François-Xavier Bouchart and for having made this a very easy task.

Thanks to Hervé Sentucq for his support, friendship, and valuable technical assistance.

Thanks to Bernard Martinez for his material aid and, in moments past, for having enjoyed listening to music together.

Thanks from the bottom of my heart to my grandmother Denise Cervera, Suzan Beaudry, and Valérie Beausoleil, without whom this book would not have seen the light of day.

Enormous thanks to Delphine for her love, support, and valuable aid, whenever I have needed it most while writing this book.

To my parents and little sister, thanks from the bottom of my heart.

I dedicate this book to François-Xavier Bouchart, for he has given direction to both my overall approach and my panoramic way of viewing.

For me, respect for the Other – that is to say, harmony between Humanity and Nature – seems the best solution.

Arnaud Frich

Contents

Preface

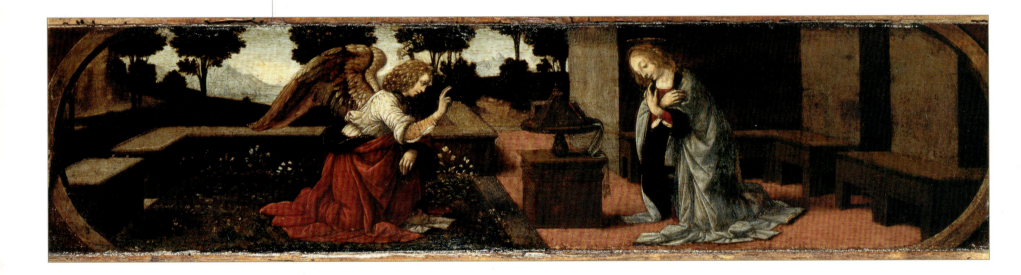

When *éditions Eyrolles*, my French publisher, asked me to write a book on panoramic photography, I accepted right away. At the time, I wasn't sure of how much work it would entail, but I was sure about one thing: I was going to speak about a subject that had fascinated me for more than 20 years. Actually, it was during my first trip to Rome at the age of 14 – equipped with the family camera, a Kodak 126 Instamatic – that I first perceived to what extent I "saw" panoramically, since I could not stop myself from wanting to crop my photos this way! It is impossible for me to say why; I simply believe that this is the natural format for me. I love to recreate the emotion that a place instills in me while viewing it.

Preparation of the Fireworks and Decoration for the Feast Given in Piazza Navona, Rome, on November 30, 1729, for the Birth of the Dauphin, on the Occasion of the Birth of the Heir Apparent, by the painter Giovanni Paolo, Louvre Museum. The painter has chosen a panoramic format to show all of the famous Roman square in turmoil.

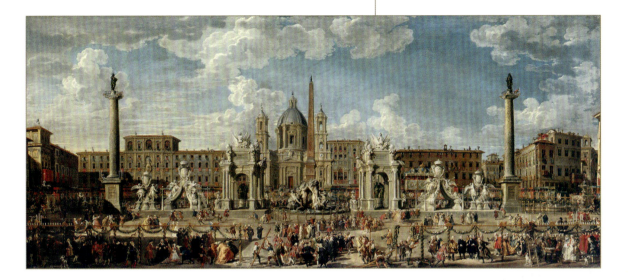

The story behind a book starts long before a publisher's contact, particularly with regard to certain experiences that are more important than others. Without a doubt, the first of these for me was reading the book, *Marcel Proust, la figure des pays*, by François-Xavier Bouchart, at the Nanterre public library when I was an adolescent. I had the strong sensation that a door had just opened wide for me. This was because a great photographer had published a book containing only panoramic photographs – and more importantly, ones that were so close to my own sensibilities – thus, permitting me to express myself more in this format than in any other.

My second important photographic encounter concerned the work of Ansel Adams. His black-and-white photographs of American landscapes and architecture, taken with a large-format camera, were unlike anything I had ever seen before (indeed, I continue to admire them). At the time, I knew that I wanted to wed the vision of panoramic photography to the richness and detail of large format. But it was only much later that I heard about a new, swing-lens panoramic camera, the Noblex 150, first produced in 1992, which is the one I used until 2004.

Two technical photo books had an effect on me as well: *La Photo*, by Chenz and Jean-Loup Sieff (because a sense of humor was always implicit), and *La Prise de vue et le développement*, by Thibaut Saint-James (for its remarkable text and the richness of the ideas expressed there). It was with the latter book that I patiently learned the Zone System, and perhaps even more, to control light. This is why I continue to think that the Zone System is an important school of thought, even at a moment when automatic light meters are achieving real miracles. Why do I say this? Because without the Zone System I never would have had the idea and the requisite technique to achieve my nighttime photographs and color photographs of twilight. However, far from being a die-hard supporter of the Zone System, I have just taken what was useful, and modified it to suit my working method. I like this combination of tradition and modernity.

Ever since I bought my first Noblex six years ago, I have not stopped hearing that panoramic photography is à la mode. But why should this type of photography be in fashion, and therefore, destined to disappear, when art history, notably painting, shows us that artists, albeit a minority, have never stopped expressing themselves in this format? Panoramic photography depends on a type of camera that, even in

the not-so-distant past, was often cumbersome and costly. However, the recent arrival of lighter panoramic cameras, compatible with journalistic photography, and the maturity of the promising joining method have begun to change this preconception.

It was during a visit to the Louvre that I first entertained this idea. While visiting the different rooms and artistic periods, I noticed that this elongated format was always present there as well. This does not seem so astonishing when one realizes that many panoramic artists have shared the opinion that this style of vision worked best because it was the most natural. How could it have been different when the Italian painter Lorenzo di Credi (*ca.* 1460–1537) painted the Annunciation in the fifteenth century?

Personally, I love this format, this privileged means of providing a sense of the entire harmony and ambiance of a place rather than just an isolated detail. This is equally the case in a painting from the eighteenth century by Giovanni Paolo (1691–1765), representing preparations for a Roman fireworks display in 1729. Nevertheless, it was not until 1799 that the word *panorama* first appeared, coined by Robert Barker (1739–1806).

So it is hardly surprising that the first panoramic cameras should arrive shortly after the beginning of photography in 1839. As early as 1843, Joseph Puchberger of Retz, Austria, was making his first panoramas on curved plates measuring 24 inches, with the aid of a swing-lens that had a focal length of around 200 mm. The angle of view was 150 degrees, the same as a Noblex or a Widelux built 170 years later. And in the *musée Carnavalet* (museum of the history of Paris), one also finds a panoramic daguerreotype view of Paris, *View of the Pont-Neuf, the quays of the Louvre and the Mégisserie*, dating to around 1845–1850.

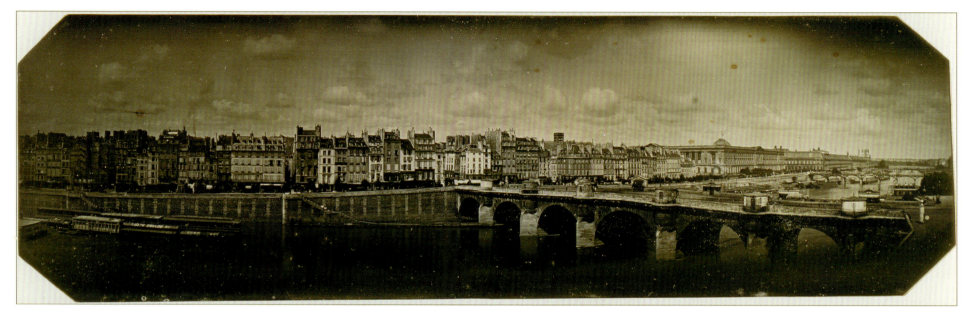

This laterally reversed photograph, titled View of the Pont-Neuf, the Quays of the Louvre and the Mégisserie, is attributed to Lerebours, ca. 1845–1850, Carnavalet Museum. François-Xavier Bouchart rephotographed this same scene 180 years later with the same kind of rotational camera.

Following this, a number of brilliant photographers continued to improve their cameras, taking them almost everywhere, in spite of their large size. And in 1859, the first patent was filed for a camera with a curved back; others were already using the joining method by juxtaposing mosaics of images placed one alongside the other. 1904 marks the next important date in the history of panoramic photography, because the famous Cirkut cameras using a 25 cm × 40 cm film format appeared in that year. A number of collectors own these today.

To conclude, I would like to mention two other important names in the history of panoramic photography. In the 1920s, the French photographer Jacques-Henri Lartigue (1894–1986) photographed scenes of daily life with 6 cm × 12 cm glass plates that were a far cry from the contemplative tradition of certain American photographers and the French 35 mm journalistic tradition. Thirty years later, Joseph Sudek photographed the city of Prague with a swing-lens camera; some of these photographs were featured in a very beautiful book, *Prague en panoramique*, which unfortunately is unavailable today. This work was made in the 1950s and published for the first time in 1959, 20 years before the first modern 6 × 17 panoramic cameras.

The goal of this book is to explore different aspects of panoramic photography as practiced today, from the most traditional to the most contemporary. I will have attained my goal if I can prove that it has never been easier to make panoramas, both in terms of the light weight of the equipment and, above all, in quality. Digital photography has also brought down many barriers and opens new vistas concerning this unique way to see the world and express oneself.

In Chapter One, we will take stock of the different ways that are available to obtain images having at least a 2:1 ratio – the minimum required for a panoramic format. Then, in the second chapter, we will look at how a panoramic photograph may be affected by the type of camera being used and how this in turn influences the final composition. In the third and fourth chapters, we will make an inventory of flatback panoramic cameras, followed by rotating ones. Chapters Five and Six are devoted to the so-called joining method. This new way of making panoramic photographs can be learned without prior experience, since the results obtained are very interesting and the creative potential is unlimited. The last chapter of the book is devoted to the presentation and archival storage of panoramic photographs, and all that concerns them at this moment when digital photography is aiding a format that is finally

moving away from being marginalized. An appendix of resources brings this book to a conclusion.

One final word: This book has been written with certain preconceptions in mind. To start, I have not wanted to overload the pages with comparative tables that just about any Internet site or similarly documented source could provide in greater detail (e.g., see my site, www.arnaudfrichphoto.com, which I have done my best to make a complement to this book). The source of supply and bibliographic sections at the back of the book will also aid you in your search for supplementary information. Instead, I have preferred to leave room for photographers whose reputation often exceeds their native land – something that is not completely out

of place in a technical book. And by stressing their respective advantages and disadvantages, I have hoped to show the characteristics of different panoramic cameras, as well as their amazing abilities. Here, I have preferred to explain the possibilities of a camera rather than emphasize what one should not try to do with them; if I had done the latter, another photographic author would soon prove me wrong.

In closing, I believe that I truly will have attained my goal when you want to leaf through this book after panoramic photography has become very familiar to you, even to the point where it is your full-fledged manner of expression – as is the case for more and more photographers in the world today.

Photo by Josef Sudek.

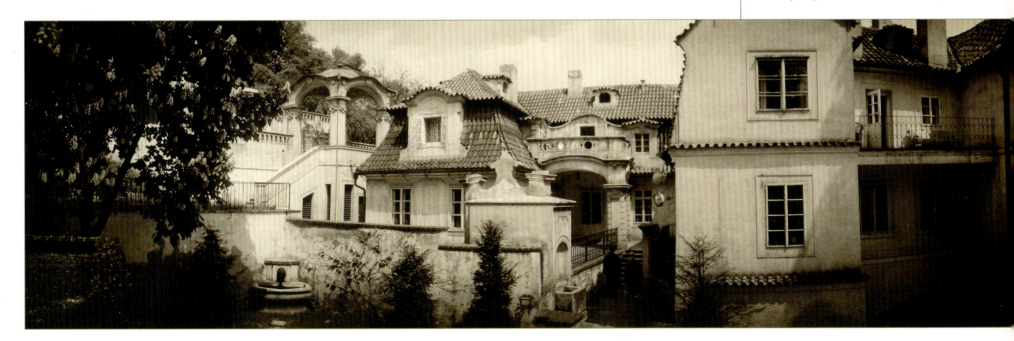

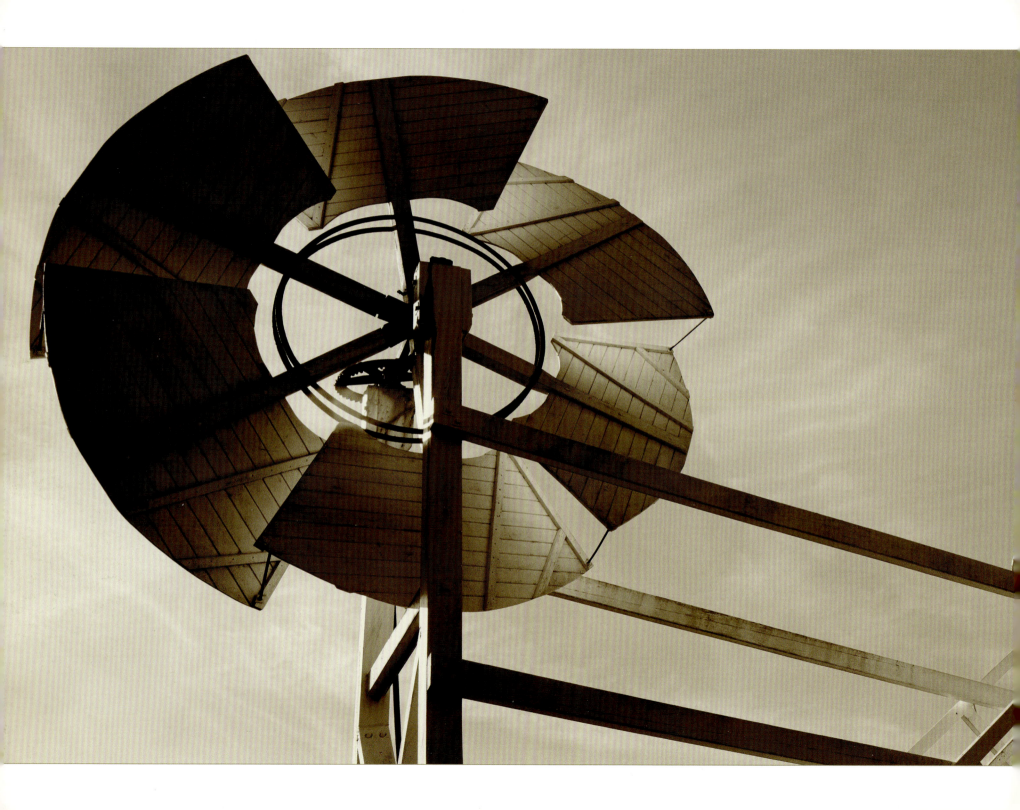

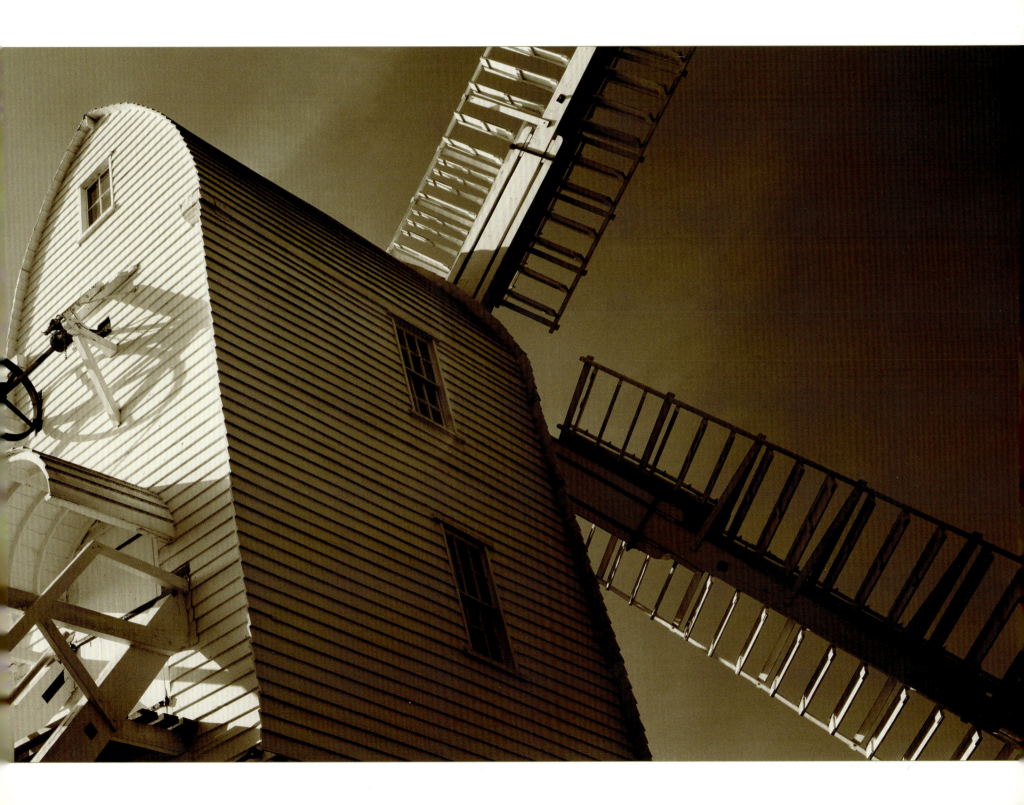

Caption (on following page):
Photo by David J. Osborn.

Photo by Hervé Sentucq.

Photo by Aurore de la Morinerie.

Photo by Franck Charel.

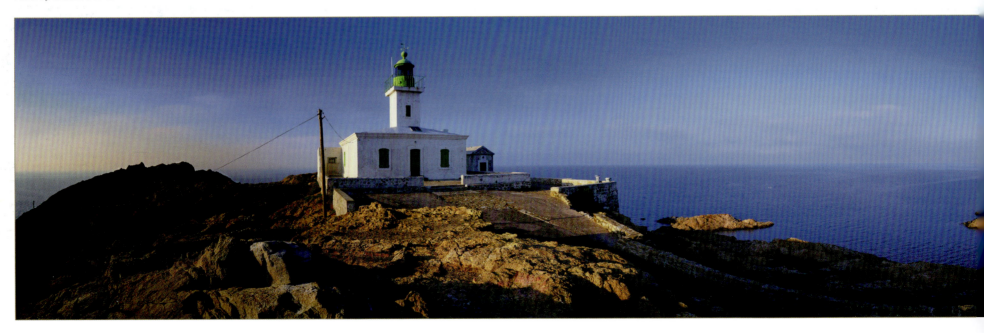

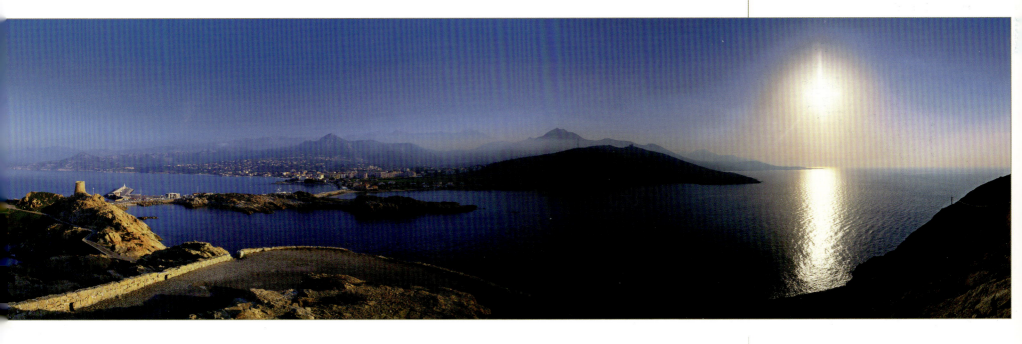

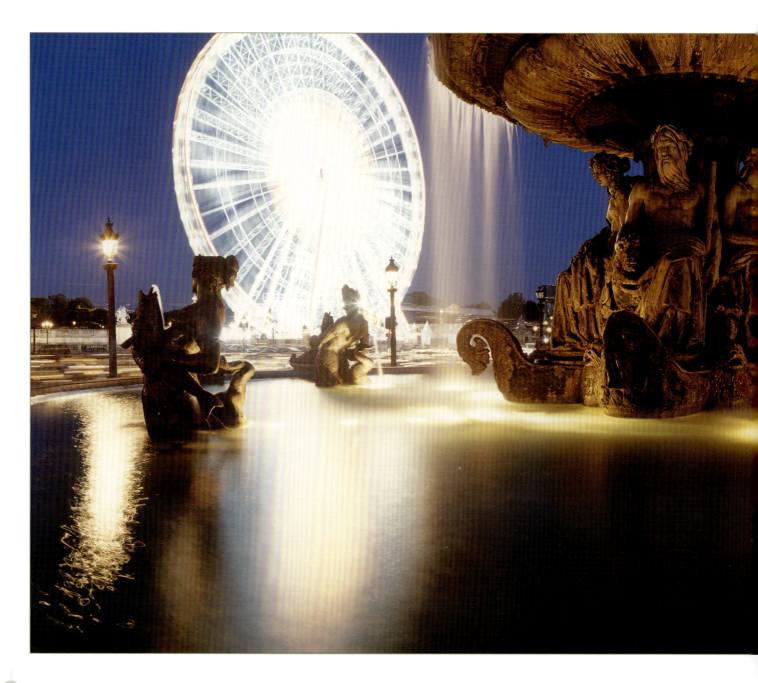

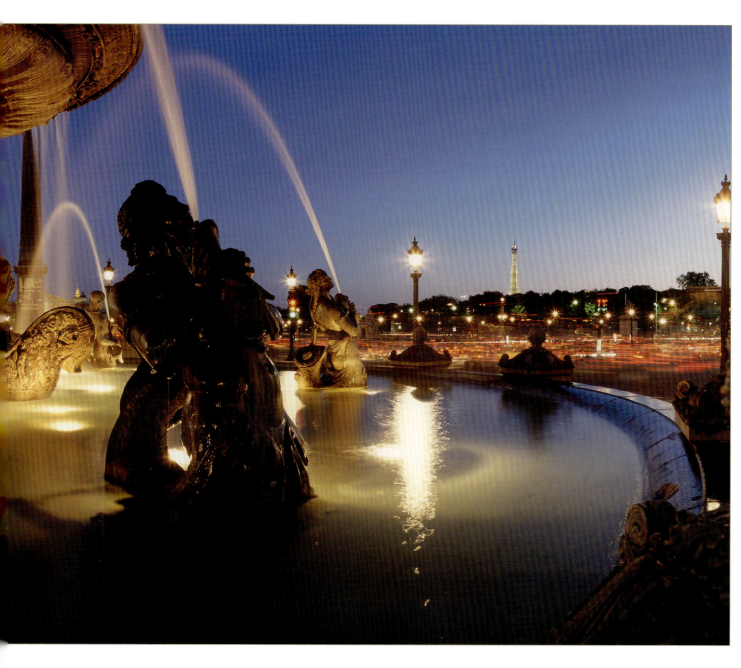

Photo by Arnaud Frich.

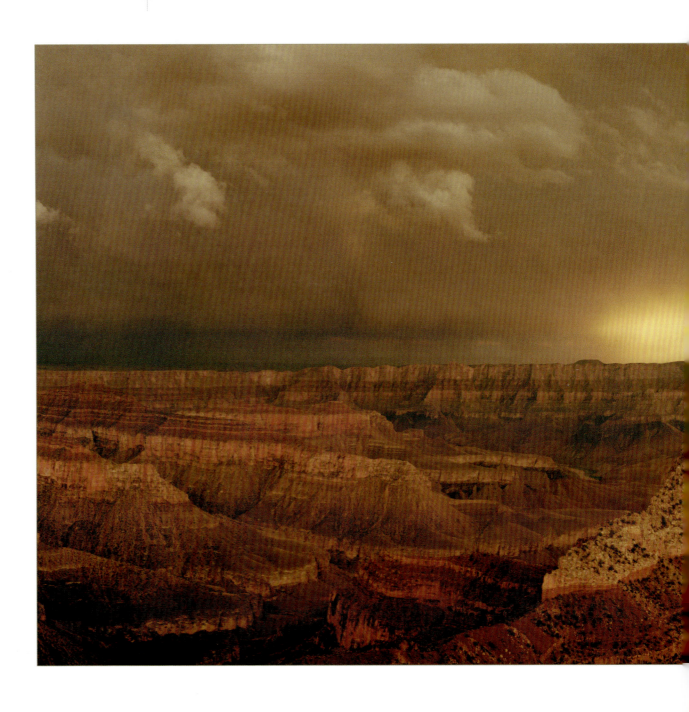

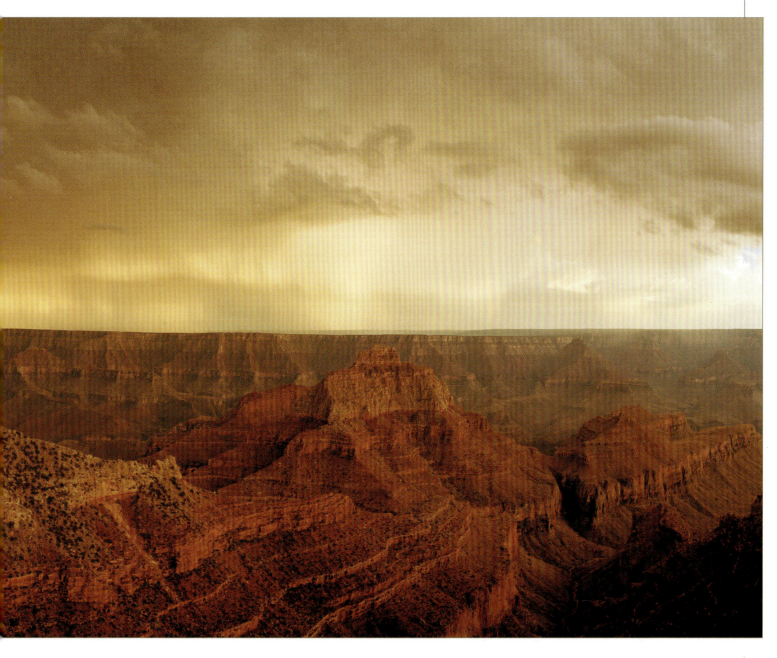

Photo by Macduff Everton.

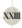

Solutions and Formats

A panoramic photograph can be created in a number of ways, and accounting for all of them can prove to be complicated. With any format, both specialty and nonspecialty cameras exist, as well as rotating and flatback ones, allowing for a wider or narrower angle of view.

Photo by Arnaud Frich.

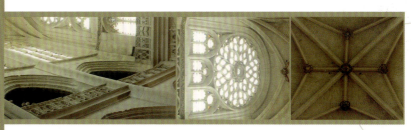

Currently, numerous paths lead to panoramic photography. Before the advent of data processing and computer software, only three approaches existed, and as we have seen in the Preface, they date to the very beginnings of photography. The easiest approach always has been the classic *letterbox* (or elongated) format of an isolated photo, which remains more or less rectangular. Here, the field of view taken in is equal to the wide angle of the more conventional format (from which the panorama is taken). Whether one trims the top or bottom of the photo, the width remains the same.

This approach holds true for certain specialized camera bodies such as the Hasselblad XPan and the Fuji 617. The XPan is basically a reformatted 6 cm × 7 cm camera, and the Fuji 617, a 5 cm × 7 cm camera with the top and bottom of the film plane cropped. A second way to make a panoramic photograph involves rotating a lens mounted in a turret while the film is held against a curved plate (the angle of view,

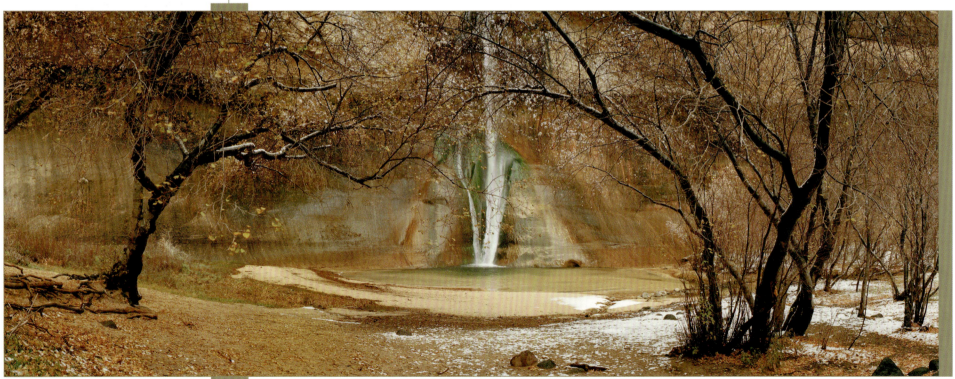

Photo by Macduff Everton.

approaching 140°, comes close to the field taken in by human vision). Finally, a third method involves turning the entire camera, potentially reaching up to 360°.

Recently, more powerful computers and joining software programs have made it possible to create panoramic photographs in which the final quality sometimes surpasses that of specialized, traditional cameras. With a single camera body, preferably digital, it is possible to address the entire field of a panoramic photo obtained by cropping (i.e., rectilinear photography), and with the use of rotating equipment, to move from a 150° to a 360° angle of view. This development is a real innovation in the history of panoramic photography. In this way, anyone can pick a format, camera, and method based on his or her own sensitivities and vision.

To begin our discussion, we summarize an inventory of the characteristics pertaining to each of these equipment- or software-based solutions. This is followed by (1) a detailed discussion about choosing an angle of view that corresponds to the camera and method being used; (2) the impact of the original film's or digital file's size relative to the end result; and (3) a consideration of specific problems pertaining to focusing in panoramic photography, such as depth of field and determination of the hyperfocal distance.

A Variety of Approaches

Among the different options available to panoramic photographers, the equipment used to make the picture should be chosen according to certain aesthetic and technical criteria. Aesthetics being of primary consideration, the photographer must select from different angles of view and different types of distortion, as well as negatives and digital files of varying size. (However, as we will see later, the quality of an enlargement does not necessarily depend on the size of the original negative or digital file.) From a technical standpoint, the panoramic photographer should give preference to either a specialty camera or the joining method. Each of these has its advantages and disadvantages, but both are equally capable of producing high-quality work.

Although the joining methods have opened new doors to panoramic photography, traditional photography has been around for so long that a panoramic photographer is still quite able to satisfy him- or herself with both specialty and conventional cameras. Indeed, all of the angle of view and format options were available well before the first digital cameras were available.

Characteristics of the different ways to take a panoramic photograph

	ADVANTAGES	DISADVANTAGES
APS, 35 mm, digital cameras, 2-1/4 × 2-1/4, etc. Cropping	• *Only one photograph.* • *No specific equipment to buy.* • *Possibility of direct or indirect shifts when shifting lenses are made for the line of equipment in question.* • *Used in a similar way to conventional photography.* • *Slide projection is possible.*	• *Maximum 115° angle of view with a 14 mm lens for 35 mm; quite expensive. (Only 80° for 2-1/4 × 2-1/4.)* • *Noticeable distortion in the corners and on the borders of image.* • *Wastes film since it has to be cropped (e.g., 12 mm × 36 mm and 18 mm × 56 mm). Less of a problem with digital.*
6 × 12 and 6 × 17: Fuji, Cambo Wide, Horseman, etc.	• *Film's large format allows significant enlarging. Incomparable image quality in a traditional print or digital scan. Scanned at 2400 dpi and printed at 254 dpi, it is possible to have an image measuring as large as 20" × 60"!* • *Direct 3:1 aspect ratio without cropping.* • *No film wasted.* • *Significant shifts with certain models.*	• *Very expensive and exclusive cameras, even if three or more kinds of lens can be used (Gilde).* • *Maximum 110° angle of view with a 72 mm lens and 6 × 17, or 47 mm with 6 × 12.* • *No shifting possible – direct or indirect – except for the 6 × 17 Gilde MST 66-17 (prohibitively expensive).* • *Projection is impossible, but it has an impressive appearance on a light table.*
24 mm × 66 mm: XPan, Mamiya 7, etc.	• *Same principle as a 6 × 17, but the final image will be less refined.* • *Much lighter. Less difficult to transport. Thus one can think about panoramic journalistic photography without problem.*	• *Same inconveniences as above.* • *Always watch out for the maximum aperture of the lens: f 4.0, in the best of cases. Highly sensitive film is almost always required.*
Swing-lens cameras: Noblex, Widelux, Horizon, etc. Rotational cameras: Roundshot, Rotocamera, etc.	• *Specialty cameras embracing a very wide field: between 120° and 360°.* • *Shifting possible with certain models.* • *Nighttime photos with dodging possible during exposure with the swing-lens cameras: highly desirable.* • *Sometimes equipped with an intelligent light meter that allows exposure compensation from left to right, depending on the orientation of the sun.*	• *Specially designed cameras, only serving one function.* • *Only one focal length with swing-lens cameras.* • *Specific curvilinear distortions.* • *Three photos needed to make a 360° image.* • *High cost related to specificity.*
Joining method 1: digital cameras	• *Today's joining software programs are of very high quality.* • *Same camera for making panoramic and conventional images.* • *Choice of focal length.* • *Very easy to use.* • *Photos in color or black-and-white and color temperature are easy to manage.* • *Dodging at the time of exposure is possible only when several photos are superimposed.*	• *Not very many in absolute terms.* • *One cannot visualize the full picture within the viewfinder.* • *The assembling process determines the shot duration.* • *Some manipulation needed at time of exposure.* • *Main limitation at present, the size of the sensors: 3000 vertical pixels would yield 12-inch prints at 254 dpi with a sensor having 6 Mb of pixels.* • *With sensors having more than 10 Mb, the maximum width is 4000 pixels.*
Joining method 2: traditional cameras	• *Same advantages as above.* • *With the best scanners presently available, it is possible to obtain an identical quality to those of the best digital cameras.*	• *More labor-intensive, since film development and photo scanning are needed. Significant retouching is also foreseeable.*

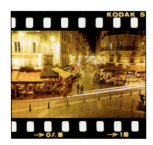
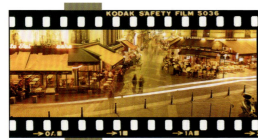
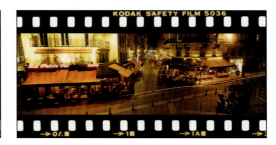
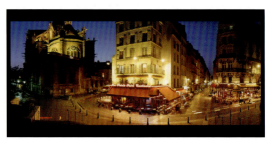

1 *2* *3* *4*

These four photographs have all been taken from the same point of view.

1. Photo taken with a 24 mm lens for a 35 mm format (75°).

2. Photo taken with an XPan and a 45 mm lens (75°).

3. Photo taken with an XPan and a 30 mm lens (90°).

4. Photo taken with a Noblex 150 (140°).

The Panoramic Image

A panoramic image is sometimes characterized by its angle of view, but more typically by an elongated format. A photographer can easily use a specialty camera such as the XPan to obtain photographs having an elongated format and an angle of view equivalent to a classic 35 mm wide-angle lens, but only the specialized rotating cameras and the joining method allow the creation of photographs that can truly be called panoramic.

Nevertheless – as is the case with all photography in general – the quality of a photograph is determined equally by the size of the original film or digital file. In fact, the entire appearance of relief, sharpness, and depth of field depends on it. A panoramist, who remains a photographer first and foremost, must always keep these parameters in mind.

Angle of View

The least that one can say about a panoramic photograph's angle of view is that it is highly variable! If 360° photos are possible with certain cameras, it is equally possible to obtain panoramic photos with specialty cameras in which the angle of view is as narrow as 25°. Even if this angle has nothing "panoramic" about it, the photo will be stretched out nonetheless.

Apart from the joining method, it is impossible to consider all of the possibilities that exist for a given camera. Choice of camera therefore should be guided by one's aesthetic preference. For example, someone who wants to reproduce the angle of human vision will opt for a camera with a swing lens, which will provide for an angle of view of approximately 135°, which is much greater than the 65° of a 28 mm lens used with a 35 mm camera. With a fixed lens, it is impossible to obtain a 135° angle of view, since none are wider than the unusual fish-eye, which has a short 14 mm focal length and a 115° angle of view. For 360° enthusiasts, superb but very expensive rotational cameras do exist (the most well-known made by Roundshot); and the joining method has undeniably come of age with regard to the image-blending quality available due to the recent progress of stitching software.

Since both swing-lens and rotational cameras cause perspective lines to be deformed in a noticeable way, certain photographers will probably prefer to use a more conventional camera and crop the image later. In this case, an angle of view of at least 100° should be sufficient. It is worth noting that as panoramic photography achieves more and more attention, photographers are starting to take it in unexpected directions – for example, close-ups and telephoto panoramas.

Different Aspect Ratios

Although some photographers think that a true panoramic photograph can made only with a swing-lens or rotational camera, it is generally conceded that a panoramic image consists of a lengthened format, or a minimum ratio of 2:1.

The more conventional formats have been determined by the various aspect ratios of the traditional cameras that have popularized panoramic photography

(e.g., Widelux, Fuji 617, and more recently, the Hasselblad XPan). For example, let us consider 35 mm photography; though it obviously is not a panoramic format, it is at least familiar to everyone. Thus, the 35 mm format is relatively long (a 1.7:1 ratio). And if one wanted to, one could crop it until a panoramic format was achieved. Apart from this, when one wants to create a series of images, it is advisable to settle on a specific format from the start and stick to it. A 3:1 ratio (e.g., 12 mm × 36 mm for 35 mm film) is undeniably pleasing; one also finds more and more posters and frames in this format.

Those who use a 2:1 ratio for 6 cm × 12 cm cameras usually appreciate it, even if the format does not seem all that panoramic. Remember, it can always be cropped down for more interesting possibilities. Ratios like 2.4:1 for the Noblex 150 and 2.7:1 for the Noblex 35 mm are much closer to the 3:1 ratio of the XPan, and have become popular because of well-known photos by Philip Plisson and Hervé Sentucq, taken with a Fuji 617. Essentially, much the same holds true for format sizes and ratios with digital sensors; however, here one is no longer thinking in inches and centimeters, but rather, in pixels.

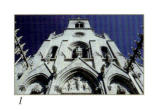

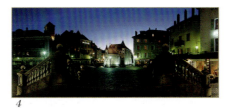

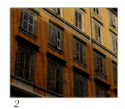

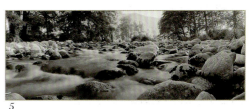

1

2

3

4

5

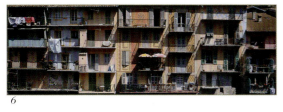

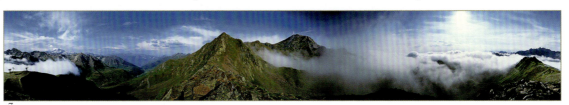

6

7

1. Issoudun Basilica, Indre, France. Photo by Arnaud Frich. This 35 mm photo has a 3:2 aspect ratio. This is a standard format, but its size does not allow cropping to 3:1 without a significant loss in quality.

2. Facade, Rome, Italy. Photo by Arnaud Frich. 120 and 220 roll films have a much larger surface area than small-format (35 mm) film – on average, five times larger.

3. Loch Laggan, Scotland. Photo by Hervé Sentucq. This 56 mm × 120 mm photograph has the first aspect ratio considered panoramic, 2:1. The size of this image puts it in the large-format category. The sharpness and tonality of the enlargements will be incomparable.

4. Le Palais de l'Isle, Annecy, France. Photo by Arnaud Frich. Swing-lens cameras like the Noblex 150 allow you to obtain photographs with a 2.4:1 aspect ratio. Although pictures are not that elongated, it does allow the possibility of cropping from the top or bottom.

5. L'Ouvèze, Gard, France. Photo by Arnaud Frich. Having the same 2.7:1 aspect ratio as photographs taken with an XPan, this photo was made with a Noblex 135 U, using 35 mm film. The enlarging possibilities are already much better!

6. Facade, Provence, France. Photo by Hervé Sentucq. The Fuji GX 617 allows 3:1 aspect ratio photographs to be obtained directly. The resulting image is quite large and allows amazing enlargements to be made.

7. Pic du midi de Bigorre, Pyrenees, France. Photo by Franck Charel. The characteristic of rotational cameras and the joining method is to make photos that have a particularly elongated format, starting with a 4:1 aspect ratio.

Format	Diagonal in mm	Angle of View/Focal Length					
		104°	94°	84°	74°	55°	30°
35 mm	43	16 mm	18 mm	20 mm	24 mm	50 mm	75 mm
APS Digital	22	8 mm	9 mm	10 mm	12 mm	24 mm	37 mm
24 mm × 66 mm	70	–	30 mm	45 mm	–	90 mm	–
6 × 7	90	–	–	43 mm	55 mm	90 mm	165 mm
6 × 12	125	47 mm	55 mm	65 mm	75 mm	115 mm	240 mm
6 × 17	180	72 mm	90 mm	105 mm	150 mm	180 mm	300 mm

To make a photograph taking in a 104° horizontal field of view, it is necessary to use a 16 mm lens for 12 mm × 36 mm, and 72 mm for 6 × 17.

Format Size

As the format of the film or digital sensor changes, its influence on the image affects the amount of tonal depth and detail in the photograph, irrespective of what one wanted from the start. And as either the film or sensor format increases, it becomes necessary to extend the focal length of the lens to obtain an equivalent angle of view. Using a longer focal length will make small details appear magnified, and the separation of focus between foreground and background elements will increase.

Divergent effects will also be noticeable with regard to the depth of field, or area that is in focus. On the one hand, it is difficult to obtain a lot of depth of field with long focal length lenses in traditional photography; on the other, it is equally hard to escape having too much with small digital sensors – and one is always prone to forget. So remember, they work in opposite ways!

Influence on Image Detail

Amateur and professional photographers who seek quality usually settle on film formats that are larger than 35 mm. And panoramists are no exception to this rule – in fact, rather the opposite holds true – regardless of the weight of the equipment they have to carry around. The larger the original image matrix is, the less one will have to enlarge when making the final print. Image detail will be enhanced, and tonal depth will be increasingly nuanced. For example, a color transparency made with a 6 cm × 17 cm format camera is 22 times larger than a cropped-down 12 mm × 36 mm transparency (thus, requiring only 1/22 as much enlargement). Given the larger image matrix, both traditional and digital prints of larger sizes will be of an incomparable quality. The comparable result will be less spectacular in the case of a Hasselblad XPan or a Mamiya 7; but what remains important is that the negative will be four times larger than 35 mm! And that's why many photographers use these cameras in all kinds of locales, and in all parts of the world – even the most dangerous.

In order to arrive at an equivalent angle of coverage, one has to realize that the larger the image matrix is, the longer the focal length needs to be. Partly on

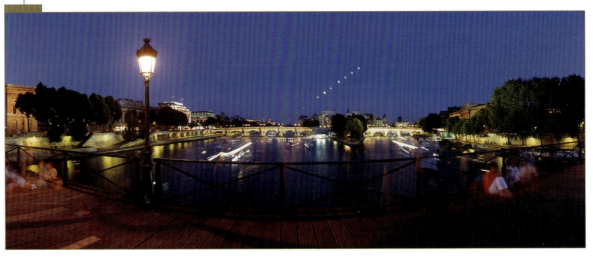

Moonrise seen from the Pont des Arts, Paris. Noblex 150 U, f11, three hour and 30 minute exposure!

Photo by Arnaud Frich.

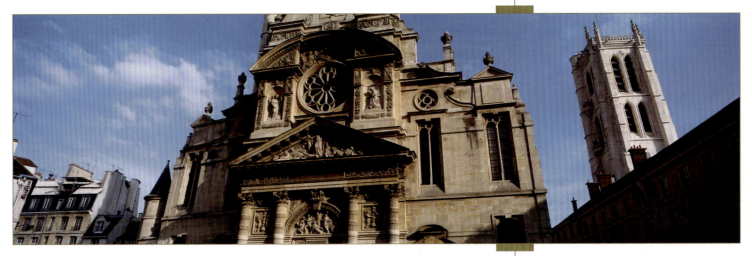

These two photographs were taken from the same point of view with a 35 mm camera (left) and a 6 × 17 camera (right).

Photos by Arnaud Frich and Hervé Sentucq.

Here are two enlarged details from the above photographs. The difference in quality is glaringly apparent! With the enlarged detail on the left, the smallest details are lost in the grain of the film.

account of their lenses' slight telephoto effect, medium or large format panoramic cameras also have less of a tendency to lose small details in the film grain. A glance at the table of corresponding film and focal lengths reveals that a 90 mm lens used with a 6 cm × 17 cm format camera has the same angle of view as a 20 mm lens used in 35 mm.

A 90 mm lens is slightly telephoto with 35 mm. Used with 6 × 17, it becomes a bit like making a number of photographs with a 35 mm camera, where all the resulting pictures have been stuck together in order to obtain a much taller and wider panoramic photo. Not only will the details be more prominent than the film's grain, but they will also be larger. Even more details will be noticeable in a giant print. Take the moon for example; instead of depicting a small round ball in the sky, as would be the case with a 20 mm lens on a 35 mm camera, you now will be able to make out some details.

Influence on Depth of Field

The laws of optics teach us that the longer the focal length of a lens is, the shallower the depth of field will be for a given f-stop. Thus, a telephoto lens inherently reveals less depth of field than a wide-angle lens. And the less depth of field there is, the less sharp the subjects outside of the critical area of focus will be. Similarly, the longer the focal length is, the easier it will be to isolate a detail, since it will tend to stand out more as the focal length increases. Portrait photographers often use this technique to call attention to the face, which is presented in front of a completely out-of-focus background.

In dealing with space, making panoramic photographs with a shallow depth of field is a good way to force a part of the image to stand out and creates an opposition between the foreground and background. (Obviously, the opposite holds true when stopping down on the lens.)

Depth of Field

When one focuses on a plane or object, maximum sharpness is obtained for this distance. In practice, one can observe that certain planes beyond this distance – both in front and behind – are also in focus. But the further one moves from the area that has been focused upon, the more it appears out of focus. The more one stops down on the lens or the shorter the lens focal length is, the more the total area that is in focus will be. This is what is called depth of field. It does not occur in exactly the same way in front and behind the area that has been focused upon, but slightly more toward the rear.

Photo by David J. Osborn.

However, it is equally important to keep in mind that a panoramic photographer is usually looking for a maximum depth of field – particularly with regard to landscapes, which have a long history in panoramic photography. And as it becomes harder to obtain depth of field as the size of the film format increases, it correspondingly becomes necessary to stop down on the lens to make up for this. All the same, achieving complete depth of field is not that difficult with larger formats because the quality of the optical engineering really comes into play as the lenses are increasingly stopped down. So if stopping down a 35 mm format lens to f5.6 or f8 is needed to achieve a desired effect, a large format lens would have to be stopped down to at least f22, perhaps even as much as f45, to obtain a similar result. At f45 – even with, say, a 90 mm lens on a 6 × 17 camera – the depth of field would be quite pronounced.

With digital cameras the opposite holds true, and achieving a similar level of quality does not require the use of a sensor as large as traditional film. For example, a sensor with 6 Mb of pixels for the APS format (13 mm × 18 mm) with an 8-1/2 × 11 print-out would compare favorably to a 35 mm negative with regard to image definition and subject tonality. But with such a small format, only a 9 mm focal length is needed for a 90° angle of view (see Table 1.2). A very short focal length like this means that it is not necessary to be too concerned about achieving depth of field; rather, the smaller the sensor, the more difficult it will be to achieve shallow depth of field and isolate details.

The size of the sensors is often quite small, especially with the compact, pocket digital cameras. And their operation introduces noise since they have a large number of miniscule pixels. Using such a small sensor also means that one must understand the new optical environment where a focal length of only a few millimeters takes in a normal field of around 55°. That's pretty much the same as using a 35 mm lens with a 35 mm camera! To repeat, with a 9 mm lens, the depth of field is already quite considerable, even when it is opened all the way to f4 or f5.6. And these tiny digital sensors make it extremely difficult to obtain a shallow

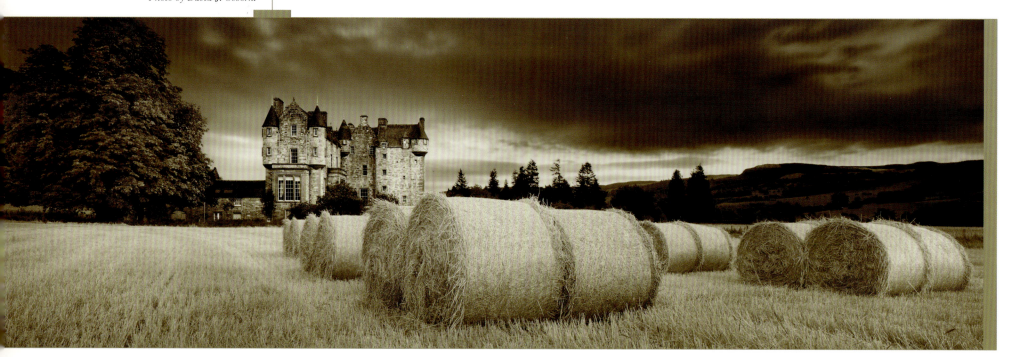

depth of field. This means that the panoramic photographer will have fewer means of expression at his or her disposal.

In summary, the longer the focal length, the more difficult it is to obtain depth of field. On the other hand, it is much easier to isolate a subject by focusing on it and leaving its surroundings out of focus. The main difficulty lies in achieving complete depth of field, especially with landscapes. Regarding the often-tiny digital sensors, the opposite holds true: depth of field is inherently maximal due to the shortness of the lens focal length. Here, everything is sharp, or close to it.

Hyperfocal Distance

Often used in panoramic photography, determining the hyperfocal distance allows a photographer to obtain the maximum depth of field for a given aperture setting. Therefore, this subject is particularly important – but to what does "hyperfocal distance" exactly refer?

When one places the critical focus at the horizon (with the aperture wide open), and then stops down on the lens, the depth of field increases with some of the foreground appearing in focus in addition to the background. Beyond the horizon, the depth of field theoretically continues to infinity. With the critical focus still being maintained at the horizon, and with the aperture partially stopped down, the closest foreground plane in front of the horizon that appears in focus is the hyperfocal distance. And the more the aperture is stopped down, the closer this plane will appear. Having successfully determined this, one opens up the aperture and replaces the critical focus at the hyperfocal distance. This is followed by stopping back down on the lens, whereby the maximum amount of distance between the horizon and the foreground will now be in focus.

Whether or not one makes panoramas, the hyperfocal distance will still need to be determined whenever one wants to obtain the maximum depth of field.

At first, the focus (F) is placed at infinity. Because of the depth of field (DoF), certain areas in front of infinity (the horizon) are also in focus. The closest area to the camera that is in focus is called the hyperfocal distance (HD).

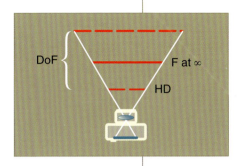

Afterward, the focus is no longer placed at infinity but exactly at the hyperfocal distance. Because of the depth of field behind the hyperfocal distance, everything will be in focus all the way to infinity (the horizon); and, in front of the area that has been focused upon, everything will be in focus up to a distance equaling the hyperfocal distance divided by two (HD/2), which is known as the initial foreground focus (IFF). By placing the focus at the hyperfocal distance, a photographer benefits from a maximum depth of field.

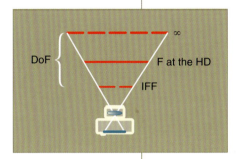

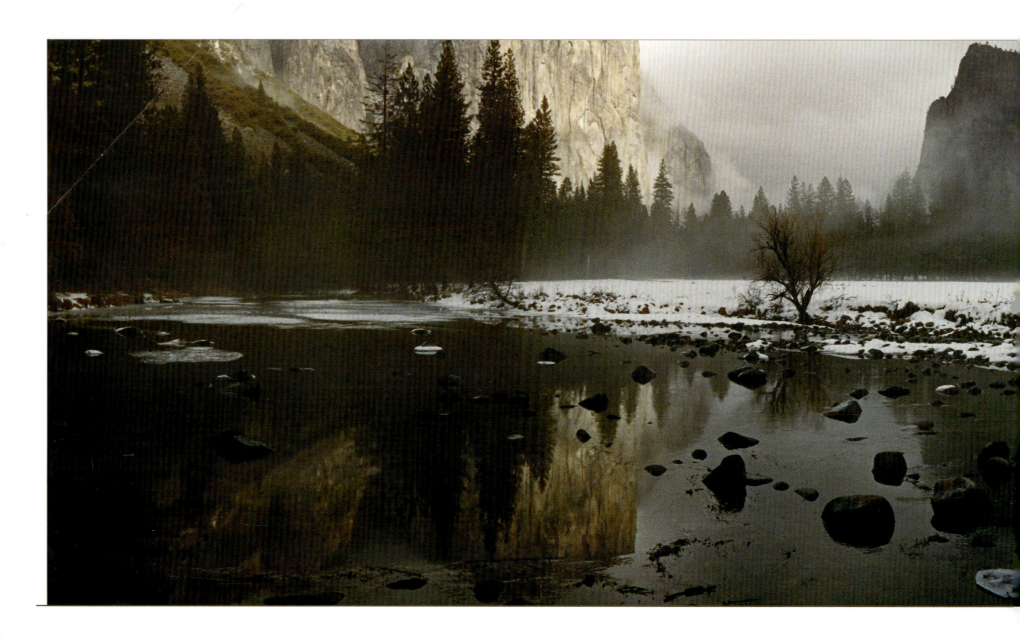

Framing and Composition

For many photographers, the framing of a pano-ramic image naturally depends on the subject. However, with any kind of camera – specialized, rotational, or conventional – it remains necessary to know how to frame and compose, and to take account of certain image distortions.

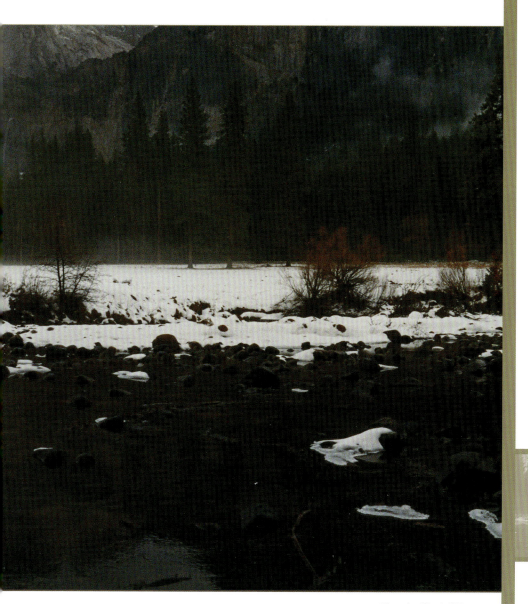

Photo by Macduff Everton.

"To compose is to form a harmonious whole from different parts." Difficult to teach and understand, composition reveals our sensitivity and point of view with regard to the world around us. This is more than just a series of rules laid down by the great masters of painting and photography, so I urge you to allow yourself to express your desires, feelings, and creative vision. Even though your point of view may change with time and experience, your letting go should always remain instinctive. With regard to panoramic photography, composition is influenced mostly by framing and certain telltale deformations that characterize the image, which are caused by either the camera used or the chosen joining method.

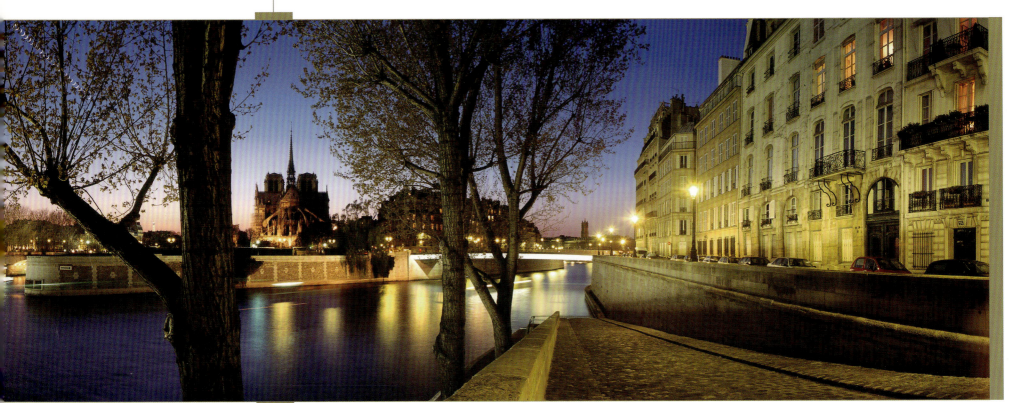

Photo by Arnaud Frich.

Using balance and harmony in a photo – or, in the opposite case, by deliberately introducing imbalance and disharmony – a photographer seeks to provoke an emotion or arouse a reaction. By suggesting a way to read the image along rhythmic lines, or determining the color saturation or level of grey, one strengthens his or her argument or point of view. And because it is difficult to eliminate an undesirable area at the moment of framing – when zooming, for example – the quality of the light, the color harmony, and the nuances of grey become ever more important in panoramic photography. Photographers working with large format go so far as to wait hours at a time for the ideal light needed to guarantee a beautiful photograph. Very often it's the light that makes all the difference, even more than the framing.

Framing

Framing in panoramic photography is influenced by two fundamental criteria: the frame of the viewfinder and normal image distortions introduced by specialty cameras and joining software. These distortions are so noticeable that they cannot be overlooked at the moment of taking the picture.

With the so-called *rectilinear* cameras (e.g., Hasselblad XPan, Linhof Technorama, Fuji 617), image distortions typically are present because their lens focal lengths are very short – about the same as those observed in photographs taken with a 35 mm camera with a shorter than 24 mm focal length lens. As for the rotational cameras (Noblex, Roundshot, Spheron, etc.), the distortions curve any horizontal line departing from the median. Therefore, with these cameras, the entire art of composition consists of either concealing or exaggerating these tendencies. But the chance to take in the entire view of the human eye (or perhaps even more) in an individual photograph explains the passionate attachment that certain photographers have for it. In Chapters Five and Six, we will see that joined panoramic photography allows one to make photographs identical to those taken with these two types of camera, and that sometimes joining even goes further, most notably with regard to decentering the lens.

Because no panoramic camera, rotational or otherwise, is equipped with a reflex viewfinder, it is necessary to remain extremely vigilant when framing with auxiliary viewfinders because of parallax and focusing problems. With these cameras it also is impossible to directly control the focus, which normally is done with a rangefinder and a viewing window, rather than on the actual field being photographed.

Viewfinder

A conventional 6 × 7 medium format camera is able to take the same photographs as an XPan: in geometric terms, the images have the same characteristics or "fingerprints." The 43 mm lens of the Mamiya 7 and the 45 mm lens of the XPan have the same horizontal angle of view. But one element (fundamental in my opinion, even if it seems insignificant) makes all the difference: the viewfinder. It is very difficult to compose and frame in a format that is different than the viewfinder's; it just doesn't appear right. Therefore, when photographing with a nonpanoramic camera, I suggest that you buy a ground glass with grid-markings, or better still, that you install two small masks that cover up the high and low areas.

Detachable viewfinder for a Noblex 150 U.

Even if it is technically possible to make panoramic photographs with a modified, conventional format camera, my own experience, as well as that of my peers, has shown that it is difficult to work on a regular basis in this way. Don't painters sometimes cut specific windows into cardboard to view the intended format at the end of their outstretched arms? This is a major reason why, apart from the simple fact of getting the most out the height of the film (35 mm or 120), fervent enthusiasts decide to purchase a real panoramic camera.

However, this process is reconsidered in discussions of joined panoramas made from conventional cameras. In that situation, it is impossible to have a preview of the final photograph, apart from sweeping the entire scene; and more and more, this is being done with the camera held in a vertical position. Only those already accustomed to the conventional cameras being used will be able to easily preview the future joined photograph and not be thrown off-track.

The viewfinders of panoramic format cameras (which are neither reflex nor capable of measuring distances) are often detachable and usually provide a sharp and very clear view. On the Noblex 150 and the Fuji GX617 for example, they contain three multicoated lenses, allowing for a very bold range of contrast. And once again, even though the viewfinders are normally quite sharp, they neither control the actual focus of the camera nor solve the parallax problem. Therefore, it remains necessary to pay close attention to position of the viewfinder at the moment of framing, always making sure that it is aligned directly behind the lens and on the same axis, regardless of whether the viewfinder is detachable.

Sometimes the grid-markings of certain viewing screens are already marked with a panoramic format, as in this case. The two lines above and below the median line allow an elongated format with balanced proportions to be cropped from it.

The geometry of this Norman facade is respected in this photograph taken with a Fuji 617 (90 mm).

Photo by Hervé Sentucq.

Flatback Cameras

Doubtless, everyone has already experienced framing and composing with a flatback camera – who has never used a 35 mm camera? Panoramic or not, these cameras project a recognizable image based on rectilinear geometry. Straight lines remain straight, even when they converge upon a vanishing point when tilting the camera. And to prevent the vertical lines from converging, no matter what camera one uses (since the problem is not specific to panoramic photography), shifting the lens from the optical center is required.

Because flatback panoramic cameras are essentially conventional cameras with the top and bottom of the image removed, the field of view being photographed is not all that different from the customary 35 mm format; and it will never extend much beyond 110°.

Horizontal Framing

Framing with a flatback camera is very easy, and that's its main advantage. If the camera is aimed straight ahead, all the horizontal and vertical lines should remain straight as well. If the camera is tilted toward the sky (as when viewing something from below), the horizontal lines will remain the same, but the vertical lines will converge toward a vanishing point. To avoid this (i.e., to aim higher without tilting the camera and introducing convergence), a photographer could theoretically shift the lens from the fixed or zero position – a technique often used in architectural photography – but unfortunately, this is rarely possible with flatback panoramic cameras. None of the three most well-known models – Hasselblad XPan, Fuji 617, and Linhof Technorama – are capable of shifting. Only lesser-known 6 × 12 and 6 × 17 cameras like the Glide MST, the Cambo Wide DS, and the better-known VPan can do this.

The symmetry of this image would not accept the curvature of lines introduced by a rotational camera (image taken with a Fuji 617).
Photo by Hervé Sentucq.

The chandelier placed in the lower right corner of this cropped photograph reveals the disagreeable stretching tendency that flatback panoramic cameras introduce when used with very wide-angle lenses.
Photo by Arnaud Frich.

The lens projects an image upon the entire surface of the film, whereupon the quality tends to diminish as it moves away from the optical center – most noticeably on the borders and in the corners. The only way to compensate for this age-old problem is to stop down on the lens in order to obtain a more consistent overall image.

Even more annoying is anamorphic distortion, which can be seen in the corners of the image when the angle of view is greater than 80°. Although this type of problem is infrequent in conventional photography (where a photographer does not normally use such short focal lengths), it is fairly endemic in panoramic photography. Indeed, this optical effect can be noticed in just about any panoramic photograph, whether it be taken by a 30 mm lens with a 24 mm × 66 mm format camera, a 72 mm lens with 6 × 17, or a joined panorama where the angle of view exceeds 80°.

Vertical Framing

Vertical framing is much easier with a flatback camera than with a rotating camera, even if the percentage of vertical images in specialized photo collections remains low. Two reasons for this are (1) the angle of view is not as considerable, and (2) flatback cameras do not graphically bend straight lines. Thus, they might be the panoramic cameras of predilection for architectural photographers who are not necessarily expected to render really creative work.

Swing-Lens and Rotational Cameras

With cameras where either the lens or the entire body rotates, the framing and composition need to account for distortions caused by the rotation of the lens. These distortions are immediately recognizable, like those caused by a fish-eye lens in conventional photography. Certain precautions, therefore, need to be taken each time one frames the image, so as not to constantly fall into the same trap.

Of course, it is important to remain as alert with vertical framing as it is with horizontal. If rotational panoramic photography remains the privileged means to show a wide-vista landscape or a scene as a whole, other subjects are nevertheless quite suited for the game of framing them vertically in a pleasing way.

Horizontal Framing

If the camera is aimed straight ahead, all vertical lines will remain vertical, as they would with a conventional camera. (This differs from a fish-eye lens, which curves all but the median lines.) The horizon line also is straight, but all the lines above and below this horizontal axis are noticeably curved. Even though the Earth is round, its curvature cannot be detected by viewing the horizon, so any curvature introduced by lens is a problem that needs to be addressed – except when called for in artistic photography. After a little practice, one can easily overcome this effect. All the same, it is necessary to note a few cases where it really can be quite discreet: in the city (e.g., old alleyways) where horizontal lines are not very long; and, of course, in natural environments.

If the camera is tilted, the horizon line curves as well. I do not find this aesthetically pleasing; however, I have noted a few cases where the effect was not too disturbing, and in some, even quite successful, especially since it breaks away from the rigid, geometric coldness that many photos can have. In these cases, any horizontal line that is too long is cut away from the bottom edge of the frame. Thus, the image resembles a typical low-angle shot, with a predominating convergence of vertical lines.

The angle embraced by this photograph of streets in Paris is 140° along the horizontal axis (Noblex 150U, plus lens shift).

Photo by Arnaud Frich.

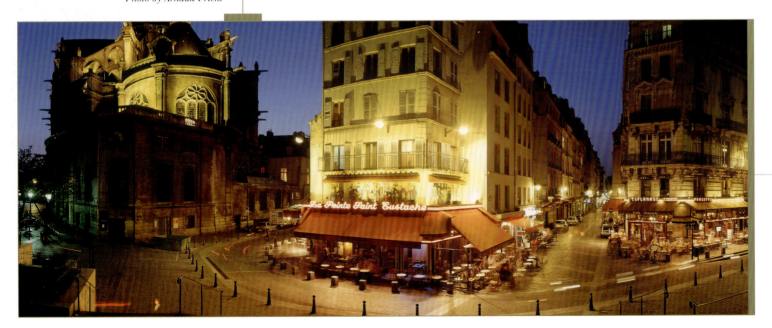

An extreme low-angle shot makes the inevitable curving of horizontal lines introduced by rotational cameras fairly discreet.

Photo by François-Xavier Bouchart.

As mentioned earlier, only a lens-shift will allow one to raise or lower the vantage point without curving the horizon line. This can be done with certain Noblex 135, 150, and 175 cameras (the top-of-the-line models), and with rotational cameras with interchangeable lenses. Thus, it is necessary to buy shifting lenses that are compatible with the types of camera that actually allow for this kind of perspective correction, as we will see later.

In natural settings, the curvature of vertical lines is quite discreet.
Photo by Arnaud Frich.

Vertical Framing

Few vertical photographs are taken with swing-lens cameras, since it is the vertical lines that curve here. The effect is largely unnoticeable, especially if the subject is either centered (e.g., a column) or relatively far off (e.g., buildings in the distance that appear quite small). This is the case in the photograph of the statue of Henry IV that I took from the Pont Neuf (see page 33).

As agreeable as it is to embrace the entire field of human vision in a horizontal photograph, it seems rather excessive to embrace a 140° field of view along the vertical axis with a swing lens. In addition to the difficulty of preventing the feet of the photographer and the legs of the tripod from entering the picture frame, the very characteristic bending of vertical lines is also a problem. This method does not really lend itself to every kind of subject, however. Although I am very fond of some of my vertical images taken with a Noblex, I think that vertical framing remains mostly the domain of rectilinear cameras and wide-angle lenses, where a 90° angle of view normally works quite well.

Photographic Assemblage

By putting photographs together, currently it is possible to obtain the same kind of image (geometrically speaking) as a Fuji 617, a Noblex, or a Roundshot. The field of possibility even extends to lens shifts and formal composition. Here the component images are taken first with a conventional, traditional camera (35 mm, 120 film, or even 4 × 5) or a digital camera (3, 6, or 11 Mb of pixels) and then joined by a dedicated software package, such as the Panavue ImageAssembler or the Realviz Stitcher. This method lies somewhere between cropping with conventional format photography and using a rotational camera. The final result depends mainly on the mode of joining (tiled or rectilinear) and the type of software used. Chapters Five and Six will look more closely at this relatively new way to make panoramic photographs.

Types of Joining Methods

Certain software packages allow the possibility of joining images in different ways. The better ones permit the creation of tiled assemblages (curved fields ranging from 120° to 360°) or rectilinear ones (flat fields up to 110° wide) when working from the same set of component photographs. A tiled assemblage will require a few extra photos, since the angle of view extends beyond 110° to 120°. With this method, one can achieve exactly the same effect as with rotating panoramic cameras like the Noblex or the Roundshot, especially if the lens focal length is short. And the more the lens focal length increases, the subtler the curvature effect will be.

With a rectilinear (straight line) assemblage, one obtains the same kind of photo that a conventional camera with a wide-angle lens would produce. In this way, one can observe the characteristic limits and shortcomings of photos made with extremely short focal lengths: these tend to visibly stretch objects on the edges and in the corners of the image. With a 35 mm camera, this effect starts to be noticeable with a 20 mm lens. It is quite apparent with 14 mm – the shortest focal length presently made for this format.

OPTICAL QUALITY

With a conventional camera, optical quality diminishes both in the corners and on the edges of the photograph. However, this is definitely not the case with rotating cameras, because the lens's optical center sweeps along the entire length of the film. In this way, image quality remains ideal, even at the edges. And for this same reason, corners and edges are not distorted by stretching. This is an undeniable advantage.

This photo, taken with a flatback camera, would look exactly the same if joined with software using a rectilinear mode.

Photo by Hervé Sentucq.

This joined image has been adjusted to place the horizon line at the upper third of the composition and to keep vertical lines parallel.

Photo by Arnaud Frich.

Types of Software Programs

The better joining software programs make it easy to frame things: they make it possible to tilt the camera and take a picture with the horizon line away from the middle of the photograph, while avoiding a convergence of vertical lines. With other software packages – those sold with pocket digital cameras – this is not possible.

The result obtained by tilting the camera upward (low-angle) or downward (elevated view) depends on the software being used. With the majority of software programs, it is absolutely impossible to join the images in a way that prevents the complete horizon from making a series of successive arcs at each (tiled) linkage, instead of the single, continuous curved line that the Noblex can achieve. With the Autopane Pro, Stitcher 5.0 from Realviz, ImageAssember from Panavue or also from PTGui, the Realvis Stitcher, and Panorama Tools, both the horizon and architectural lines remain straight, without any convergence toward the top or bottom, as though the photograph had been taken with a shifted lens.

It is never recommended to use lens movements in combination with software packages; when assembling the images, it would be a catastrophe. On the other hand, if the camera is aimed straight ahead while taking the picture, and if the photographer is careful to keep it at the entrance pupil, the joining will be perfect, no matter what software program is used (see Chapter Six).

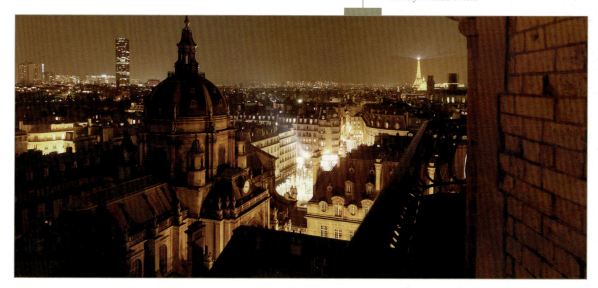

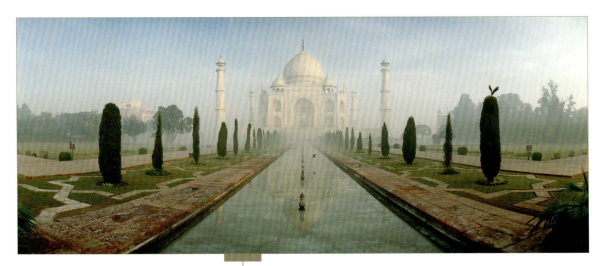

A balance is struck because of the subject's perfect symmetry.

Photo by Macduff Everton.

Composition

Any subject can be taken with a panoramic format, although framing possibilities are more limited than with conventional formats (e.g., one cannot eliminate problem areas by opting for a closer view). Don't let this keep you from moving around to find the best possible point of view! Any urban or natural landscape, even a street scene, is perfectly capable of contributing all of the necessary aesthetic qualities needed to make a beautiful photograph. One needs to decide only whether to frame a little to the left or the right, a little bit higher or lower. Similarly, a judicious placement of both the horizon line (possibly aided by shifting the lens) and the strongest elements of the scene will often result in a beautiful composition.

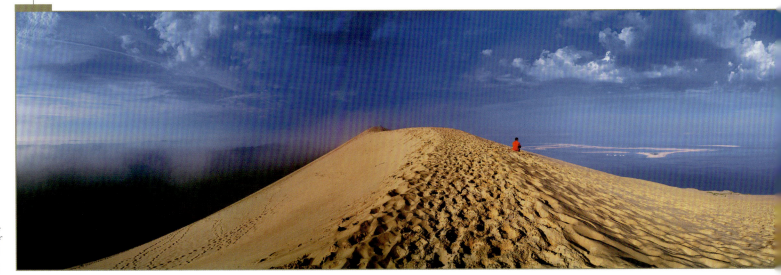

The two summits of the Dune du Pilat have been placed at the two vertical thirds of the photograph (Roundshot 220).

Photo by Franck Charel.

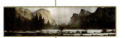

Rule of Thirds

I do not want to approach the thorny subject of explaining the composition of a photograph; however, I would like to share some observations drawn from my practice of panoramic photography for several years, primarily with rotary-lens cameras.

Photography is far too recent a means of expression in the history of art for photographers not to have benefited from the rules of composition laid down by painters in the Middle Ages and Renaissance. The rule of thirds, perhaps the most well-known rule, states that overall balance often is determined by mentally dividing the frame into three equal parts, either from top to bottom or from left to right, and then placing the significant subjects at the dividing lines. This constitutes an important start, even if one sometimes departs from it. Photographs made using this rule are undeniably harmonious, even if their uniformity can eventually become tiresome.

When using the rule of thirds, it is desirable from the start to imagine two vertical and horizontal lines dividing the frame into nine roughly equivalent areas, and to place the most significant lines there, most notably the horizon line and the main

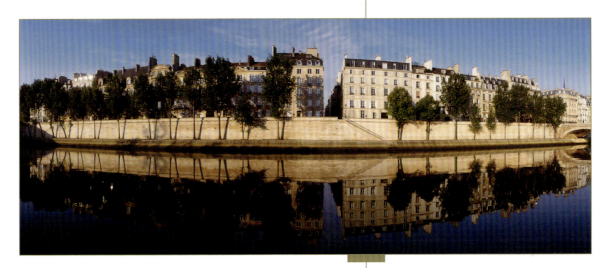

Given the significant angle of view of rotational cameras, placing the horizon line on one of the two horizontal thirds is not required.

Photo by Arnaud Frich.

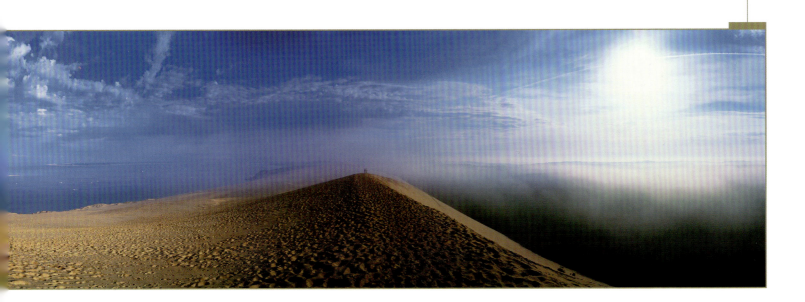

subject. As in reading from left to right, it is desirable that a photograph would be read in the same way as well. In this way, placing the subject to the right would tend to end the image, while placing it to left would begin it. Therefore, the position of the subject is never insignificant, even if it is difficult to always know what is the best option to take. Obviously, much of this depends on the subject, the lighting, the photographer's style, or how long the resultant photograph will be. Apart from this, if the rule states that it is best to divide the image mentally into nine equal parts, and does so according to an aspect ratio of 2:1, to my mind it seems better to divide the image into three equal parts for a 360° photograph, which usually has a ratio exceeding 4:1.

Placing the Horizon Line

A well-placed horizon line is normally an important part of the aesthetic success of a photograph, and even more so with panoramas. Apart from shifting the lens, tilting the camera remains the only way to move the horizon line away from the

middle of the photograph, or to photograph a monument. However, not bending the horizon line is sometimes so important that a photographer will keep it in the middle, in spite of knowing that this is not the ideal place for it in the composition. Because it lacks dynamism, leaving the horizon at the middle of a photograph can contribute to a sense of monotony. With flatback cameras, the horizon line remains straight at the cost of a strong convergence of vertical lines – something we are at least used to, even if it is not ideal. In this case, acceding to the temptation to place the horizon in a more graphic location could improve the overall aesthetic scheme.

Because most panoramic photographs are displayed lengthwise, keeping the horizontal line in the middle of the frame hardly disrupts compositional harmony, and does not go against the rule of thirds. In truth, the most important thing is simply to place the dominant visual elements on at least one of the two imaginary vertical lines that divide the frame into three equal parts. But if a photographer really wants to keep the horizon line straight, in order to avoid converging vertical lines, he or she will have to shift the lens.

To break up the monotony, and because this was closer to his personal vision, the photographer deliberately has placed the horizon line below the lower horizontal third.
Photo by Hervé Sentucq.

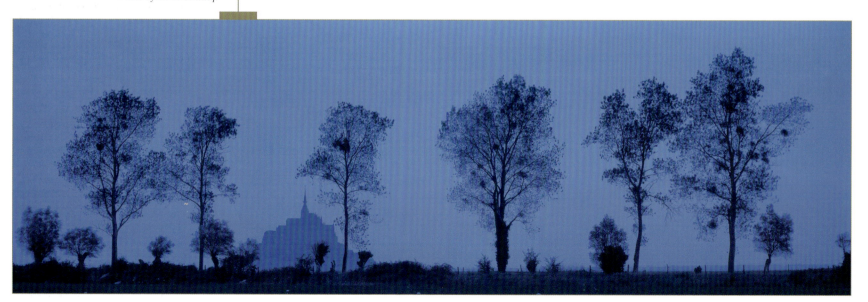

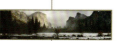

Shifting the Lens

Shifting the lens can be an important technical element in determining the composition. As stated earlier, when one tilts the camera, the vertical lines converge toward a vanishing point. To avoid this, the rules of perspective state that the back of the camera and the vertical lines of a subject must remain parallel. For this reason, architectural photographs usually are created with bellows cameras that have moveable front and rear standards, or with smaller cameras equipped with PC (perspective-correcting) lenses that shift up and down. Obviously, one can shift the lens for other subjects as well.

The first cameras were large-format; largely to overcome their earlier bulk and weight, cameras became smaller, more portable, and quicker to operate. Originally intended for the press, these newer cameras eventually lost their earlier lens- and back-moving features (i.e., swings and tilts, rise and fall), which had provided an important control over the image. As a result, our eye has grown accustomed to longer images (e.g., 35 mm) rather than shorter ones (e.g., 4 × 5), and to uncorrected photographs of buildings depicted as trapezoidal forms.

Large-format view camera, in the raised and shifted position, which allows the horizon line to be placed at the lower third division of the panoramic photograph.

Today, photographers still use camera movements, but this is far from the rule, since the majority of large format cameras are used to take pictures in the studio. For photography in general, and for panoramic photography in particular, shifting the lens is nonetheless an important factor in the aesthetic success of an image. Tilting the camera is even more noticeable when the convergence of vertical lines is combined with a curvature of the horizon line (notably when using the Noblex, or with the joining method). If we have become accustomed to viewing photographs where the lines of buildings converge, it will be difficult to get used to photos where the horizontal lines are curved as well!

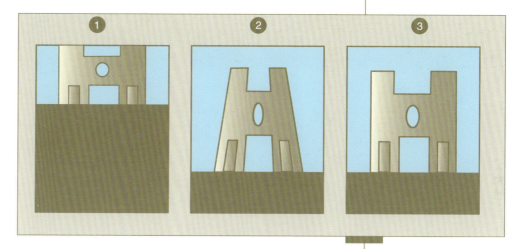

1. *The camera, placed on the ground or a tripod, remains parallel with the building. The vertical lines do not converge, since they still remain parallel on the film. But the building is not entirely visible; the point of view of the camera is too low.*

2. *The camera has been tilted slightly upward: the building is now entirely visible, but the vertical lines converge toward a vanishing point. The film and the facade are no longer parallel.*

3. *To combine the two advantages (in this example, anyway), it is necessary to use a view camera or have a very high stepladder. Here, the lens has been raised, or shifted toward the top. The building is entirely visible and its geometry is respected.*

In this example, the focused image circle is larger than the 35 mm photographic format. By keeping the back of the camera parallel to the building, it is possible to shift the lens (up to a maximum of 12 mm in this case) in order to avoid cutting off the top part or causing the vertical lines to converge.

Theory

Shifting the lens is possible when it projects an image circle significantly larger than the diagonal of the film format. For example, in 35 mm the diameter of the projected image circle needs to measure at least 43.27 mm, and at least 90 mm for 6 × 9. Returning to the example of 35 mm, if the lens projected an image circle of 60 mm, the lens could be shifted up to 12 mm vertically and 8 mm horizontally.

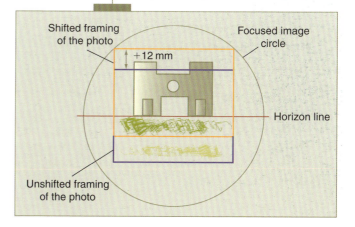

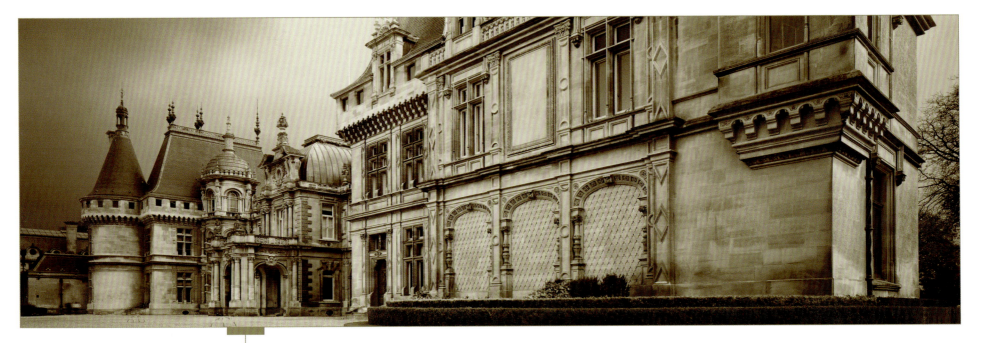

*Because of the significant shifting
of the lines, the lines of this castle remain
completely parallel.
Photo by David J. Osborn.*

Flatback Cameras

Different problems arise depending on the type of camera used. The simplest problem concerns how to crop a nonpanoramic photograph. In this case, one is not necessarily forced to work from the middle; it is equally possible to use either the top or bottom part of the entire image with the goal of profiting from an indirect shifting of perspective. When taking the picture, simply avoiding tilting the camera is sufficient when using the shortest lens possible; this will provide the maximum vertical angle of view. Also helpful is the use of a ground glass with grid-markings; the horizontal markings mark out the panoramic view and the vertical markings verify the parallelism of the camera in relation to the subject. By cropping the photograph in order to use the upper part of the image, the parallelism of the lines will be preserved, and the part of the ground, which is often of little interest, will eventually be cut away. To benefit from further shifting along the vertical axis, it becomes necessary to use a lens truly capable of shifting (called PC or Shift, depending on the brand in question), or a medium or large-format camera with an elongated back (6 × 12). Beyond this, only bellows cameras capable of shifting really short lenses are used in panoramic photography.

Apart from cropping, the only way to avoid the convergence of lines with a flatback panoramic camera is to shift the lens, which is possible only with certain top-of-the-line large-format cameras such as 6 × 12 (Cambo, Wide, Horseman SW Pro, Linhof Technorama 612 PC, Silvestri H) and 6 × 17 (VPan, Gilde MST). The Hasselblad XPan and the Fuji 617 do not allow for any control of perspective.

Swing-Lens and Rotational Cameras

All the recent rotating cameras – traditional or digital – are offered by some of the biggest makers of 35 mm and medium format cameras. Both Nikon and Canon sell three shifting lenses of different focal lengths, and Mamiya sells a shifting 50 mm, f4 lens. These are undeniable assets for composing harmonious images with medium format. The camera merely needs be squared up in relation to the horizon, and then there is nothing more to do than shift the lens, adjusting the amount of shift by looking through the view-finder, or at a portable computer screen.

Apart from these, one has to choose from cameras with noninterchangeable swing lenses. Only the Noblex 135, 150, and 175 cameras have true shifting lenses, but their movements end up being too restricted to be able to place the horizon line accurately (i.e., only 4 mm of shift for the 35 mm models and 5 mm for medium format). My idea was to combine the shifting capability of my Noblex with an indirect shift obtained by cropping my color transparencies (for photographs of mountains, for instance). Now the aspect ratio for the Noblex 150 is 2.4:1, as opposed to 2.7:1 for the 35 mm models. But ever since Philip Plisson exhibited his well-known seascapes taken with a 6 × 17 camera, a new ratio, 3:1, has been in demand for panoramas. With this in mind, I cropped the color transparencies from my Noblex to this slightly longer ratio, removing a portion of either the sky or the ground, and placing the horizon line where I wanted it.

Joining Method

This method not only allows for taking panoramic photographs with a conventional camera (making it more economically feasible), it also allows you to place the horizon more or less where you want it, without having to shift the lens. The converging lines caused by tilting the camera while taking the picture are corrected by the software, regardless of whether one makes a tiled or a rectilinear assemblage.

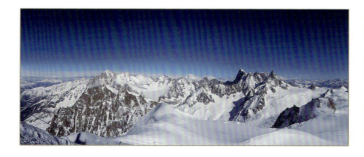

By cropping the image, I was able to move the horizon line and adjust the image's proportions. The Alps, Aiguille du Midi, Chamonix, France (Noblex 150).

Photo by Arnaud Frich.

This subject typically works well with a centered horizon line. The presence of clouds in the sky serves only to reinforce the strength of this beautiful, symmetrical composition (Noblex 150).

Photo by Macduff Everton.

Symmetry

The panoramic format also lends itself to symmetrical subjects. The architectural lines of monuments and cityscapes work quite well in this format, enhanced by the combination of a long format with horizontal or vertical symmetry. And here the subject can be photographed with or without tilting the camera, as it will rarely harm or impair the overall scheme of this type of composition.

In nature, there still remains at least one subject that demands a centered horizon: a pond of water and its reflections. In this case, the use of symmetry would accentuate the serenity of the place, which could also be complemented by the absence of wind, to avoid having ripples on the surface of the water.

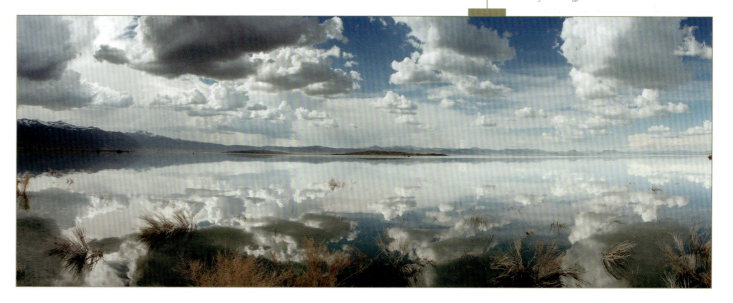

With swing-lens cameras, one must always avoid photographing the sun directly; wait until it is slightly covered by a cloud.
Photo by Macduff Everton.

The presence of the sun in the field of view embraced by the lens is no longer a problem with flatback cameras equipped with modern lenses.
Photo by Benoît Ancelot.

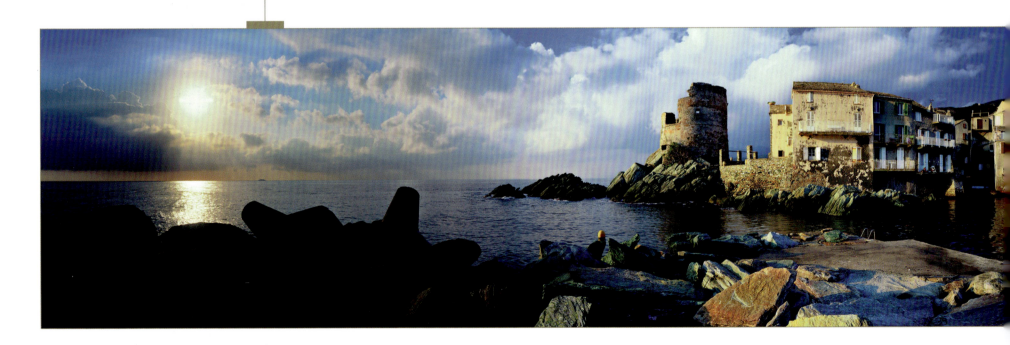

Composing with the Sun

Depending on the weather and the time of day, the panoramist sometimes must compose with the sun. Although this does not pose a particular problem in the case of flatback cameras or when using the joining method, with rotational cameras and swing lenses it is impossible.

Midday

Due to the way in which they function – a rotating lens projecting an image through a slit onto the film – cameras with swing lenses cannot photograph overly bright subjects (e.g., the sun, public lighting). The excessive light seeps beyond the edges of the slit, resulting in very noticeable halos of light running along the height of the film (the effect is particularly noticeable on a light-table).

I do not know of any remedy for this, so I never photograph the sun directly, even at sunset, unless it is obscured by a thick, cloudy haze.

Rotational cameras like the Roundshot, in which the entire body rotates, are not quite as affected by this problem. Here, the light source has a tendency to spread out on both sides, rather than mark the entire height of the film. This is a lesser evil in my opinion, and not wholly unacceptable. Flatback cameras do not have this problem at all; however, it becomes necessary to guard against a diffuse halo known as lens flare (although they are becoming more and more protected against this as well).

Since the joining method makes it possible to create the same kind of image as a rotating camera, and since conventional cameras are not subject to flare problems, it seems better to use the joining method when photographing a direct light source (always be sure to avoid looking directly at the sun as this damages the eye!). I use it to complete work that could not be achieved with a swing-lens camera.

Due to the angle of view of the Roundshot (360°), the photographer is able to show both the sun and the building facades warmed by its light.

Photo by Franck Charel.

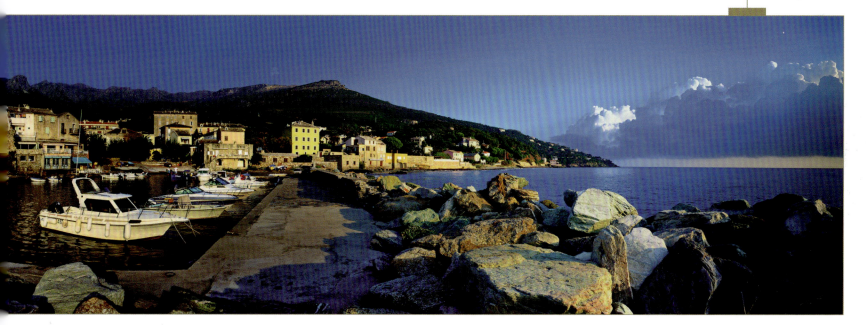

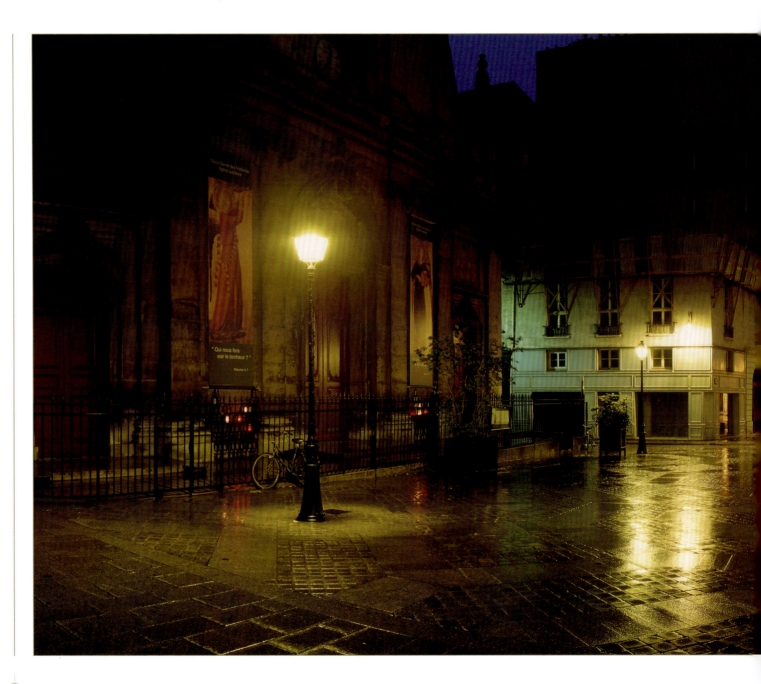

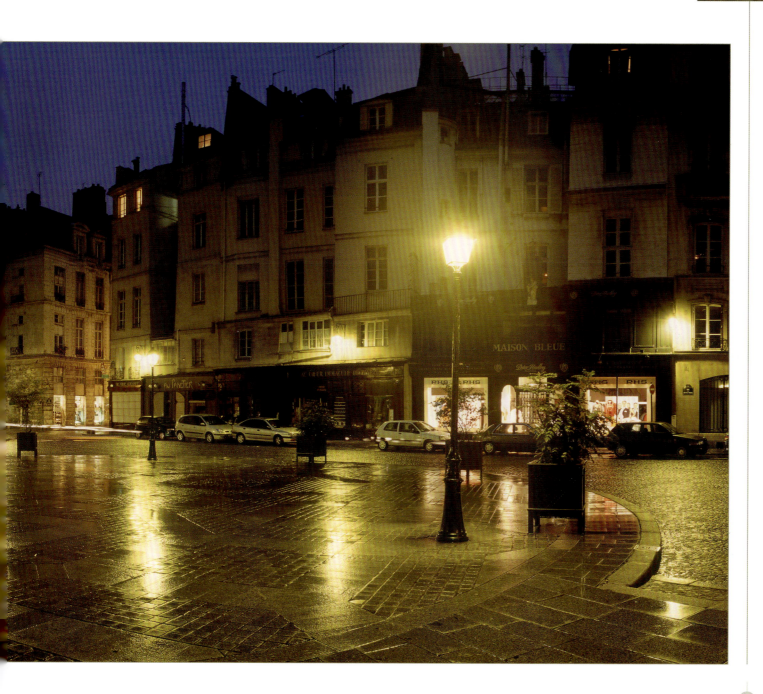

Place des Petit-Fréres, Paris.
This photograph, taken at dusk, required an hour
and 30 minutes of exposure in the rain.
Photo by Arnaud Frich.

At the End of the Day

The end of the day and the hour preceding are especially good times to make panoramic photographs with the Roundshot or joining method. For example, in the same photograph it is possible to see both the setting sun and the entire surrounding environment bathed in the glow of twilight. Concerning the overall plan of the composition, I want to draw your attention to a problem that I have encountered. With a rotational camera, the angle of view is so vast that the sun appears quite small. With an angle of only a fraction of a degree, the sun (and the moon) is represented by a miniscule point in photographs of 150° or more. Although we are charmed by a beautiful sunset, the resulting photograph will probably be a disappointment since the film will record only the tiniest star above the horizon.

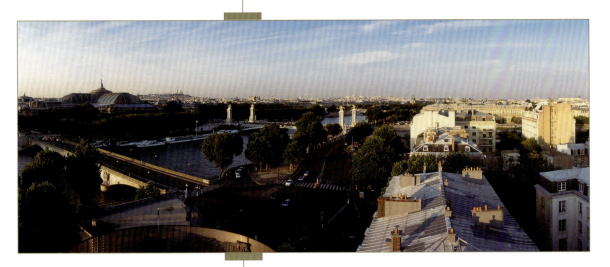

This photo has two major problems:
(1) taken at sunset with a Noblex 150, there are
not enough illuminated areas and
(2) the horizon line is too flat and centered.
Photo by Arnaud Frich.

Composing at Night

Nighttime photography is linked directly to the ability of making long exposures. Some panoramic cameras, both rotating and flatback, lack shutter speeds slower than 1/2 second, making them unusable at night. Certain Noblex cameras allow an exposure of one or two seconds (i.e., certain 35 mm models and the 150, respectively – the 150 also has a handle for slow shutter speeds). This is often not enough, so they make up for it by adding a multiple-exposure function. No other swing-lens camera offers both possibilities at once, which is a real advantage and quite original. Thanks to this function, I have been able to make a series of twilight and nighttime photographs in several French towns, by manipulating the exposure of the picture. This possibility will be explained in more detail in Chapter Four.

Traditional rotational cameras allow for longer exposure times (sometimes up to 128 seconds), but their operation, which differs significantly from swing-lens cameras, makes long exposures fairly impractical. I remember once it took the camera a full hour to operate during an actual exposure of six to seven seconds. For an exposure of 45 seconds – something I often need in an urban setting – seven hours would be required.

 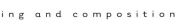

At present, digital rotational cameras do not permit multiple exposures or exposures longer than a half-second; therefore, nocturnal panoramic photography is nearly impossible. Flatback cameras do allow nighttime photography, however, and have done so for some time now, thanks to their "B" (bulb) exposure setting. This has become even easier now that the new films don't have the old problem of reciprocity failure that was inherent in long exposure times with traditional film.

The wind and fleecy clouds have allowed this photograph
to be made under a mottled sky (Noblex 150 U).
Photo by Arnaud Frich.

Twilight or Black Skies?

Although a question of personal taste, one thing is sure: a black sky will never be very aesthetically pleasing in a panoramic photograph, especially since the sky is located in a dominant area. Also, there is a greater chance that the photograph will be poorly composed; therefore, it is absolutely crucial that the exposure of the photograph not be done too late in the day. However, in large cities, where ambient, artificial light is always present, nighttime photographs are still a possibility, provided that the sky is covered with low-lying clouds. In this way, the city's illumination bounces off the layer of clouds, providing a pleasing brownish or orange-colored aspect to the sky, which harmonizes nicely with the rest of the photograph. If the clouds are really low, irregularly shaped (i.e., cumulus), and pushed by the wind during exposure, this can provide a very interesting effect, as shown in Figure 2.28.

Although it requires a high degree of sensitivity, because the balance between the end of the day and onset of artificial lighting does not last longer than 10 minutes, twilight remains the best time to take photographs that have a nocturnal quality. And if the sky is clear, colors will be particularly intense and stand out from the rest of the photograph. The difficulty lies in starting the exposure at the right moment, and for this we will turn to an expert on the subject in Chapter Four.

Film sensitivity is given for a specific range of exposure time. However, when the exposure time is too long, or even too short, the sensitivity falls and no longer corresponds to the ASA number listed on the film packaging. Colors are no longer reliable and shift according to the manufacturer's stated listings, since the three RGB layers have lost their nominal sensitivity (but never to an equal extent): thus, the photographs are dominated by one color that only a filter used during the time of exposure can correct. This is known as reciprocity failure, or the Schwarzschild effect (named for its discoverer). This effect no longer exists with digital sensors.

Reciprocity from Film and Sensors

Ten years ago, color films were not capable of exposure times longer than one second; beyond this, their sensitivity declined dramatically. For example, a film rated at ASA 100 actually had the sensitivity of ASA 12 with a one-minute exposure, so the rule was to give additional exposure to make up the loss of sensitivity. In addition to this major inconvenience, the problem of color shift made it difficult both to preview and correct. Today, the evolution of color films largely has eliminated this from the concerns of photographers. Manufacturers now market films that allow an exposure of a minute without much correction, both in terms of color shift and light sensitivity. And if digital sensors are spared these two technical constraints, the tiny sensors of pocket digital cameras, with pixels having less than four microns on each side, introduce excessive thermal noise as the exposure is extended. This translates into a multitude of colored dots covering the background of the image, which is most disagreeable.

Headlights

The traces of car headlights are another important element in the composition of photographs taken at night in urban settings. They form long red and white ribbon-like trails with conventional cameras, as well as with certain flatback cameras. Rotational cameras tend to produce more of a colored staccato effect, and because the angle of view is very wide, one even can see them register as two different colors. However, this sometimes gives a dynamic aspect to photos that lack movement.

Composing with Passers-by

Rotational and swing-lens cameras produce different effects than flatback cameras do. With the former, it is absolutely necessary to anticipate the movement of both passers-by and cars due to a lag-time between the pushing of the shutter release and the moment where the lens truly starts to sweep the scene. Because this is often difficult to control, it is not uncommon to have to reshoot a photograph because someone has entered the field at the very moment the lens is sweeping that area. Here again, the problem does not affect the joining method since the photographer can always pause between consecutive exposures.

One can equally exploit the anamorphic distortions caused by the rotation of the camera or lens during exposure and their simultaneous movement with the subject being photographed. These are characterized by geometrical transformations: if the subject (i.e., a passer-by or car) moves in the same direction as the lens, it will appear extended in the photograph; moving in the opposite direction will make it appear compressed. One really can use this effect for creative ends.

The simultaneous movement of the camera and turret has created this anamorphic distortion that one could never tire of experimenting with (Noblex 135 U).
Photo by Arnaud Frich.

These photographs show the different traces left by moving head- and taillights, depending on the type of camera used. On the left, a rotational camera was used, on the right, a flatback camera.

Photos by Arnaud Frich and Hervé Sentucq.

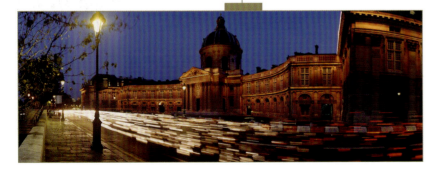
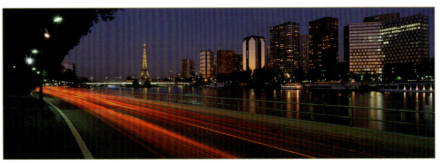

Noting Location

Noting location is very useful in urban and landscape photography, as it is in reporting. Like many photographers, whether I have a camera or not, I always am aware of my surroundings; this is where noting the location naturally begins. Very often, I carry two separate viewfinders with me. With these I note framing possibilities and surroundings that please me, and I try to anticipate what kind of light (e.g., morning or evening, winter or fall) would make for the most beautiful panorama. Nothing beats walking on foot and remaining vigilant; it is not always easy to fill a field of 120° or more in a pleasing way, especially in the city. Noting locations on maps can be difficult, no matter how precise they are, but there remain times when it is necessary, for example:

- To determine the time of year that the sun will shine on a certain facade or monument, and at what angle
- When visiting an unfamiliar place or area
- To determine where the moon will rise, and at what time of year (e.g., in order to integrate it into a landscape as a string of time-lapse exposures).

On the walls of my house, I also pin up precise maps of cities and places I want to photograph, noting observations there. A relief map is equally useful for mountainous regions if the relief is sufficiently pronounced. With this kind of map and a directional penlight, it is both easy and fun to simulate sunlight in order to anticipate how the mountains' shadows will change during the day.

With panoramic photography, the angle of view is sometimes so wide that determining the location can be done only in the field. In other words, how can one totally predict that the sun will leave a particularly beautiful shadow on a certain facade at a specific time of year? Maps only allow you to predict the season. This being the case, there can be some surprises: with 150° to 360° in the city, either all the conditions are present at that very moment or it is already too late and one has to wait another six months or a year (see the expert's opinion section in Chapter Four).

Urban or Natural Settings

In the city, filling an angle of view exceeding 100° in a pleasing way is never easy, especially because one often lacks enough room to move away from the subject (rotational cameras with more than a 140° angle of view are more appropriate here) and because sidewalks are often too narrow or busy to set up a tripod.

An urban milieu is also characterized by the constant presence of geometric lines, so the optical distortions produced by panoramic cameras, rotating or flatback, will automatically be revealed. A little experience is needed to know how to anticipate these curvatures,

AUTHORIZATION

For certain pictures, authorization is required, regardless of the destined use of the photos (even personal). During the period when I was still an amateur, someone asked me for $450 for a half-day of taking pictures in a courtyard interior that was open to everybody. One thing is sure, the law regarding the use of images is constantly evolving and its application perhaps even more so. Between 2002 and 2003, photography was faced with some dark moments and sensational trials; however, the future seems calmer.

Photo by Didier Roubinet.

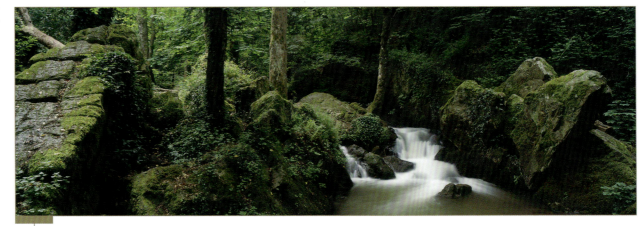

In natural settings, the absence of geometric lines permits a great deal of freedom in choosing a panoramic camera, rotating or not.

Photo by Hervé Sentucq.

and how to discretely hide them. Facades can be covered with scaffolds, which can be detrimental to the photograph, or spoiled by road signs. Fortunately, retouching software allows one to eliminate them in some cases. But as I am not necessarily looking to reproduce an ideal city, I often leave them there.

In natural environments, the limitations of camera choice are far fewer as there are not many straight lines that could betray the camera's presence. Here, the difficulties concern mainly the weight of the equipment in transportation, which is a problem for all of large-format photography, not just panoramic photography.

NOTE

Although it is sometimes difficult to get close enough to a scene, this distance is even more accentuated with the short focal-length lenses used with panoramic cameras. Here, the subject risks being small and far away in the image. This is a frequent pitfall with panoramic photography, especially rotational. Journalistic photographers who justifiably love to be at the center of action do not have this problem.

Journalism

The Hasselblad XPan has achieved real success in journalistic photography. Thanks to this compact, modern camera, panoramic photographers have started covering events in places all around the globe, even the most dangerous. What better means exists to show an event and people in context? Before this camera came to prominence, journalistic photographers used the swing-lens Widelux camera, like Michael Ackerman did for his well-known work, *End Time City*.

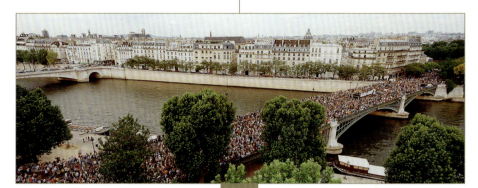

The elevated view and use of an XPan equipped with a 30 mm lens have allowed the magnitude of this event to be revealed.
Photo by Didier Roubinet.

Photo by Benoît Ancelot.

Chapter 3

Flatback Cameras and Picture-Taking

From a simple throwaway to large-format, any digital or traditional camera will allow you to discover the joys of panoramic photography. All you need to do is to crop the film or final print lengthwise!

Photo by David J. Osborn.

The possibilities for taking a flatback panoramic photograph are numerous. Using a "non-panoramic" camera, one can mentally crop a horizontal, panoramic band in the viewfinder while taking the picture; then the print can be cut to the same dimensions. Some flatback cameras are specifically designed for panoramic photography, however, and will directly provide the desired result. These less bulky cameras contain panoramic viewfinders and use a film format that does not need to be cropped.. With these flatback cameras, one will obtain as much of a panoramic format as any rotational camera embracing a very wide field – so shouldn't panoramic photography truly start here?

Photo by Hervé Sentucq.

Having remained unpopular for a long time, due to the prohibitive price and size of specialty cameras, flatback panoramic photography has recently expanded, in part due to panoramic-format APS cameras, certain throwaway cameras, and, more recently, the Hasselblad XPan II. Using the latter camera, which is hardly larger than either a compact camera or the celebrated M series Leica, one can make both regular 35 mm and 24 mm × 66 mm format photographs, discovering the satisfaction of transforming a street scene or a landscape into a panorama (although the really wide-open spaces still remain the domain of the Fuji 617, Linhof, and various 6 × 12 cameras).

We begin by discussing conventional, digital, and traditional cameras that are very easy to use for panoramas. We then discuss specialty cameras – also called rectilinear or orthoscopic – where one gains superior image quality without much added weight and bulk. And prior to ending the chapter with some advice on how to make pictures with these types of camera, we will describe some necessary accessories for the panoramic photographer to use.

Conventional Cameras

Whether small in size, like APS cameras, or large, like studio monorail cameras, my use of the term "conventional camera" refers to all cameras that have a conventional format photograph – that is, a square or rectangle. The most conventional of these, of course, is the 35 mm camera. With these cameras you can make a photograph panoramic by cropping it lengthwise. Panoramic photography is at least possible with throwaway cameras, but expanded dimensions open up with the larger format cameras.

Throwaway, APS, and Compact Cameras

The APS format has popularized panoramic photography by allowing a longer rectangular framing to be selected at the time of exposure. By positioning built-in masks in front of the film, the camera can create a variety of formats, from conventional to elongated (16/9). However, one can criticize APS for the mediocre quality of the resultant image, largely due to the small size of the negative. But this format is in the process of disappearing.

Throwaway cameras are similarly marketed in a panoramic format. Their optical quality leaves much to be desired, however, since they lack sharpness, which is especially noticeable at the edge – but a fault that some photographers know how to exploit in creative and artistic ways. These cameras have the advantage of being neither costly nor fragile. One can take them without concern to difficult places such as street protests, mountains, and the like.

Some compact cameras are adapted for panoramas. Like APS cameras, these sometimes have a system of moveable masks that slide in front of the film when in the panoramic mode. And as we saw in Chapter Two, these cameras can allow for an indirect shift by cropping the top or bottom of the resultant photo, rather than from the middle of the print.

Hasselblad XPan, 45 mm lens; photo by Aurore de la Morinerie.

Sometimes nonspecialty cameras have the direct ability to make a panoramic format. Two shutters slide from the top and bottom of the film; because the useful part of the negative is significantly reduced, the image quality is often mediocre. This is even more true with the APS format, which is smaller than 35 mm.

The horizontal field embraced by these types of camera is often limited, since it is rare for them to have zoom or really short, wide-angle lenses. Normally, it will be difficult to go wider than a 28 mm lens, or a horizontal angle of view exceeding 65°; however, certain throwaway cameras have a 17 mm lens with a 90° angle of view! With compact digital cameras, the situation is even more limited: not only is their sensor very small – under two million pixels – but the shortest focal length, without additional lenses, is often equivalent to a 38 mm lens with 35 mm, or 50°. On the other hand, if one decides to join several images together, it becomes possible to obtain a much wider angle of view (see Chapter Five, which addresses joined panoramic photography).

fish-eye lens. Here it is truly possible to take up panoramic photography without buying any additional equipment or changing old working habits. And with a 14 mm or 17 mm lens, one can really start to explore a large visual field.

35 mm camera.

35 mm and Digital Cameras

Digital camera.

35 mm is the most accessible format among nonspecialty traditional cameras, although increasingly its place is being taken over by digital cameras. Still, the market for 35 mm photography remains so large that one can choose from a wide variety of brands and focal lengths. In the best of cases, lenses will provide angles of view ranging from 4° to 115°; one exception, however, is the 180°

The widest angles of view are limited to the shortest focal lengths. Today, this is 115° with the 14 mm lenses made by various brands. However, here it also will be necessary to compose with significant anamorphic distortion at the edges and in the corners of the image. In other words, objects or persons at the limits of the photo will appear stretched out and deformed. So if you usually photograph people, remember that they may not always be happy about this!

In Chapter One we learned about the impact of the focal length on the resultant size of objects on the image matrix. Therefore it is necessary to prevent the finer details from being obscured by either the grain of the traditional film or the noise introduced by the sensor. Also, recall that the part of the film being used will measure only 12 mm × 36 mm after cropping. Thus, the shorter the lens focal length, the more miniscule the resultant details will be.

The cost of this type of lens is very high, approaching that of the Noblex brand of 35 mm swing-lens panoramic cameras, and something that could justify the purchase of the latter instead. Yes, a conventional 35 mm camera is lighter in the camera bag, but a Noblex 135 or a Horizon 202 is not all that bulky, and their weight is hardly more than a fast 35 mm lens with a lot of glass.

As we have seen in Chapter Two, concerning framing and composition, it is possible to shift the point of view in the following ways:

- **Indirectly**. A strip measuring approximately 12 mm in height can be cropped from anywhere from the length of a 35 mm exposure (i.e., from the top or bottom, and not necessarily from the middle of the photo).

- **Directly**. Using a shifting lens, when available, this is used to place the horizon line where one wants and to prevent the vertical lines of buildings from converging.

Digital Cameras

As of this writing, digital cameras are becoming increasingly serious rivals to traditional cameras. Today, their sensors' quality is already as good as 35 mm film and nearly as good as medium format. As a result, they are becoming more and more adaptable for panoramic photography.

Although the problem with aiming is the same as in traditional photography – one has to mentally imagine an elongated frame in the

viewfinder – computer technology makes the problem of cropping very simple. It is almost always necessary to use a computer to process the digital files produced by the cameras, and all the image-processing software programs have framing tools allowing the dimension of the digital file to be changed. Afterward, the photographer only has to crop the photo to the desired dimensions.

The full-sized photograph.

The top and bottom parts of the image have been cut away to create a panoramic photo and remove the less interesting areas of the image.

Photo by Arnaud Frich.

Medium-Format Cameras

More common in the world of professional photography, medium-format cameras also are used by enthusiastic amateurs seeking to obtain better image quality than 35 mm can provide. A medium-format camera is any camera with a format ranging from 4.5 cm × 6 cm to 6 cm × 9 cm and that takes 120 or 220 roll film. These types of camera have greatly improved in recent years, in some cases becoming entirely automatic (e.g., focus, light-metering). The range of available lenses is also quite wide, although not yet as wide as 35 mm. To convert them to digital cameras, they need only to have a digital back attached that has been designed for them. As opposed to 35 mm models, here there even is a choice among different brands of sensor!

Medium-format cameras are certainly heavier and more bulky than 35 mm cameras, but the resultant image quality is really worth it.

Between 2.7 and five times larger than 35 mm film (on the left), medium-format (on the right) allows for greater tonal rendition and much finer details. Even with a small-sized print, one made from a medium-format negative will already have a different look. The landscape panoramist will definitely want to consider this format, even if it means moving away from a more specialized, panoramic-type camera.

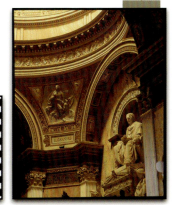

Large-Format Cameras

These slightly particular cameras require a different way to produce photography, quite different from taking pictures with 35 mm. Panoramist or not, the photographer who uses one of these bellows cameras believes that the search for optimum quality is a higher priority than the bulkiness or weight of the equipment. Large-format photography is often formal, posed, and contemplative. Those who work with large format are not in a hurry to make a beautiful photograph. Also, learning how to work with a bellows camera takes time and experience, especially with regard to the movements, and the panoramist will certainly need to have this knowledge prior to the realization of any project that can be called artistic. These cameras also allow perfect control over framing, critical focus, depth of field, and – thanks to the shifting ability of the lens – perspective.

With a large-format camera, there is complete control over the image and the final result is wonderful. Having seen a large print made from a 4 × 5 or larger negative can really make you want to sell your 35 mm camera, regardless of whether you decide to crop your small negatives in a panoramic format!

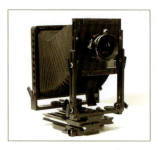

Large-format, 4 × 5 view camera. Because of its shifting movements and swings and tilts, there is complete image control.

Specialty Cameras

By far, the most well-known specialty camera is the Fuji 617, but recently the Hasselblad XPan (now in model II) has started to eclipse the former camera's fame. In addition to these two, we will discuss other flatback panoramic cameras. Other models will be mentioned but glossed over; the appendices will lead you to further information about them. As of this writing, a digital panoramic camera does not exist.

DEFINITION

Orthoscopic

An orthoscopic line is a straight line that is perfectly rectilinear. Panoramic cameras that are orthoscopic do not distort horizontal or vertical lines in the form of an arc – rotating cameras are prone to do this. This is not to say that the lines do not converge to a vanishing point, just that they remain very straight.

24 mm × 65 mm Cameras

These cameras have a lengthened format, and are essentially 6 × 7 cameras modified to use 35 mm. With these, one approaches medium format without wasting film since the final image will have a 24 mm × 65 mm dimension. In other words, this type of camera is already

equipped with a cropped panoramic format. I remember using 6 × 7 cameras with 56 mm × 67 mm windows for 120 and 220 film. By a happy coincidence, with these newer cameras, one now can obtain a medium format-caliber image with a ratio approaching 3:1 on 35 mm film!

With cameras like these, the photographer cannot lose. The film is larger, has finer grain and more tonal depth, and the focal length is longer than an equivalent angle of view in 35 mm. Small details will appear larger, and the overall improvement in quality is spectacular. However, one condition does remain: it is necessary to work with slower lenses (less glass means smaller apertures); thus, these cameras are difficult to use without a tripod.

Hasselblad XPan II

The Hasselblad XPan II is a camera specifically designed for 35 mm film, but with two different formats: the standard, 24 mm × 36 mm format and one that measures 24 mm × 66 mm. Obviously, it's the latter format that concerns us here. Currently, the XPan can be used with three lenses: 30 mm (104°), 45 mm (74°), and 90 mm (40°). This camera has revolutionized panoramic press photography. Modern, well made, motorized, quiet, equipped with automatic features, not very bulky, it has only one fault – its lens does not let in enough light. But then, the lenses would be unaffordable if they did.

Hand-held panoramic photography with the XPan demands a certain amount of experience. But the XPan II, appearing on the market in 2003, introduced shutter speed indications in the viewfinder that made photography in the field easier.

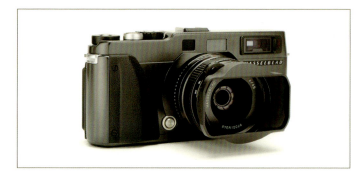

The Hasselblad XPan I and II have popularized the panoramic format's use in journalistic photography. And it's for this reason that they are reproached for not having fast enough lenses. Still, that has not prevented them from being used by many reporters, even on the battlefield, which is enough to prove their versatility.

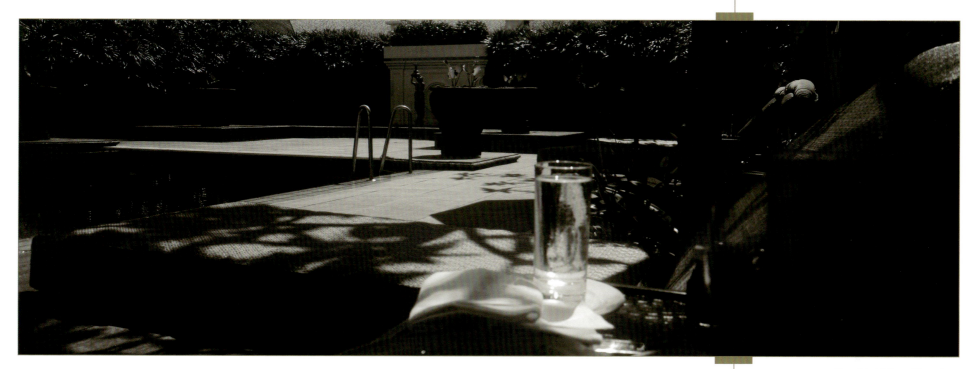

Hasselblad XPan, 45 mm lens.

Photo by Aurore de la Morinerie.

As a result, many press and amateur photographers have started to use this exceptional camera. Its optical range does not allow for shifting lenses; but given that its primary purpose is for journalistic photography, this is not a significant problem.

Mamiya 7 II

The Mamiya 7 II is a conventional 6 × 7 medium-format camera with an optional accessory that allows one to adapt the back to receive 35 mm film. . Mamiya also makes nicely performing lenses for the camera, ranging from 43 mm (84°) to 210 (20°); the problem here is it lacks shorter focal lengths. For example, a 38 mm would be better suited for the panoramic purpose of this camera accessory. Bulkier than the XPan, the Mamiya simply provides the photographer with a choice between panoramic and 6 × 7 formats. And like the XPan II, it is a modern camera with plenty of automatic features. These features are certainly enough to

satisfy the demanding photographer, and the really demanding photographer will be impressed by the remarkable quality of its optics.

Convenient as it is, the Mamiya 7 II very much remains a medium-format camera, so one is faced with the same dilemma as with the XPan – choosing between the quality that the larger negative provides or the speed of faster lenses that come with the smaller format 35 mm cameras.

However, when used as a 6 × 7, this camera offers the additional advantage of allowing you to crop the negative as needed – above, below, and not just in the middle. Once again, this allows one to profit from indirect lens shifts, especially in architectural photography. But also like the XPan, the Mamiya 7 II does not have shifting (PC) lenses in its line of optical equipment.

With its panoramic back, the Mamiya 7 can take 35 mm film. Here, the 6 × 7 window turns into a 24 mm × 66 mm window.

The XPan and Mamiya, being relatively light, are easy to handle. This compensates for what one loses in comparison to the image quality of the larger 6 × 17 cameras. Their lightness also allows for the exploration of other photographic horizons, like hand-held photography. The work of Aurore de la Morinerie and vincent b. are perfect examples of this.

6 × 12 Cameras

Before advancing to the aforementioned 6 × 17 format cameras, there remains another interesting alternative: 6 × 12 cameras. Really, the size of their film places them in the category of large-format cameras, and very large prints made from them will be of an irreproachable quality. Many companies make these cameras – Cambo, Horseman, even Silvestri and Linhof. The exposure is made on 120 or 220 film, and the format has a ratio of 2:1. This ratio, cropped down to 3:1, again offers indirect shifting possibilities. However, some of the cameras described next also permit direct shifts, which is even more advantageous.

The makers of these panoramic cameras obtain their lenses from two of the best names in the business: Schneider and Rodenstock. Essentially, these are lenses designed for bellows cameras that are mounted on a threaded, helical housing that allows them to be easily focused by hand. On a view-camera, this would be achieved by racking the front and rear standards back and forth. All the lenses have the same range of shutter speeds: T, B, and then from one second to 1/500 second. In order to obtain the maximum quality, the photographer needs to stop down to at least f22. Used in this way, one will obtain a depth of field where the closest area in focus will rarely be less than one meter away. However, it is necessary to add that since these cameras do not possess a reflex viewfinder, the placement of the critical focus will have to be estimated. By determining the hyperfocal distance and by stopping down considerably, the results should never present any focusing problems.

All the 6 × 12 cameras have a viewfinder of high quality and remarkable clarity. Detachable, they can be brought along when scouting around and noting locations, or carried in the palm of the hand while hiking with the camera in a backpack.

Finally, these cameras are distinguished from the other 120 and 220 film cameras we will consider by their lack of light meters. Use of a separate light meter is therefore indispensable in order to measure the light correctly and to determine the adequate exposure. When a panoramic photographer uses this type of camera, he or she works slowly, attempting to achieve quality on all levels. Exposing the film when rushed and without adequately metering the light would be counterproductive.

Cambo Wide DS

Relatively light and compact, the large-format Cambo Wide DS camera possesses an impressive range of Super-Angulon optics, from the 38 mm XL to the 72 mm

XL, and soon, 90 mm. The angle of view reaches 115° at its widest, or the equivalent of a 14 mm lens with 35 mm (but here the format is 13 times larger). The normal lens is the 58 mm XL, with an 86° horizontal angle of view.

The Cambo allows one to shift the lens over a large area, ranging from +40 mm to −20 mm on the vertical axis and +/−20 mm on the horizontal, enabling the photographer to easily place the horizon line where her or she wants! Recall that, ideally, the horizon line should not be placed in the exact middle of the photograph. Because of this shifting ability, this would be the camera to use when one wants to avoid tilting the camera in order to prevent the convergence of vertical lines (notably with monuments). And with a shift of +40 mm allowed

The size of the film, the quality of its lenses, and direct and indirect shifting abilities make the Cambo Wide DS a marvelous large-format, panoramic camera. Because of its shifting features, one might even prefer this format to the more conventional 6 × 17.

toward the top, it is possible to place this horizon line near the bottom of the film. The distance that separates the middle of 120 film with its edge is only 28 mm.

If this camera allows such significant shifts, that's because it was originally designed to take 4 × 5 sheet film. Film backs can be interchanged for either 4 × 5 or medium format 120 or 220 roll film.

Horseman SW 612/SW 612 Professional

Similar in design to the Cambo but a little bit less bulky (since it does not permit the use of 4 × 5 film), the Horseman 612 SW Professional panoramic camera has less shifting ability: +/−17 mm along the vertical axis and +/−15 mm along the horizontal. Therefore, it will not be as useful for placing the horizon line where one wants, although it still remains possible to place it at the upper or lower third of the photograph. The SW 612 differs from the professional version because it does not have a lens-shifting capability.

Horseman's very nice lenses are made by Rodenstock, Schneider's rival, and range from a 35 mm lens to a 90 mm Grandagon or Apo-Grandagon. Warning: The angle of view of the 35 mm lens is so wide (115°) that it will prevent accessing the full range of the professional camera's shifting capability.

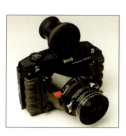

Less bulky than the Cambo Wide, the Horseman SW 612 Pro has less shifting ability and does not take 4 × 5 sheet film.

Of top-notch construction, the Linhof 612 camera is also endowed with an off-centered lens position that is oriented toward the top. With this camera, architectural photography is quite easy. However, this advantage can also be a handicap in other situations.

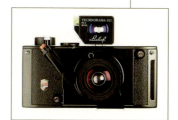

Linhof 612 PC

This camera possesses one amusing particularity: the lens is mounted directly in the shifted position, and it is not possible to move it from there. When the camera is oriented toward the horizon, this is placed automatically at the lower third of the photo – or the upper third, if the camera is turned the other way (there is a tripod thread on the top as well). When this camera arrived on the scene in 1976, it offered a real advantage; but today, faced with the competition, it seems rather limited. Much the same holds true with the II model, dating to 1996. Still, the quality is remarkable, as is often the case with Linhof cameras.

Linhof's optical line is made by Schneider and ranges from the 58 mm XL Super-Angulon to the 135 mm Apo-Symmar. The quality of the optics is really stunning, and they come with the further advantage that one can change them while in the middle of a roll of film, thanks to a protective slide located in front of film that prevents exposure.

Silvestri H

Modular in design, Silvestri cameras accept lenses by the best two names in large-format optics: Schneider and Rodenstock. Although these are essentially medium-format cameras, they also accept 6 × 12 backs and have the added benefit of direct shifting abilities. Thus, in this regard, they start to resemble large-format cameras. However, one is still obliged to use 120 and 220 film.

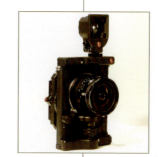

There are many Silvestri cameras. Model H is shown here.

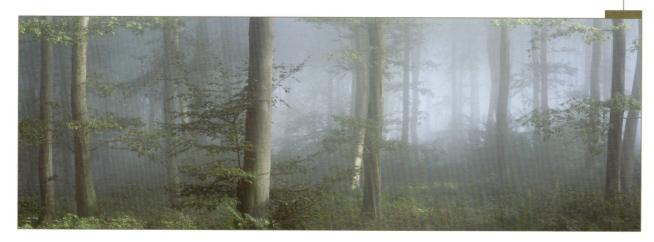

Fuji GX 617 II, 300 mm lens.

Photo by Hervé Sentucq.

6 × 17 Cameras

This film format justifies the investment, since one naturally wants the best image possible. Until recently, the Fuji 617 was significantly more expensive than a 35 mm camera, but today, the game has definitely changed. An up-to-date 35 mm camera and two accompanying lenses costs about the same as a 6 × 17 camera with one lens. Of course, the level of versatility is not the same; rather, it's the quality that is so much better. Popularized by Philip Plisson and Jean-Baptiste Leroux, both the format itself and the impressive quality of posters originating from images made with these large-format panoramic cameras have seduced a new generation of photographers, forcing everyone to consider panoramic photography in a new light.

No film is wasted either, since these cameras use 120 and 220 film, resulting in a large 6 cm × 17 cm image with a 3:1 ratio. These cameras now accept interchangeable lenses, ranging from a narrow 20° telephoto to a very wide-angle 105° that has the advantage of producing much less distortion in the corners and on the edges than an equivalent lens focal length in 35 mm (21 mm). Similarly, comparing equivalent, 90° angles of view, if one used a 15 mm lens in 35 mm, it would require a 72 mm lens with 6 × 17, the latter focal length being short telephoto in 35 mm. Viewed in this way, not only is the 6 × 17 format giant in comparison to the 35 mm format cropped down to 12 × 36, but the former also introduces a comparative telephoto effect that enlarges small details. Unlike 35 mm, these details truly stand out here, and are never buried in the grain of the film. Thus, prints resulting from 6 × 17 color transparencies, negatives, and scans are of excellent quality.

I find two problems with these cameras, however. Apart from the relatively unobtainable Gilde MST66-17, shifting the lens, directly or indirectly, is not permitted since one cannot cut film that is already at a 3:1 ratio. To shift indirectly, it would be necessary to buy a 5 × 7 view-camera and crop the film to a 56 mm × 170 mm format. Due to this shortcoming, it becomes necessary to tilt the camera upward or downward when moving the horizon line away from the middle, introducing vertical-line convergence. The other problem is that their bulkiness and weight often remind one that the progress of large-format lenses has made it possible to obtain similar quality with the smaller 6 × 12 format.

However, note that their high-quality viewfinders are detachable and can be carried separately when scouting around, so as to avoid the encumbrance of constantly having to lug the camera around.

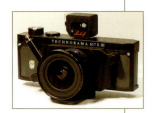

Since the arrival of the Photokina 2000, it is possible to buy Linhof Technorama cameras in a variety of colors.

Fuji GX 617

The best-known example of a specialty, large-format panoramic camera, the Fuji GX 617 can be outfitted with up to four reputable lenses. Although the image quality is quite good provided that one takes care to stop down to at least f22, the camera itself has a few inconveniences, like the impossibility of changing lenses without exposing the film due to the lack of a dark slide. Also, a battery is sometimes necessary – and not even a lithium battery can prevent the camera from freezing up in extremely cold weather (most notably in high mountains).

Also, it is important to mention that short focal length lenses (e.g., 90 mm and 105 mm) necessitate the use of a center-spot neutral density filter, as is equally the case with the other 6 × 17 cameras. We will return to this subject shortly, in the section dealing with accessories.

This large-format panoramic camera's reputation is built on its relatively light weight – which makes hand-held exposures possible – and its reasonable price compared to other 6 × 17 cameras. Used, you also can find the first model of the Fuji 617, which dates to 1982 and has a fixed, 105 mm lens.

Linhof Technorama 617

Linhof 617 cameras first appeared in 1976. The present mark III version accepts three lenses: 72 mm, 90 mm, and 180 mm. Although expensive, each of these lenses is quite good, and each comes with a center-spot neutral density filter – a necessary item with color transparency film.

Of a well-made quality that equipment enthusiasts can appreciate, Linhof 617 cameras offer a much wider angle of view than the Fuji's 90 mm lens is capable of, thanks to a Schneider 72 mm lens. Thus, the horizontal angle of view is wider than 100°.

As opposed to the Fuji 617 cameras, which require a battery, Linhof cameras are always fully mechanical. Therefore, one can operate them in extremely cold weather. Only slightly more bulky than the Fuji cameras, one can also make hand-held exposures with them, if need be.

The Fuji GX 617 has a range of four lenses: 90 mm, 105 mm, 180 mm, and 300 mm (with rubber-coated protection bars that are very practical during transportation); these cover an angle of view ranging from 90° to 20°.

Gilde 617

Kurt Gilde, a German doctor, makes three types of 6 × 12 and 6 × 17 camera by hand, which, in addition to high quality of their materials, is the reason for their high price. And the range of possibility available with these cameras easily makes them the Rolls-Royce of their kind. As proof of this, consider the following: their design makes it possible to attach any kind of large-format lens – not just Schneider and Rodenstock lenses, but also Nikkor and Fuji, telephoto lenses included. Changing formats from 6 × 7 to 6 × 17 is possible, even while in the middle of a 120 or 220 roll of film (thanks an inventively designed dark slide). Therefore, changing lenses in the middle of a roll of film also is permitted. These characteristics alone would make it a most versatile 6 × 17 camera, but that's not all – the image control possibilities are also quite remarkable. With the top-of-the-line 66-17 MST camera (if I may call it that), it is possible to shift the lens +/−25 mm (as compared to only +15 mm with the other brands), as well as tilt it +/−10°. Very heavy – close to seven pounds without lens – these wonderful cameras require a tripod.

The Rolls-Royce of 617 cameras is obviously the most expensive, too. But what style and versatility! Swings and tilts, direct shifts when needed, this camera is extraordinary.

Accessories

Here we describe some more or less indispensable accessories found in the camera bag of a panoramist. And although the camera bag itself is not specific to panoramic photography, for me this is simply a chance to sing the praises of backpacks, due to their practicality and therapeutic benefits. One quickly finds the following to be essential: a tripod (sometimes large), a set of filters (sometimes with very specific uses), one or two hand-held light meters, and other small accessories.

Camera Bag

There are three large categories of camera bag: backpacks, shoulder bags, and fanny packs. Personal habit will determine one's preference for a certain type, but

I particularly appreciate the Lowe Pro Trekker backpack that I've had for more than six years. I find it has a number of advantages, the best of which is that it does not hurt the back of its owner! As the backpacks increase in quality, they offer the possibilities of attaching harnesses and specifically adapting to each individual's build. If they are large enough, one can even hang a tripod on the outside, leaving the arms free, which is always preferable when hiking. In fact, the only thing I carry in my hand is a small viewfinder, which is far less heavy and bulky than a camera.

For those who always want to have their camera on hand, however, carrying a pack on the chest provides a nice alternative. This choice is also very practical for storing frequently used accessories, like hand-held light meters.

My backpack allows me to carry my tripod on the side. In this way, I avoid leaning backward because of a strong pull. A fanny pack will also prove useful here, enabling you to have small accessories like a light meter and filters on hand.

Tripod

Certain large-format cameras are so heavy that a tripod is almost always required. But independent of the camera's weight, another reason for a tripod exists. A panoramic photographer is often not in a hurry, preferring a creative and contemplative manner of working instead, which leads to a creative routine where the final result should be as close as possible to the photographer's original vision. Thus, to frame a photo well becomes a deliberate act, making it necessary to take one's time. Framing, exposure – everything requires care. The utility of a tripod, even a light one, makes this possible. Also, both dim lighting and stopped-down lenses result in longer exposure times, making the use of a tripod necessary. Much the same holds true for artistic, soft-focus effects.

Normally, any tripod will do; but sometimes bringing the camera close to the ground is called for, and at other times it needs to be very high (notably in the city). A tripod also needs to be as stable as possible. For a good combination of adjustability, quality, and economy, the Manfrotto tripods are very good. My Gitzo also works quite well, and has done so for a very long time.

Due to the arrival of the cameras like the XPan, a certain style of hand-held photography borrowed from journalism has started to gain acceptance. At first, those who experimented with this approach were few in number, due to the older cameras being large and heavy.

Gitzo Series 2 Reporter tripod. The rapport between weight and stability is very appealing here.

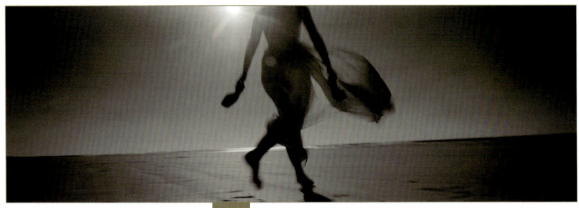

6 × 17 camera; photo by Benoît Ancelot.

Cropped medium-format image; photo by vincent b./chambre 5.

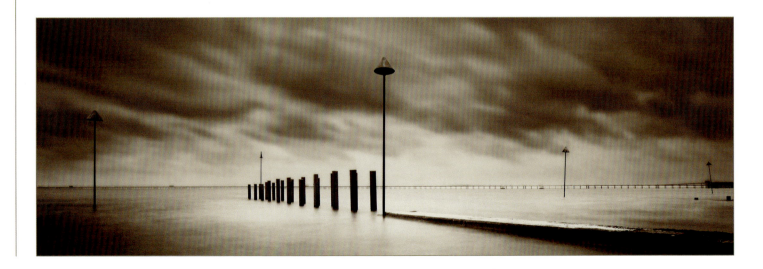

6 × 17 camera; photo by David J. Osborn.

Level

If the camera does not have a level in the viewfinder, you should always carry one with you. When choosing to use a panoramic camera, it is primarily to photograph a wide field and a straight horizon; thus, it would be too bad to lose a photo due to an off-balance camera – unless, of course, one is seeking an original and creative effect.

Small levels located on tripods, or at the base of tripod heads, are not really useful. It's the camera that needs to be level, not the tripod! Rather, the ideal level is one with two perpendicular markings, the level then being placed on the hot-shoe pad of the camera.

Another solution involves visually lining up the vertical lines of a scene with a ground glass marked with a grid. This makes a level nearly superfluous. Although the XPan and the Mamiya 7 do not permit this, it is possible with certain 6 × 12 and 6 × 17 cameras.

The form of a built-in, center-weighted light meter. This light meter thinks that the principal subject is in the center of the photo. Thus, it is necessary to know how to interpret its readings.

Light Meters

Except for the Hasselblad XPan II and Mamiya 7 II, no other panoramic cameras have built-in light meters. In these cases, a separate meter becomes necessary.

Just about every conventional 35 mm camera has a light meter, though, which could be used for a panoramic camera, metering with it as usual. (This means that the following advice does not apply just to panoramic photography.)

Built-in light meters have come a long way in the last 10 years, and now are as intelligent as the microprocessor that directs them is powerful. Dot matrix, ESP, and the others are very precise, but not infallible. Understanding how they function and react, and verifying their readings with a second light meter is never superfluous. One other aspect tends to make one forget their shortcomings: they work very quickly.

With an 18 mm lens where the horizontal angle of view is, for example, 90°, the central disc will measure the light over an area covering 10°, which is far too wide, especially for meter readings at night.

Although the spot meter is very useful for making precise readings and for working with the Zone System, in certain lighting conditions, an incident light-meter reading allows you to work more quickly and confidently.

Because of the very narrow field of view embraced, from 1° to 5°, the reading of a true spot meter is done on a very small and precise area. These differ from spot readings that are sometimes built into reflex cameras. Actually, the latter work from a small round disc, which represents two to three percent of the total view rather than 1°. Thus, the reading will be very precise when done with a telephoto lens, but quite insufficient with a very wide-angle lens, which is more typical in panoramic photography.

With an 18 mm lens where the horizontal angle of view is, for example, 90°, the central disk will measure the light over an area covering 10°, which is far too wide, especially for meter readings at night.

Photo by Hervé Sentucq.

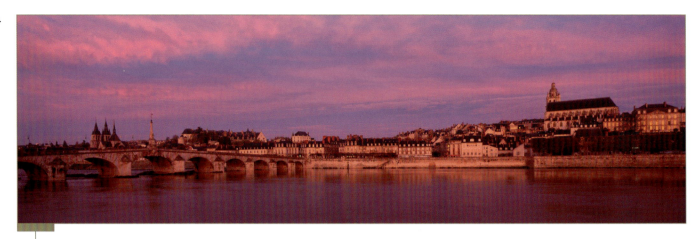

The more one approaches the center, the denser the spot filter will be. The exposure correction is between one and one-and-a-half stops depending on the lens's angle of view. In this way, the fall-off caused by using a very wide-angle lens can be effectively corrected.

There are three main types of hand-held light meters: incident, reflected, and spot. Panoramic photographers often agree that the most practical and useful type is a spot meter, which measures from 1° to 5°. Because of the small details that it can read, I definitely prefer a 1° spot meter.

Hand-held light meters, especially spot meters, require a sound understanding of and experience with the light-metering process in order to correctly interpret the reading. In situations where one needs to work quickly or the when lighting conditions are right for it, an incident light meter renders a valuable service. And things are getting easier, since it is not hard to find hand-held meters that combine spot readings with the other kinds, like the latest Minolta VI flash-meter.

Filters

There are several categories of filters, but none are specifically designed for panoramic photography. Therefore, some restrictions need to be applied when using filters with panoramic photography because the angle of view is usually very wide. The most frequently used filters will be center-spot neutral density filters, suited primarily for large-format cameras with very short focal length lenses; and graduated neutral

density filters. Other choices area polarizing filters, where again, it is necessary to avoid fields greater than 90°; and color filters, which correct predominant colors in traditional color photography, or improve contrast in black and white.

Lens Filters

Lens filters are more applicable to large-format photography than panoramic photography, but as we saw in the section dealing with 6 × 17 cameras, certain specialty cameras have format characteristics overlapping this category as well.

Shown in the opposite photograph is a center-spot neutral density filter. Being denser at the center than at the circumference, it is used to introduce an exposure correction between the center and borders of a wide-angle panoramic image. On average, a filter like this reduces exposure by a factor of two – the equivalent of one *f*-stop. So when using one in tandem with a hand-held light meter, always remember to give an extra stop of exposure.

Cosine Law

When photographing with a very wide-angle lens (as is the case with cropped panoramas), the angle of the light rays passing through lens becomes wider and

wider in direct proportion to its distance from the optical center. Thus, the shorter the lens focal length, the wider the angle; and the wider the angle, the more noticeable the fall-off in exposure on the film. The well-known cosine law further explains this.

If light rays passing along the optical axis of the lens can be said to have a luminosity of 100 percent, then rays that obliquely strike the borders of the film would have the following luminosity (here, the angle of view of the lens is 80°, as would be the case with, say, a 105 mm lens and a 6 × 17 format):

$100 \times (80/2 \cos^a)$, where $a = 4$,

$100 \times (40 \cos^a) = 34\%$

Again, this difference is significant mainly between the center and the limits of the film, and it becomes more noticeable as the format size increases. So although this fall-off is fairly negligible with conventional 35 mm, a center-spot neutral density filter is required with the XPan 30 mm lens, as well as with wide-angle lenses for 6 × 12 and 6 × 17 cameras. Only this will guarantee correct, homogenous exposure with color transparency film.

Conventional Filters

Any conventional filter – polarizing, graduated neutral density, or color – can be used without hesitation since panoramic photography resembles normal photography in this regard. Here, I simply want to mention that a graduated neutral density filter with a coefficient of one stop is also very useful in landscape photography. This darkens the sky a little, keeping it from appearing too washed out, both on film and in digital files. Similarly, a polarizing filter will be beneficial for landscape work, provided that the angle of view does not exceed 90° (the filter also being most effective when the sun is positioned at a right angle). Once again, if the angle of view is greater than 90°, the effect of the filter will be noticeable only in one area of the photograph. Only one part of the sky will be darkened, and the result will probably not be very pleasing.

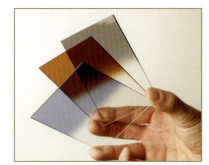

Graduated filters in different colors are made to cut down the light-level of the sky and to modify its tint slightly.

Other Accessories

Another accessory that immediately comes to mind for inclusion in the camera bag of the true panoramic photographer is a cable release, for the obvious reason of the quality of the final image (unless one decidedly wants a little bit of camera shake). When equipped with a locking device, a cable release both prevents a photographer from vibrating the camera at the moment of exposure and allows for very long exposures to be achieved without the obligation of having to continuously hold the release. In nighttime panoramic work, this is absolutely necessary.

A cable release can take the form of a normal, cord-type release (preferably with a lock for long exposures) or a remote control, with or without cord (infrared), for use with high-tech digital and traditional cameras.

Finally, but much less frequently, a flash sometimes finds a place in the camera bag of the panoramic photographer. Indeed, these can be used without any particular problems, provided that their spread capacity reaches that of the field taken in by the lens. Today, it is not uncommon to see a flash equipped with a diffuser that is able to spread as wide as a 21 mm or even 17 mm lens (i.e., 80° and 92°, respectively). Of course, their throw capacity also limits their field of action, but it is still possible to use them for an interior shots or to make the foreground subjects stand out.

Two cable releases: on the left, an infrared remote-control and on the right, a flexible cable release with lock-down button.

Very useful with interior shots, a flash nonetheless needs to have a throw or spread matching the field of view embraced by the lens (wide-angle). Some flashes can cover the field of a 20 mm lens for 35 mm (more than an 80° horizontal angle) on their own, or aided by an accessory.

A Day in the Life a 6 × 17 Expert, Hervé Sentucq

Before starting a photographic project in the field, a large part of the work takes place indoors. Long periods of research in the library and on the Internet, concerning the subjects in question, result in note cards, maps, and a travel plan.

Arriving at the site, often in the middle of the day and therefore under harsh lighting, I am still a long way from the moment of clicking the shutter. The first question relates to the light, the season, the state of the place (e.g., the condition of the pathways), and so on. Is it better to return another time? If I think that the necessary conditions for showing this landscape to its best possible advantage are present, I then begin a long period of visual observation.

Locating the vantage point or points requires exploring the landscape thoroughly. While doing this, I carry only the detachable viewfinders that correspond to my lenses. In this way, the search for original compositions is done while traveling light. Gradually, I obtain a mental or interior vision of the landscape. And once the framing has been settled upon, I return to the place in question with the camera and the right kind of lens.

For the magic light, the one that really exalts a landscape, it is necessary to wait hours, even days, for something that often lasts only a few seconds! It is capricious, unpredictable, and ephemeral, often forcing me to return several times to the same place over the course of a few days. I give myself about 24 hours to observe a site under different lighting, weather, and coloration, preferring evening and just before dawn. With only four shots per roll of film, I want to have at least one good one, so it is not advisable to hurry things. After

long periods of waiting, one becomes aware of every variation of light, and one tries to anticipate them.

During the day, I mostly prefer turbulent skies and storms. And with the goal of obtaining a highly nuanced illumination, I watch for the precise moment when the sun hides behind a cloud and the moment when it reappears. This trapped light enlivens the scene by casting more pronounced shadows. The landscape, transformed into two dimensions, maintains all of its three-dimensionality.

To profit from all the lighting variations at dawn and dusk, I have to sleep on the spot, in my vehicle. In other words, I force myself to be present at the place of exposure an hour before sunrise (which is around 5 A.M. in summer!). And to reach this place sometimes requires an hour of walking beforehand, using a flashlight so as to be able to move in the darkness. So it is not desirable to add driving in a car (e.g., from a hotel) to this, since it would only reduce my sleep that much more.

The equipment is heavy: nearly 45 pounds for the tripod (stable and sturdy) and the bag containing the panoramic equipment (consisting of the Fuji GX 617 camera, 90 mm, 180 mm, and 300 mm lenses, and rolls of Fuji Provia 100F film). The completely manual ritual of setting up the tripod and camera takes several minutes and puts me in a good mood. And while putting the finishing touches on my framing, my critical sense sharpens, preventing me from forgetting the constituent elements of a successful panoramic image. I seek only places that can be seen and visited by everyone, without having to pay a fee or be a top-level athlete to reach it. Everything is manual: installation of the viewfinder and cable release, various adjustments, focusing, setting the shutter speed and aperture, incident light-meter readings, cocking the shutter, advancing the film after every exposure, switching lenses in a changing bag, and so on. I generally seek to create an image with depth, profiting from the first significant foreground subject and an elevated point of view.

Large-format panoramic photography is costly and therefore reserved for exceptional photographs of refined subjects, both well-composed and literate. Often, one brings back only one photo after a whole day of work. The size of a 6 × 17 color transparency allows for very fine details and giant enlargements without seeing the grain of the film.

I took up photography in 1988 and became a panoramist toward the end of 1997. I also set up the first panoramic photo archive of artistic images of France and Scotland. My graphic string is fully calibrated and I digitize and process my photos myself. My activity as a photographer-author is oriented mostly toward advertising and illustrating themes dealing with tourism and the environment. To find out more about my exhibits and publications, visit the following Web site: www.panoram-art.com.

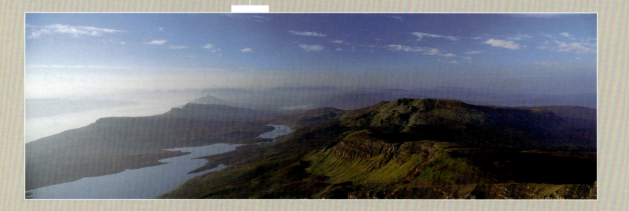

Photo by Hikaru Ushizima and vincent b./chambre 5.

Taking the Picture

Although one naturally thinks about using a tripod to create pictures of urban or natural landscapes, many current photographers have also started creating journalistic photographs with panoramic formats – these being mainly hand-held since the arrival of the Hasselblad XPan. Achieving maximum depth of field requires stopping down considerably, however, necessitating longer exposure times. And only a tripod will allow one to prevent the lack of focus caused by a moving camera.

Yet, in spite of these forewarnings, it does remain possible to make a hand-held panoramic photo of a landscape, even with large format – something at least better than returning home empty-handed! But the resultant image will neither be truly focused, due to camera movement, nor evenly exposed, because the lens was not stopped down enough. So to be able to work with these harmful effects, the photographer must accept them as much as possible.

Framing

The fundamental principles of framing and composition in panoramic photography have already been considered in Chapter Two. What remains is to study the peculiarities of each category of flatback camera in order to get the most out of their creative potential.

Flatback cameras are distinguished from swing-lens and rotational cameras mainly by much smaller angles of view, but also by their more conventional distortions of the image, which are equivalent to those encountered with a normal camera equipped with a very wide-angle lens.

To conclude this subject, I will discuss the problem of exposure and light metering with this kind of camera, which is quite similar to normal cameras.

Choice of the Angle of View

It's really the vision that one has of a subject and what lenses are available that determines the angle of view and composition of a photograph. In all cases, it is necessary to crop a part of a conventional rectangular format photo (e.g., 35 mm,

6×7, 4×5, 8×10). Masking the top and the bottom of an image turns it into a panoramic format (i.e., a ratio of at least 2:1).

Many specialty cameras are founded on this principle. The angle of view is determined by using one of the short focal length lenses in the optical range of the original format. They simply use a smaller film size, so less is wasted. 35 mm becomes 12 mm × 36 mm with an angle of view varying from 70° to 110° (28 mm to 15 mm) without changing the film. 6×7 and 6×9 become 24 mm × 65 mm with an angle of view varying from 35° to 94° (90 mm to 30 mm), as is the case with the Hasselblad XPan II, which uses 35 mm film instead of 120. 5×7 becomes 56 mm × 170 mm with an angle of view varying from 45° to 100° (180 mm to 72 mm) in the case of the Fuji 617 and Linhof Technorama (with 120 or 220 film), although not with sheet film.

In this way, the angle of view is always that of a conventional wide-angle lens with the top and bottom of the image removed. The large format of the Fuji 617 allows one to obtain a much better quality enlargement, while offering exactly the same perspective and horizontal angle of view as a picture made with a 35 mm camera with equivalent lens, as we saw in Chapter Two.

Photo by Hervé Sentucq.

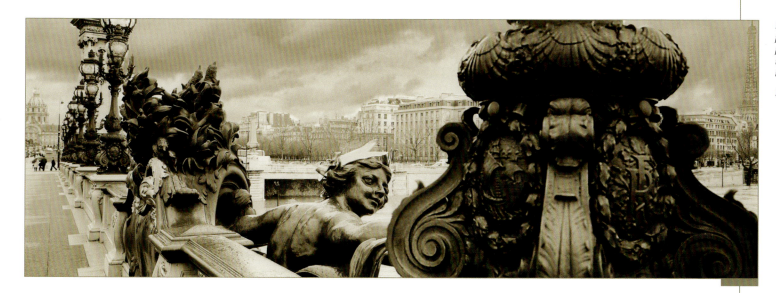

Because of a proper use of depth of field, the photographer has succeeded in obtaining a photograph where just about all the planes are in focus, from foreground subjects all the way to the horizon.

Photo by Peet Simard.

It goes without saying that with this kind of camera, framing resembles framing in conventional photography. The horizontal lines remain horizontal, even when the camera is tilted for a low-angle shot – that is its primary advantage. A vertical convergence effect will also inevitably appear in tilting the camera, something that only a shifting lens could prevent. All too often, this kind of camera does not allow for lens shifts.

With these cameras, the optical quality will have a tendency to degrade on the borders, especially in the corners. One can also observe an enlargement of the image in the corners when the angle of view is greater than 80°. This is not a problem in journalistic photography, but it needs to be guarded against in architectural photography.

Parallax

As is the case with all nonreflex cameras, it is a good idea to be vigilant when framing a subject that is nearby because of *parallax* – the difference between what is seen in the viewfinder (often placed above the camera) and what is actually photographed.

The further the viewfinder is from the film, the more noticeable parallactic effect will be. However, this inconvenience is not that important with cameras that allow one to remove the viewfinder from its support and place it at the height of the

film. This advantage pertains almost exclusively to large-format cameras; although smaller format cameras like the XPan II and the Mamiya 7 II do permit one to attach a supplementary removable viewfinder with really short lenses. This being the case, note that the shortest distance that can be focused with these lenses is rarely less than a yard, so the ability to come in really close is limited. Much the same holds true for correcting extreme close-up parallax problems as well.

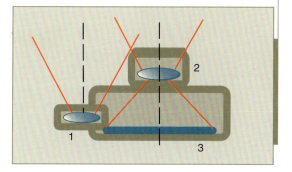

Parallax only becomes significant when focusing on fairly close subjects and with cameras that have nonreflex viewfinders. In these cases, if the subject is too close to the camera, the viewfinder and the lens will not even be aimed at the same spot.

1. Viewfinder
2. Photographic lens
3. Film or digital sensor

Depth of Field and Hyperfocal Distance

A panoramic photographer often is seeking the maximum depth of field. This is why it is important to consider the hyperfocal distance once the lens has been stopped down. And again, depth of field is one of the reasons why the exposure time will be long and a tripod will be necessary.

Different scenarios are possible, depending on the type of camera used:

1. The cameras have either a manual or an autofocus focusing system and a reflex viewfinder. This often is the case with modern cameras, and makes it easy to control the focus. Some cameras even have a depth of field preview that allows one to see all that is in focus, through the viewfinder. This feature is especially useful in determining the hyperfocal distance.

2. A rangefinder in certain specialty cameras, like the XPan I or II and medium-format cameras, allows one to control the focus precisely. However, here the depth of field preview is often lacking. In this case, it is necessary to consult the depth of field scale on the lens barrel, using it to move the critical focus to the hyperfocal distance.

3. Large-format specialty cameras have a hand-held viewfinder, and the focus remains relatively fixed. Here the use of the hyperfocal distance has already been calculated, guaranteeing a reliable and regular result, in spite of the lack of a focusing control.

Light Metering and Exposure

Whether it is done with a built-in light meter or one that is hand-held (incident, reflected, or spot), light metering in panoramic photography resembles light metering with a conventional camera and a wide-angle lens. The most frequent problem is thinking that the main subject of interest is larger than it actually is. Actually, the main subject often appears small on the film, so a high quality of exposure is needed to minimize this. The only way to achieve precise measurement of small details is to use a spot meter, which is why it is so popular among panoramic photographers.

Normally, from the start, one takes an overall light-meter reading for the entire scene, resulting in one or two combinations of f-stop and shutter speed. If there is a large difference between the left and right areas of the photo (or the shadows and highlights) using this method, it will be essential to take note of this, in order to determine what specific area to base the exposure on (which also depends on the type of film or sensor used). At this stage, it is important not to measure areas that are significantly brighter or darker than the rest of the scene, since this would bias the light meter. For example, in this way one would purposely avoid metering very bright light sources like a lamp or the sun directly. Once the overall exposure time is determined, it is necessary to take more precise measurements in order to account for local contrast differences – if there is enough time, of course.

In this way, making a good exposure is a matter of compromise. Neither the digital sensors nor the film can record more than a predetermined range of contrast between the brightest and darkest areas of a scene. This range (often fairly limited with digital sensors, which resemble color transparency film in this regard) is frankly more extended with black-and-white and color negative film. But "extended" does not always imply "sufficient." If the film or the sensor is incapable of registering all of the nuances of a landscape, the photographer will need to know how to give preference to certain areas and sacrifice others.

If the photograph is made with either a digital camera or color transparency film, the choice of the final exposure will depend on the highlights, which above all should not be blocked up or "cooked." If these two kinds of image recorders are overexposed, they subsequently become unusable, since the overloading of information is irretrievable. Conversely, if the shadow areas are not exposed enough, it can always be corrected with retouching software or in the darkroom, when making the print. In the former case, much of this will depend on the quality of the digital camera's sensor; while in the darkroom or with a color transparency scanner, the talent of the printer comes to the fore. Thus, with these types of image recorders it becomes necessary to be very attentive when metering the highlights with a spot meter. If one places the highlights – as is done in the Zone System – the shadows risk being under-exposed. So, for example, in the case of a landscape photograph with a fair amount of sky, a graduated neutral-density filter would be called for. The photographer can also decide to sacrifice a little of the highlights, but only a little, in order to avoid underexposing the shadows in a way that would be detrimental to the image.

When the image is taken with black-and-white or color negative film, the opposite holds true. Here, it is necessary to expose for the shadows and correct for the overexposed highlights during the subsequent development. As opposed to the positive and digital processes, if there is not enough information on the film due to underexposure, one cannot add any later! On the other hand, if the highlights have received a little overexposure, it will always be possible to reduce the time of development to prevent them from blocking up. However, if correcting overexposure by development is still not enough to obtain a desired end result, then the photographer needs to make a compromise at the time of

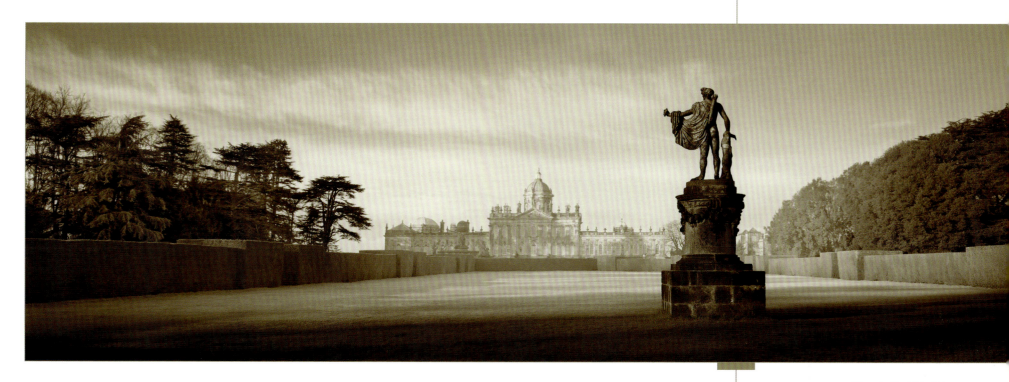

exposure by choosing one part of the image – the area deemed more essential in expressing one's actual sentiment – over another. This choice cannot be made by the light meter, no matter how intelligent it is.

As you can see, all this refers back to the problems encountered in light metering with conventional photography, which is equally important in panoramic photography.

Chapter 4

Photo by Arnaud Frich.

Picture-Taking with Swing-Lens and Rotational Cameras

Panoramic cameras first appeared in the nineteenth century, shortly after the beginnings of photography. Panoramic cameras with swing lenses and rotational cameras with completely rotating bodies are considered specialty items, and truly panoramic when the angle of view exceeds 120°.

Rotational and swing-lens cameras function quite differently than conventional cameras (e.g., 35 mm). In order to take in a large field of view from the same point of view, two solutions are possible: one, make the lens turn in front of the film (i.e., an angle of view between 120° and 150°); and two, cause the entire camera to make a complete turn, taking in the entire horizon. Certain panoramists even think that true panoramic photography exists only with these two methods.

Whether one uses a digital sensor or traditional film, rotational and swing-lens cameras come in many formats and will respond to all of a photographer's demands for quality. Some of these take 35 mm film, others take 120 or 220 (medium format) films, and still others have digital sensors with varying numbers of pixels. Their way of functioning is so unusual that exposing film or a digital

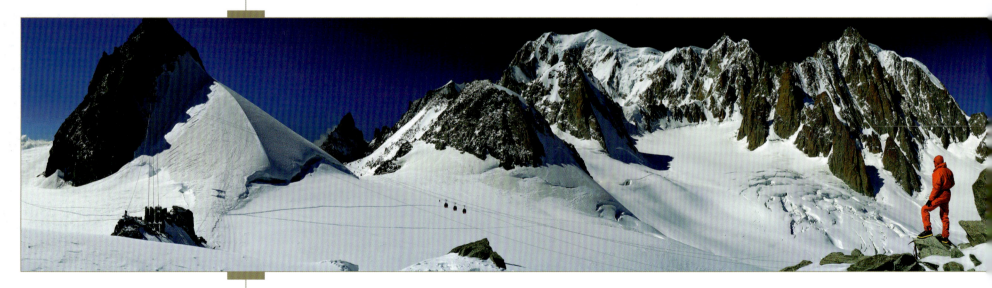

Photo by Franck Charel,
with the assistance of Jacques Barthélmy.

sensor requires some explanation. Combining this singular way of functioning with the ability to make multiple exposures on film makes it possible to create some particularly original photographs at night. This is notably the case with my Noblex, with which I have made a series of photographs of Paris and religious architecture. In this way, multiple exposure allows one to "sculpt" the light.

To begin, I will explain how these two types of camera work; then, I will provide an inventory of the main kinds of rotational and swing-lens cameras (e.g., angle of view, format). Following this, and after having mentioned the characteristics of some useful and indispensable accessories, I will reveal what is so special about taking pictures with these cameras, especially at night.

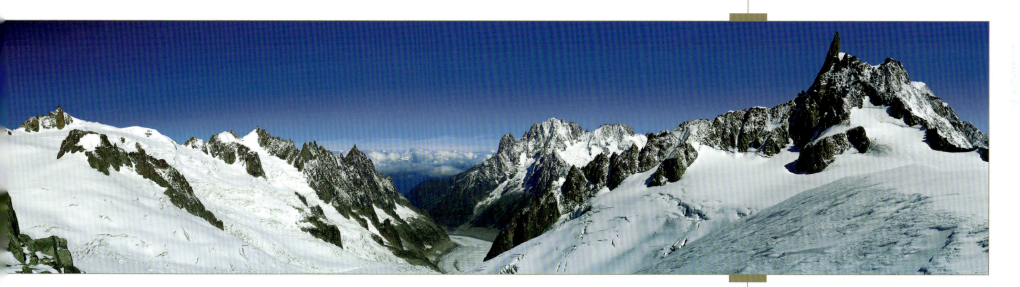

How Do Swing-Lens and Rotational Cameras Work?

There are two categories of rotating panoramic camera, depending on whether the lens or the entire camera body turns. The former category consists of traditional film cameras that photograph a maximum angle of 145°; in the latter are both traditional and digital cameras that take in a much larger field (up to 360°).

NOTE

Real Exposure and Effective Exposure

To be properly exposed, film needs to receive a certain amount of light, depending on the film's light-sensitivity. In a conventional camera, exposure time is given by a shutter opening that passes across the totality of the film's surface. In the particular case of rotational or swing-lens cameras, it is given by the speed of a slit's sweep in front of the film. The width of the Noblex 150's slit, for example, is 3 mm and does not change. Therefore, here it's only the rotational speed of the turret that determines exposure time. If each section of the film effectively receives one second of exposure (for example), the camera will really have taken at least a minute to take the photo. During this minute, the camera should not be moved.

Traditional rotational cameras take films (35 mm, 120, or 220) that unwind behind a slit located at the rear of the lens at the same time and speed as the rotation of the camera. Thus, the movement of the camera and the film are synchronized. In the case of digital cameras, the sensor remains fixed and simultaneously stores the information in its memory as the camera rotates. These are very precise machines.

Both types of camera are, properly speaking, shutterless. Instead, they have a slit of a generally fixed height and a flap that prevents fogging the film between exposures. The speed of rotation in front of the film determines exposure time. An immediate problem presents itself: all the film does not receive exposure at the same time. This means that there always is a discrepancy in the time between the exposure of the left and right ends of the film. Although this is only a fraction of a second for short exposure times, unfortunately, it can be several minutes for, say, a full second of effective exposure! Except for a few of the shorter exposure times, instantaneous photography is thus off-limits, or at least a bit of anticipation will be needed when photographing moving people. Between the moment when one pushes the shutter release button and the moment when the film is truly exposed, the time delay can be fairly significant with speeds slower than 1/15 second. That's the difference between real and effective exposure times. For example, it takes more than three minutes to make a complete rotation with a Roundshot camera, whereas on average the effective exposure would be only half a second!

When the Lens Rotates

The Noblex and Horizon 202 are both swing-lens cameras. There are no digital versions, and there probably never will be, since it would be too complicated to install a digital sensor in the form of an arc at the back of the camera. With these cameras, a turret housing the lens rotates to photograph the panorama, usually embracing a 135° field of view. Some are relatively light and equipped with fairly bright viewfinders of high quality.

Exposure times vary from one camera to another; the more recent models can have exposure times up to 1/500 of a second, perhaps even 1/1000 of a second. At these speeds, the turret turns quite rapidly, and the exposure time is short enough to freeze almost any kind of action. At the other end of the scale, most of these cameras slow down to at least a half-second of exposure, and some even slow down two second exposures. And if that still isn't enough to allow for night photography without using grainy, high-speed film, a few models offer a remarkable alternative: multiple exposure. With multiple exposure, it is necessary to make several two-second exposures; but this possibility is fairly rare, even with digital cameras (see the expert's opinion later in this chapter).

Cutaway view of a swing-lens camera. The film is held in an arc at the back of the camera body, and the lens sweeps the field, exposing the film. This technique does not work with digital sensors. 1. Film Spool; 2. Slit; 3. Film; 4. Nodal Point and Rotational Axis; 5. Lens; 6. Starting Point; 7. Stopping Point.

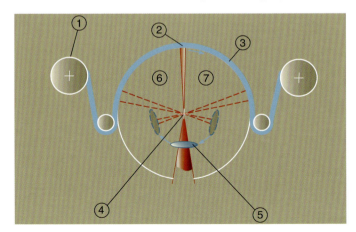

Focusing often is reduced to its most rudimentary function. The lens is set for the hyperfocal distance, with the depth of field extending from two yards to infinity with 35 mm film, and the critical focus being at five yards for medium format with the lens wide open. Everything is necessarily in focus, or close to it, with this kind of camera. The only way to achieve softness is to shake the camera during exposure, so as to create a blurred effect. By stopping down, one gains a few more inches in the foreground.

Turret cameras do not have interchangeable lenses, but the aperture can be changed. 35 mm models often have a lens where the widest aperture is *f*2.8, which always guarantees short exposure times with fairly bright subjects, and even shorter exposures when circumstances demand it (e.g., journalism, street scenes, brief events).

Interior view of a Noblex. The film is held against a round support and is exposed by a slit located behind the lens.

Photo by Arnaud Frich.

When the Camera Rotates

To photograph between 150° and 360° (sometimes in several passes), the entire camera must turn, which makes digital photography possible once again. A straight digital sensor is placed behind the lens – a CCD module, like that used with a laser scanner for prints or color transparency film – which stores the information on a memory card or computer while the camera turns. In a traditional film camera, a motor advances the film at the same time and speed as the camera. This demands a lot of precise engineering. These cameras are often very bulky and complex, and the price reflects this. And because the film advances as well as the camera, over-exposure is impossible. To permit photographs at night, rotational cameras sometimes offer far longer exposure times than the Noblex 150. The exposure is made in a single pass, but this takes an enormous amount of time: for example, it takes an hour to make an effective exposure of only nine seconds with a 360° view. On the contrary, the shortest exposure time (1/250 of a second) allows one to freeze fairly fast movement without problem.

These cameras, taking 35 mm and 120/220 films, sometimes accept interchangeable lenses with high quality optical components. This is becoming more commonplace, offering the convenience of continuous and precise focusing. These cameras also allow control over the vertical angle of the photograph and permit the use of a shifting lens, if it exists in the optical range in question. Apart from the cases of artistic and creative projects, tilting the camera is of course not feasible here, since it would result in moving from an elevated shot to a low-angle shot, or vice versa.

One specific quality of these cameras is that they produce an enormous image. Exposed on 120 film, which is 56 mm high, the resulting image will be more than 30 centimeters long. A lasting impression on a light-table is guaranteed!

The camera turns by itself to sweep a 360° field at the same speed as the film. A slit serves as the shutter. The faster the camera body turns, the shorter the exposure time will be.

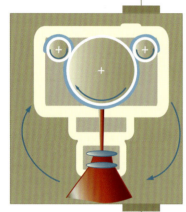

Interior view of a Roundshot taking traditional film.

> ### OPTICAL QUALITY
>
> *The further one moves from the optical center, the more the image quality degrades. Thus, the image is not quite as good in the corners and on the edges. Fundamentally, the same holds true for lenses used in rotational cameras, except that they sweep the entire length of the film with a straight slit that covers only the center of the lens. In this way, the image quality at the ends is absolutely identical to that of the center. The only noticeable difference occurs between the middle band of the photograph and the top and bottom edges. Consequently, all that is needed is to stop down a little on the lens to even out the image quality.*

Camera Types

In this section, we discuss the swing-lens and rotational cameras currently on the market, both new and used, sometimes called *"cylinder"* or *"turret"* cameras". Some of the older cameras are found only on the used market or in collections representing the recent history of panoramic photo equipment.

In this category are specialty cameras that can make only one kind of photograph, but always in a remarkable way. Sometimes, their price and light weight put them in direct competition with fixed focal length cameras with very wide angles of view, both tending to be fairly expensive. For example, both Nikon and Canon market 14 mm lenses (115°) that cost more than $2,700, which matches the price of the top-of-the-line Noblex 135 (135°). Rotational cameras are often much more expensive than this.

Rotating cameras (camera body or lens) do not have reflex viewfinders. Thus, when looking through the viewfinder, it is impossible to determine exactly what will be photographed, and difficult to place the critical focus on a specific subject.

Both will be judgment calls, so it becomes necessary to pay attention to the issue of parallax when framing and to find the hyperfocal distance when focusing, as we already have noted several times.

Swing-Lens Cameras

Three major brands compete in the field of swing-lens panoramas: Noblex, Horizon, and Widelux. The last is an older model, but you can still buy it new. Thanks to its nice balance of quality and price, many photographers have begun making swing-lens panoramas with the Horizon 202. Much more recent, highly efficient, and versatile, Noblex cameras set the present standard for photographing approximately 140°.

As opposed to other swing-lens cameras, Noblex cameras have one interesting feature, although it is sometimes a handicap in instantaneous photography (if one can use this term in describing how these cameras operate) – their turret rotates 360°. Consequently, it returns to the original position after each exposure. After the shutter is released, it takes a half-turn to reach its operating speed after accelerating from the start. During this lapse of time, the lens is turned toward the film and the slit (covered by a protective flap) faces the scene. Once the operating speed has been reached, the lens faces the subject and the slit moves in front of the film. Then, the flap slides open with a brief mechanical sound, and the effective exposure of the film begins. During the initial rotation (i.e., when the slit is facing the subject), the time lag can be longer or shorter depending on the shutter speed. This feature must be considered when photographing passing moments (notably, the movement of people), but it guarantees that all of the film will be equally exposed.

Horizon 202

This Russian-made mechanical camera allows one to make truly panoramic, 24 mm × 58 mm photographs with a 120° angle of view on 35 mm film, with a fast (f2.8) 26 mm lens. As the length of the resulting image comes close to the standard 56 mm of the 6 × 6 format, it is possible to project them as slides while losing only one millimeter on each side. The lens, set at the hyperfocal distance, has a fixed focus and cannot be shifted, but the optical quality is quite good. A bonus of this camera is its low used price, which allows everyone to discover the joys of wide-field, swing-lens, panoramic photography. Consider this light, specialty camera as an option to buying a very expensive and sometimes heavy 14 or 17 mm lens., or

As opposed to the Noblex, the Horizon 202's turret does not make a complete turn with each exposure. Thus, it can have problems with the exposure of the film from left to right, especially with very short exposure times. On the other hand, there is practically no lag time between the release of the shutter and the moment when the photo is actually taken. And it's the only swing-lens camera that can

vary the width of the slit. Here, the speed of rotation does not always change, but functions in relation to the slit. For example, the lens turns at the same speed for 1/250 and 1/125 of a second, while the width of the slit changes. However, due to a combination of two slit widths and three rotational speed settings, only six shutter speeds are possible. Note, however, the absence of two very practical shutter speeds: 1/30 and 1/15 of a second.

The bright viewfinder has a level that is visible when composing and for keeping the camera squared-up while making a hand-held exposure. This principle, found in the other swing-lens cameras as well, is very practical in the field for avoiding the characteristic curvature of horizontal lines that these cameras tend to produce (see Chapter Two).

It is also important to remark that this camera does not have a good reputation concerning reliability or construction. However, in my opinion, it remains an attractive camera with regard to its ratio of quality versus price for those starting out in panoramic photography. Model 203 has begun production in Russia, in two versions. The notable differences from its predecessor, model 202, are appearance and shutter speeds: from one second to 1/250 of a second, or from 1/2 second to 1/500 of a second, and lacking only one shutter speed, 1/15 of a second. The biggest problem with model 202 is the impossibility of exposing at 1/15 and 1/30 of a second; doubtless, there is still work to be done in this direction.

The Horizon 202, the ideal camera for discovering the world of rotational cameras because of a nice balance of quality and inexpensive price when purchased second-hand.

Noblex 135

This camera, made in Germany, comes in many forms. Model U, the top-of-the-line version, has all the refinements that one could want from a modern swing-lens camera, as a brief listing of its features proves:

- It takes 35 mm film, but makes images that are 66 mm wide. The 24 mm × 66 mm format (2.7:1 ratio) with a 135° angle of view is clearly panoramic, as we have already seen.
- It has both short (1/500 second) and long (one second) shutter speeds, as well as a setting for multiple exposure. Therefore, sports, journalistic, and nighttime photography are possible.
- The top-of-the-line model is capable of a four-millimeter lens shift, allowing the horizon line to be placed at strategic places (i.e., at the upper or lower third of the photograph) without tilting the camera. As shifting is possible only toward the top, it will be necessary to turn the camera upside-down in order to introduce a shift toward the bottom.
- It takes a set of useful dedicated filters. However, their installation is tricky, since they must be placed on the lens via a magnet crossing a straight opening in front of the lens. Still, they do exist. (Since 2003, these filters have become harder and harder to find.)

The Noblex 135 is the most versatile swing-lens camera on the market and has been so for several years. It's a remarkable tool for making hand-held panoramas.

• Thanks to the effective Panolux sensor, one can vary the rotational speed of the turret during exposure, in order to balance the ends of a photograph (i.e., when moving from shadow to highlight).

• The focus is set at the hyperfocal distance, which is around eight yards. At *f*11, the depth of field ranges from five feet to infinity.

• Optically speaking, its multicoated 29 mm lens is quite good, even when it is opened all the way to *f*2.8.

• The viewfinder is a model of clarity. Even though it takes a little bit of getting used to, it is easy to anticipate exactly what will be photographed, even when the lens is shifted, because of a small notch at the top of the viewfinder. The usual level in the interior helps in hand-held framing.

• It works with batteries (LR03) only, but a back-up reserve offers more autonomy.

The Noblex 135 also exists in three other versions (S, Pro Sport, and N), in which the shared characteristic is not having slow shutter speeds (i.e., 1/15 of a second to one second). Model 135 U was my first swing-lens camera, and its only shortcoming was that the size of the image could have been larger. So I finally bought model 150. I have nothing but praise for these cameras!

Noblex 150

The 150 model, which uses 120 roll film, is an adaptation of the 135 (35 mm) model. First appearing in 1992, these cameras quickly were appreciated for their wide range and versatility. For several years I have used the top-of-the-line model and have been quite satisfied with it. It is even better made than the 135 model, with a number of small details having been smoothed over to make it more multipurpose.

• The lens is a high quality 50 mm/*f*4.5 (four coated lens elements) that covers a 50 mm × 120 mm format with 120 film. The angle of view is 146°. The top-of-the-line UX model can shift upward 5 mm; but as was the case with the 135 model, it is possible to turn the camera upside-down to make it shift downward.

• The continuous focus has three reference marks (5 m , 14 m, and infinity). Differing from the 135 model because of its longer focal length, it is possible to leave the foreground or background areas out of focus and isolate the subject by not stopping down much on the lens.

• Like the 135 model, it uses four batteries, LR06 (lithium). Thanks to these, I have been able to make long exposures in very cold weather – something that is impossible to do with conventional batteries. But because they are expensive (e.g., a package of four costs at least $18), I use them only when my alkaline batteries

freeze up, which is not very often here in Paris. Because they are slow to decay, I have used the same package for five years. Power consumption is also quite reasonable, as is the case for the 135 model.

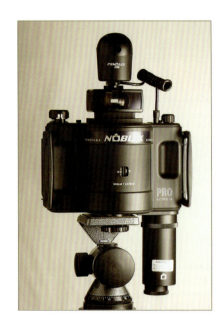

Ever since its first appearance several years ago, the Noblex 150 has remained the Rolls-Royce of swing-lens cameras.

• Because of its maximum two-second exposure (with the motor set to slow) and the necessary multiple exposure setting, night exposures have a real formality and are a treat for those who make them, as I explain in the expert's opinion section, "sculpting" the light. This possibility alone makes the camera unique. Of course, nighttime exposures take a lot of time, since an effective exposure of one minute means that the camera must turn for an hour! The traces of cars' head- and taillights are longer and nicer here than one-second exposures when using the 135 model; just the same, I am starting to appreciate that they are much shorter than with a conventional camera.

• Like the smaller 35 mm model, the 150 can be used with a Panolux light meter in the automatic mode. This permits two types of light metering: incident, with exposure compensation from left to right being achieved during exposure by varying the rotational speed; and the more conventional reflected-light reading. There is complete control over the light meter, and it is the photographer's responsibility to adjust the amount of exposure (up to three *f*-stops) between the two extremities of a given photograph.

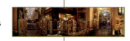

With the recent models, it is possible to vary the rotational speed of the turret in both the incident and reflected modes, up to three stops. In this way, it is very easy to balance a photo's exposure between the shadow and highlight areas.

• The viewfinder has three multicoated lenses and provides a view with more contrast than the 135 model – what a treat! It is removable with the top-of-the-line models and has two levels, only one of which is visible from inside (the one that allows you to avoid tilting the camera from left to right). The other level is located on top, but it is not visible while framing (less practical when hand-held, but definitely useful when working with a fully extended tripod). This is too bad, because the handle of the camera is quite ergonomic and the HS model is capable of really short exposure times (1/1000 second).

Widelux 135

With the F6, then F7, and finally F8, the Widelux 135 was the only swing-lens camera available for 35 mm film for a long time. Without frills and relatively fragile, this completely mechanical camera has only three shutter speeds but is still capable of producing beautiful images. It also can take modified filters. Changing film is not easy, and the price is prohibitive (unless buying it used) compared to the features offered by the Noblex.

• Available shutter speeds do not permit nighttime exposures.
• Its 26 mm lens opens to *f*2.8, but does not shift.
• It has a useful set of dedicated filters, both for black-and-white and color.
• A system for light-metering and exposure compensation is neither a possibility nor an option.
• The critical focus is set at the hyperfocal distance.
• An effective, conventional level is located in the viewfinder for making hand-held exposures.

For a long time the only swing-lens camera, the Widelux seems a bit like a dinosaur today when faced with more recent cameras, especially the Noblex.

Widelux 120

Also called 1500, this medium-format Japanese camera is based on the F8 model. The image quality is undeniable, although always a topical question, but the camera (still available as new on some Internet sites) is way overpriced considering its outmoded features. Its only advantage, very useful for those wanting to make hand-held photos, is that the lens can be opened to *f*2.8. For a medium-format camera, this is rare, especially since the image quality is unquestionable.

• As with the smaller 35 mm version or the Noblex, there is a useful set of dedicated filters, but installing the filters is tricky. It is helpful to have thin fingers that can enter the lens opening to screw on the filters.
• Unfortunately, the lens cannot be shifted (but this is normal).
• The camera has only three shutter speeds (1/8, 1/60, and 1/250 of a second) and multiple exposure. When it was first sold, it was quite normal to use black-and-white film, which was much more tolerant regarding underexposure. Thus, it is necessary to carefully adjust the aperture in order to expose the film properly. The camera also has a reputation for having erratic shutter speeds, which vary during exposure and translate into vertical image areas that are either too light or dark.

The Noblex 175 model is much bulkier. It has a 75 mm lens. The photo format is 56 mm × 170 mm, which makes for a 3:1 aspect ratio and a 138° angle of view. The lens's longer focal length offers the advantage of compressing the frame toward the horizon line, thus eliminating large areas of the sky and ground. This format is perfectly adapted to both urban and natural landscapes, especially those viewed from a distance.

The brand Eyescan, known more for its rotational digital cameras, started making a 624 model taking 120 film (56 mm × 210 mm) in 2003.

Photo by François-Xavier Bouchart.

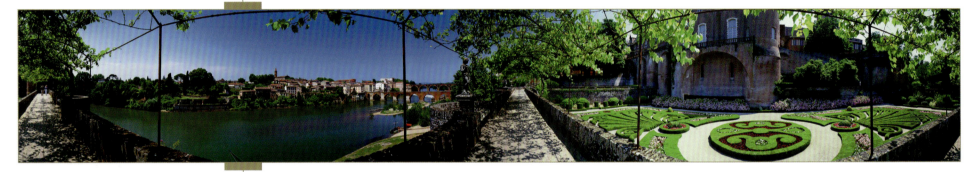

Photo by Franck Charel.

Rotational Cameras

Traditional and recently turned digital, rotational cameras allow a complete turn. Therefore, one can take in 360° on the same photograph, sometimes even more. And as we already have seen in Chapter Two, framing possibilities are reduced because one is limited to photographing a scene and its surroundings. Certain models are made in small numbers by inventors and mechanics of genius. For example, the most well-known brand in Europe, Roundshot, comes in several models. It goes beyond the bounds of our discussion, however, to address all of them here.

These cameras are characterized by the partial absence of a viewfinder; but with experience, it becomes easy to anticipate the image that one will obtain. The only thing to verify is the limit of the vertical framing, relative to the focal length of the

lens being used. Rotational cameras are defined by really long photographs; for example, with the Roundshot and a standard 50 mm lens, one can take only four photos on a roll of 220 film. The cost of making a photograph is also quite high because a photographer working with color transparency film often has to bracket (i.e., make a series of three photos involving a half-stop change of exposure – over, under, and at the meter reading). The desire to have everything digital has never been so great, even if digital cameras are still quite expensive and rather limited.

Roundshot 135

Perhaps the only rotational camera using 35 mm film on the market, the Roundshot Super 35 is built on the same principle as its 220-film version (the Super 220). Some of its noteworthy characteristics are:

• Changeable lenses, which allow one to explore the entire range of Nikkor, Leica, or Contax (from fish-eye to telephoto). The image quality is without question. For those in love with a truly beautiful image, Roundshot has achieved the impossible marriage of Leica optics and panoramic photography!

• Lens shifts, due to a sliding lens board.

• Exposure times of 1/250 and 1/500 of a second. At 1/250, the camera takes two seconds to make a complete turn. Thus, one has to watch out for moving subjects that could enter or leave the image during this period of time.

• Variable angle of view, from as little as 10° (and several rotations, until the film is used up), to well past the significant 360°.

• Exposure metering, with the possibility of corrections according to a plotted curve. Continuous variation of the rotational speed during exposure, along the entire breadth of the field being photographed.

This camera weighs more than 11 pounds and operates from a rechargeable battery. Its fabrication is of unquestionable quality, and the price painfully reflects this.

Roundshot 220

Models using 120 or 220 film are still numerous. One even takes 70 mm format film. Because it goes beyond the limits of this book to cite them all, Appendix A provides the address of a Web site containing technical information about all the models available at present. These exceptional and entirely electronic cameras possess characteristics that can satisfy any photographer who would want to obtain one.

• All models take interchangeable lenses. It will suffice to choose them from the range of major makers of 35 mm and medium-format cameras. The quality will always be there.

• Some cameras (28/220 and 28/200 Outdoor) are light (3 pounds) and not very bulky.

• Shutter speeds are variable, with automatic or manual compensation through the entire duration of the exposure.

• Some models are only available used. As you may have guessed, these are copies of the 35 mm models, but taking 120 film. Further information: the lens is a Rodenstock Grandagon 65 mm for the 65/220 model and a lens from the gamut of Nikkor or Leica lenses for the most recent model, the 28/220. Lens shifts of +/−26 mm are possible with the Grandagon and +/−12 mm with shifting (PC) Nikkor or Leica lenses. The full range can be found on the Roundshot Web site.

As mentioned earlier, a Roundshot that accepts 70 mm cinema film also exists. In addition to their prohibitive cost, these cameras have the inconvenience of being particularly heavy.

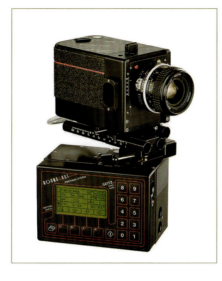

Roundshot panoramic cameras are exceptional rotational cameras.

Scantech Le Voyageur

This original panoramic camera of excellent construction (e.g., the motor is commanded by a microprocessor) is handcrafted by Gildas Le Lostec. Two versions exist, both of which use with a 28 mm or 50 mm Nikkor lens. It is possible to use a 28 mm PC Nikkor if one wants to shift the lens, but only up to 5 mm. The image is projected onto 120 film, and the combination of Nikkor lenses and roll film allows one to obtain very high-quality panoramas. Curiously, the circle of focus of these lenses for 35 mm film covers the height of 120 film (56 mm), on the condition that one stops down a little. The longest exposure time is only one second.

This camera can also be operated with remote control and allows streaked motion-type photos to be made.

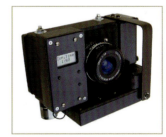

Handmade, "Le Voyageur" is an all-in-one camera.

OTHER CAMERAS

Cameras called Hulcherama, Alpa Rotocamera, or Cirkut are found only on the used and American markets. Thus, they are part of the universe of rotational panoramic cameras, but you will hardly see them, except in the possession of enthusiasts.

Digital Cameras

Ever since digital photography has existed, engineering enthusiasts have been trying to put a sensor (i.e., one that takes the form of a CCD laser scanner) in rotational cameras. Technically, it's quite foreseeable, and ultimately, financially feasible, because if such a camera is still expensive today, the resulting film and scanning budget will be close to nothing. For example, making a color transparency with a Roundshot 220 presently costs as much as 15 35mm photos! These cameras are constantly improving, just like digital cameras in the more traditional formats do. And even if the urge to come out with new models is less intense, doubtless due to their price, there is still a rapid evolution of this kind of equipment. It is not possible to change the sensor, so the purchase of a conventional or panoramic digital camera is directly linked to the quality and size of the sensor. As of this writing, digital sensors are becoming larger and larger; in height at least, they are capable of making giant posters.

These cameras still remain difficult to transport, however. To make them work and record images – and the least one can say is that they are panoramic – a nearby laptop is indispensable. A sensor's raw, 16-bit digital file can easily reach 500 gigabytes, which means that it is impossible to store more than one image on a 512Mb memory card. However, digital panoramic cameras will eventually be directed by small computers (e.g., like the Palms), and since the memory cards' size is always increasing, several images will eventually be stored there. Only then will these cameras become portable.

Eyescan MM 1 and M 1

New arrivals on the rotational camera market, the German company Eyescan makes several digital panoramic cameras. The laser-type scanner is a bar with 3600 high-quality pixels, capable of producing 3600 × 32,000 images in 360°. These cameras take Nikkor and Rodenstock lenses, which include wide-angle, shifting PC, and even telephoto. Thus, the range of possibilities is quite large! Governed entirely by a computer, the camera itself is not very bulky, since a simple, fixed, laser scanning device replaces the complex film driving mechanism.

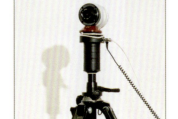

Newly arrived on the digital rotational panoramic camera market, the Eyescan is not very bulky.

Panocam 12

Spheron was the first brand to be recognized by the buying public for its digital panoramic cameras. At present, it makes several models (e.g., Panocam 12, Spherocam VR, HDR) that accept Nikon, Canon, and other brand-name lenses. The sensor, having 5200 pixels, is already of very high quality; but it also exists in an extremely expensive "high dynamic" version (60,000 dollars). Obviously, the high price will come down with time, as is the case with conventional digital cameras. And since these panoramic cameras have sensors of the highest rank, the resultant images are finely detailed, without any undesirable digital noise. The manufacturers put only the highest quality sensors in their cameras, and this is especially the case with the top-of-the-line HDR Spheron camera. At present, these cameras do not have exposure times longer than a half-second, so one cannot imagine photographing every kind of subject (night photography for instance).

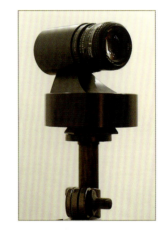

Spheron was the first brand to put a digital panoramic camera on the market.

Roundshot SuperDigital II

Specializing in rotational cameras, Roundshot brought its line of panoramic cameras toward digital with this top-of-the-line camera with interchangeable lenses. One can pick and choose among the biggest names making 35mm equipment using any focal length up to 105mm. One great advantage is that

Roundshot remains faithful to its standard of excellence with its digital cameras. Quality and versatility are always there when needed.

shifts are possible with all the lenses, not just the PC ones, because they are mounted on a board that slides vertically. The laser-scanning device currently measures 2700 pixels across, and the image can reach up to 50,000 pixels long.

This camera is as easy to use as the more conventional ones, since the automatic and variable light-metering system allows you to continuously vary the speed of rotation. As opposed to cameras made by Spheron, here, the exposure times range further because it is possible to expose up to eight seconds.

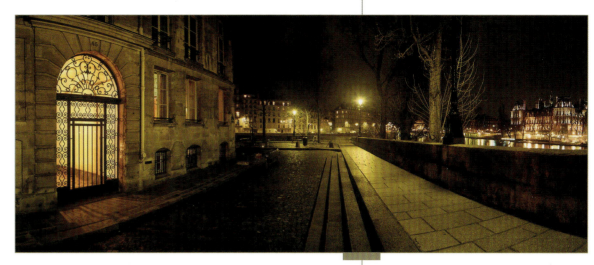

Photo by Arnaud Frich.

Accessories

Certainly heavy (but isn't a complete 35 mm outfit heavy as well?), the largest rotational camera on the market, the Roundshot Super 220 VR, is not very bulky and can be carried in a backpack without any problem. Quite often, the backpack becomes heavy when the photographer also carries a reflex camera and a set of lenses. A good way to protect one's back is to invest in an indispensable carbon tripod. These are completely stable and are noticeably lighter than their aluminum equivalents. The loss of weight is significant – pounds instead of ounces.

In the United States, it is common to meet well-equipped photographers who do not hesitate to bring large-format cameras to the rich landscapes of the American West. But if this seems a tradition in the land of Ansel Adams, it is a rare occurrence here in France. However, a magnificent Noblex 150 weighs hardly more than a classic 70/200 f2.8, and it allows one to obtain a wonderful 50 mm × 120 mm color transparency.

Although they were discussed in the preceding chapter, I would like to provide more information about the use of certain accessories, since their use is sometimes quite specific with this category of specialty camera. This is particularly true with filters and light-metering sensors.

Level

All the viewfinders of swing-lens cameras have a bull's-eye level visible in the frame. This allows one to aim straight in all directions and to avoid tilting the camera from left to right, or from front to back. This feature is quite ingenious and practical in the field, especially with hand-held photography. (However, as we saw in Chapter Two, the resulting image is distorted with these cameras.) The level also works well when the camera is on a tripod. Rotational cameras, as they currently exist, have a level on the base that guarantees horizontality.

The level is always visible in rotational cameras' viewfinders in order to make hand-held picture-taking easier.

A bull's-eye level seen from the top of the camera as well as from the interior makes hand-held framing very easy.

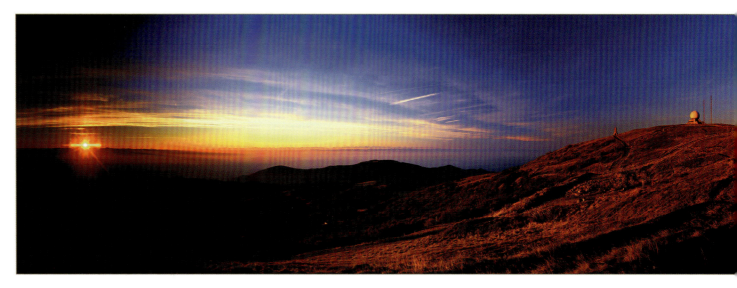

Photo by Franck Charel.

Filters

The use of filters is nearly identical in panoramic and normal photography (apart from polarizing filters), but their manipulation is noticeably different, and always for the same reason: the rotation of the lens or camera body during exposure.

The polarizing filter – allowing one to render, among other things, more saturated blue skies – is a separate case. In theory, its use seems so difficult as to discourage it from 360° panoramic photography altogether. But one only has to look at photographs by Franck Charel, which were taken in full sun, to realize that it is possible in practice. However, one important condition remains: one must have access to a rotating camera that allows the speed of the turret to vary, to account for the maximum effect of the filter in certain directions and its inefficacity in others. Franck Charel owns a Roundshot with this

characteristic. Without it, certain photographs taken in the most beautiful weather would be much less harmonious, since the sky would be an intense blue in some areas and completely washed out in others. Changing the rotational speed of the turret eliminates this pitfall.

Conventional or dedicated, filters are perfectly usable in panoramic photography, with the slight possible exception of polarizing filters, which must always be used with caution.

Even swing-lens cameras will accept filters mounted on a specially adapted frame, behind the lens opening that doubles as a light shade. And here again, it is important to note that it is becoming harder and harder to find new filters on the market for Noblex cameras.

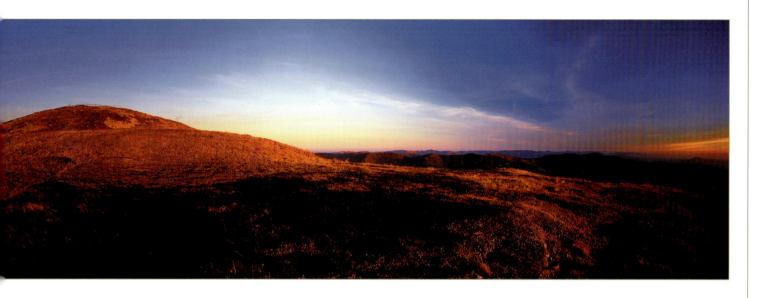

Noblex filters are placed on the lens with a magnet. To put them in place, it is necessary to use the tongs included with the set of filters.

Use of a graduated neutral density filter is not the norm (the following explanations concern swing-lens cameras – Noblex and Widelux – and possibly rotational cameras like the Roundshot; however the installation of the filter is more practical in the Roundshot's case, since they are screwed into the front of the lens, which is normal).

When using a graduated filter (e.g., neutral density) on a normal camera, it is necessary to place it in front of the lens, more or less in the middle. With this type of filter, one generally seeks to darken the sky in such a way that it will not alter the lower part of the photo. And depending on the height of the subject, one either raises or lowers the filter upon its support to achieve this. The opposite is the case for swing-lens cameras. Here, the filter is round, so it cannot slide upon its support, but only turn. Thus, in principle, there is no possibility of using the effect other than in the middle of the photo if the graduation stops halfway. Still, that doesn't account for the peculiarity of cameras that expose the film or sensor via the fine line of a slit, especially in a left-to-right movement (or vice versa). To raise or lower the graduated effect on the image, it is necessary raise or lower the filter's graduation by turning it slightly to one side. Then, as the lens rotates, the effect will be felt either higher or lower as it sweeps across the entire length of the film.

Graduated neutral-density filters for Noblex cameras stop slightly above the middle of the filter. By using them in the same way as with a normal camera (i.e., very flat), it is theoretically impossible to create a darkening effect under this line, which remains slightly above the horizon.

Limit of graduated shading

Middle of filter

When the filter is positioned straight up and down on the lens, the effect is visible only on the upper part of the photograph.

When the filter is rotated slightly, and when the lens sweeps the film, the effect will be felt further down.

Light Meters

No swing-lens camera has a built-in light meter, whereas many rotational cameras do. Therefore, the photographer needs to have a separate light meter, preferably with incident or spot readings. The Noblex is an exception in this regard, since some models include a special meter, the Panolux, in their list of options. It is mounted on the hot shoe pad and makes the camera completely automatic.

Remember, when varying the speed of the turret is not permitted, the chief exposure difficulty with swing-lens panoramic photography will pertain to balancing different areas of the final photograph. In such cases, how can one introduce a compromise between the shadow and highlight areas that must be included in the same image? If today's films – especially color transparency films – were able to record the wide range of contrast, the question would not need to be asked; but this is far from being the case. Except for cloudy days, contemporary films and many digital sensors cannot be prevented from overexposing and underexposing certain parts of the film. Only a manual measurement with a hand-held light meter can gauge exactly which areas should be sacrificed.

To alleviate this major inconvenience – fortunately, occurring only in certain lighting situations – Noblex Panolux light meters and the built-in light meters of a number of rotational cameras alter the rotational speed of the turret to match the different conditions of light encountered, after having precisely measured the scene. This works really well, and its absence from the Horizon and the Noblex

cameras is regrettable. In the case of the Noblex, it operates by slowing down and accelerating between different parts of the scene, from left to right of the film; and in the case of rotational cameras, a continuous variation over the entire width of the film.

I have owned a Minolta spot meter for more than 10 years, and I no longer use anything – else – both in color and black-and-white photography. With experience, it becomes incredibly effective.

Finally, and this is the irresistible charm of swing-lens cameras having multiple-exposure, night photographs can be created by dodging the image during exposure, like one does when enlarging (see the expert's opinion section). In other words, one can "sculpt" the light and therefore "photograph" in the etymological sense of the term, "write with light." To do this, a spot meter (measuring 1° to 5°) is required. Nothing beats it; Noblex cameras need to be admitted into the rotating panoramic camera Hall of Fame.

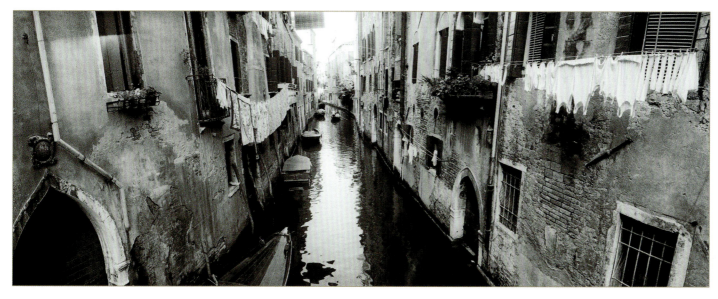

Photo by François-Xavier Bouchart.

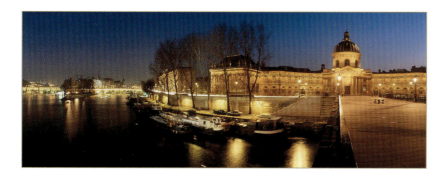

Photo by Arnaud Frich.

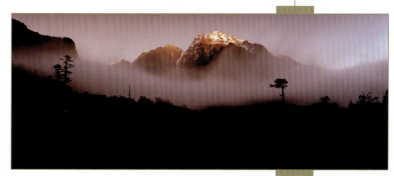

Photo by Macduff Everton.

Taking the Picture

Rotating panoramic photography has finally begun to expand beyond its rather specialized domain. The Horizon 202 and Noblex 135 series are light and manageable enough to be used where they might not normally be expected (i.e., in journalistic photography). What is more natural than to want to photograph a scene and its surroundings using this format? Or to place an event in its context, rather than simply isolate it?

Hand-held or Tripod?

Certain cameras, like the Noblex 135 or the Horizon 202, are clearly intended to make hand-held photos, even in difficult situations. They are light, being outfitted with a viewfinder and built-in level, and the lens opens to *f*2.8 (making it quite fast) and is set at the hyperfocal distance. Used with highly sensitive film, they permit journalistic photography (I am thinking specifically about Michael Ackerman and his book, *End Time City*; see Appendix A). However, pay strict attention to one important detail: the turning of the lens during exposure. This turning takes a certain amount of time, especially at speeds slower than 1/30 of a second. For example, it takes one minute for a Noblex to make an effective exposure of one second. In normal use, the photographer needs to stay below 1/60 of a second – not because of camera shake, but to avoid introducing anamorphic distortion (i.e., a stretching or shortening of moving objects).

As soon as it becomes possible to photograph the urban or natural landscape, the panoramist often adopts a more composed and reflective attitude; this naturally involves a tripod. It's not only the weight of the camera that justifies this, but also the creative process. And very heavy rotating cameras make a tripod absolutely necessary. Finally, I note that the desire for a maximum depth of field often obliges one to stop down further on the aperture, the result being longer exposure times. For example, with my Noblex 150, I often stop down to *f*11. Only a tripod will permit me to avoid shaking the camera in this case. The only criticism of the freedom that hand-held photography provides is that it has to be used at around 1/30 of a second.

Framing Options

The question of framing need not be posed to the fortunate owners of the Roundshot, Spheron, and other rotational cameras; when using 360° one has decided to photography everything. All that remains is for the photographer to determine the starting point and the ideal lighting. And here, experience proves that this quest is quite long and demands a lot of patience.

The viewfinder is very important when composing, therefore one that provides an elongated view makes it easier to frame the shot. With certain rotating cameras, a viewfinder is nominally present but serves mainly to verify that one has, for example, properly included the top of a building. As soon as the photograph is narrowed from 360°, the photographer is confronted with a real framing decision – the choice being even more limited with a telephoto lens. Here, the quality of the

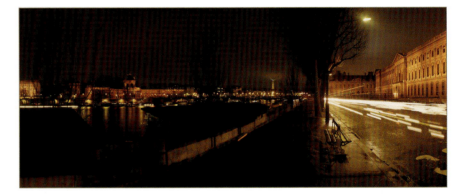

Photo by Arnaud Frich.

viewfinder becomes important; this is determined as much by its ability to sharply depict the scene being photographed as its clarity and freedom from distortion. All the cameras and viewfinders that I have seen have been very satisfactory with regard to these two criteria. Some are even quite beautiful (notably, the Noblex 120).

Finally, watching out for the problem of parallax is always necessary, even when close-up photography is not the preferred domain of the panoramic photographer!

Depth of Field and Hyperfocal Distance

As we have just seen, rotational and swing-lens cameras are not equipped with reflex viewfinders or distance scales. Therefore, the focus will have to be estimated, as was the case with 6 × 17 cameras. The only way to ensure depth of field will be to stop down considerably upon the lens, with the optimum image quality being guaranteed by placing the critical focus at the hyperfocal distance – which is pretty much the norm in panoramic photography anyway. One result of this process is an increase in exposure time, as in other forms of conventional photography. This more or less requires the use of a tripod.

Different situations arise, depending the type of camera used:

• Cameras without focusing controls (e.g., Horizon, Widelux): here, the lens is set at the hyperfocal distance. The more one stops down, the more the foreground and background will come into focus, from one or two yards to infinity. With these kinds of cameras, everything or almost everything is sharp.

• Swing-lens cameras with focusing control (e.g., Noblex): here, it is possible to have a rough (very rough) idea of the critical focus, since the camera has three reference marks, 3 m, 15 m, and infinity. Thus, again, one will need to increase depth of field in order to enlarge the area of focus. At f11, with the lens set to infinity, everything will be sharp from around 14 feet to infinity. If one leaves the lens open and places the focus at 10 feet, it will be possible to soften far-off distances. This allows certain effects to be achieved, since it can be difficult to break away from a maximum depth of field with this kind of camera.

• Cameras taking standard lenses, but without viewfinders: one has access to an adjustable lens with a distance focusing scale. Only one inconvenience remains: they do not have a viewfinder that can directly control focusing with the lens. Again, this will have to be done approximately, setting the focus to the hyperfocal distance in order to obtain the maximum depth of field.

NOTE

Digital rotational cameras do not have viewfinders. The image is visible only on the screen of a portable computer.

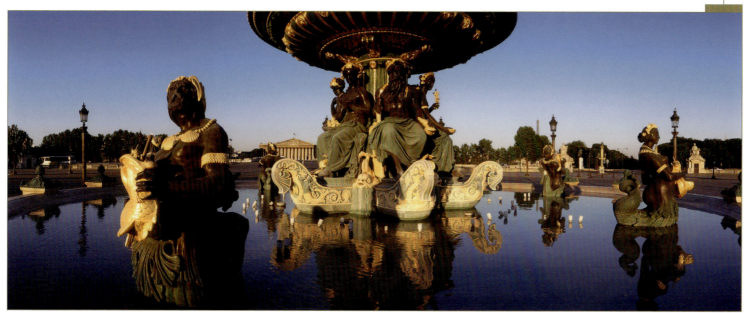

By placing the critical focus on the hyperfocal distance and stopping the lens down to f11, I was able obtain sharpness in all areas.

Photo by Arnaud Frich.

DEFINITION

Schwarzschild Effect

Film has a specific light-sensitivity, indicated in ASA or ISO, which is effective only in a certain range of exposure time. Generally speaking, it falls dramatically for long and very short exposure times. Thus, the solution lies in increasing exposure time to make up for this. This Schwarzschild effect (named after its discoverer) also causes a noticeable color shift with color film. Unquestionably, it is much less of an issue with digital photography, where one does not usually have to consider it.

Modern films have come a long way, and it's because of this progress that I have been able to make my nighttime photographs. For exposure times less than a minute, it is no longer necessary to make any corrections, either by extending exposure or by color correction.

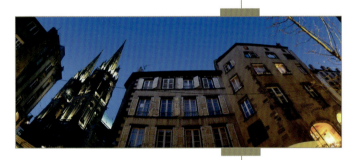

Because of a very slight reciprocity problem with modern films, night photography is a real possibility with rotational cameras. Exposure of 45 seconds with Fuji Provia 100 F film; the downtown area of Clermont-Ferrand.

Photo by Arnaud Frich.

Light Metering and Exposure

Sometimes the area photographed is so wide that the light range is more separated than in normal photography. Also, certain details that seem important to the naked eye may be quite small on the 360° color transparency. To bring them out further, one must pay special attention to the quality of light. Chapter Two addressed the problem of the relative size of details in the photo. I truly believe that the choice of lighting is crucial in panoramic photography, perhaps even more than in normal photography, since framing and exposure have never been so tied together as they are here.

We already have mentioned that there are three scenarios in which a camera does or does not have an integrated light meter. With a Widelux (35 mm or 120 film) or Horizon 202, a separate light meter is required. And all of a photographer's experience will be needed to correctly meter and expose the film embracing a very wide field of view. The balance struck between the shadows and the highlights in particularly nice weather is extremely delicate. In such cases, I recommend using an incident light meter, because it offers more reliability. This measures the amount of light that falls on a subject or scene, rather than metering reflected light in different areas. And since it's not necessary to interpret the reading, as is the case with reflected light-meter readings, it's perfect for panoramas.

Unfortunately, the separation of shadows and highlights in sunny weather is often so significant that the shadow areas risk being underexposed, and the highlight areas risk being overexposed. Thus, the photographer needs to make a compromise depending on the nature of the subject. The best way to overcome this problem is to vary the rotational speed of the turret. Only swing-lens cameras made by Noblex, and only the ones that are governed by a Panolux light meter, allow this. On the other hand, all modern rotational cameras have this ability, sometimes with the advantage of minute adjustments since the variation is continuous.

The height of refinement is reserved for Noblex cameras, whose long exposure times combined with multiple exposure possibilities allow nighttime photographs to be made without major overexposure or underexposure (i.e., when using a spot meter).

Noblex Cameras

The Noblex's Panolux light meter is attached to the camera body and directs it. In the incident mode, the light meter operates with two integrated sensors beneath a white cone that has a nice feature: it automatically corrects the exposure in order to slightly darken the highlights or lighten the shadows. In this way, during exposure, the

motion of the turret speeds up or slows down from one end to the other. This works very well, allowing an adjustment of two to three stops from one end of the image to the other. There is nothing like it for balancing the exposure of color transparency film in full sun with a camera that is capable of embracing around 140°.

The Panolux light meter has two different sensor systems. One of these is a sensor that faces both forward and slightly downward to avoid being overly influenced by light from the sky. Above it, a dome conceals two other sensors (left/right) that read incident light. Because of these two light-metering systems, the camera knows where the sun's light is coming from.

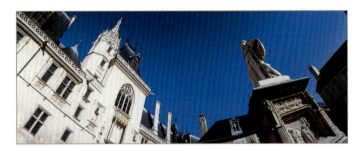

Without exposure compensation, the area in the sun is slightly overexposed, whereas the opposite holds true for the shadows.

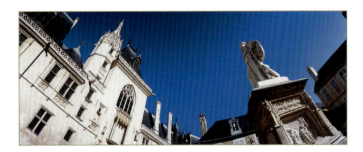

Because of exposure compensation during exposure, the balance of the photograph is reestablished. The area in the sun has been underexposed by a stop, and the area in the shadow has been similarly overexposed. The change in speed is smooth enough not to be noticed on the film.

Roundshot Cameras

The exposure system of roundshot cameras is even more advanced, since acceleration and deceleration occur over the entire length of the film, alternating back and forth as occasion demands. The camera is governed by a computer, so it is even possible to control the contrast range on a screen, modifying it as much as one wants. In this regard, its effectiveness is truly amazing!

In much the same way, all new panoramic digital cameras contain some sort of integrated exposure system, and these are often quite elaborate.

Multiple Exposure

Because the top-of-the-line Noblex cameras allow both multiple exposure and exposures at least one second long, it is possible to achieve astonishing results with nighttime photography by dodging and burning at the time of exposure. With little strokes, like a painter, one can perfectly expose color transparency film for both shadows and highlights. This is a unique feature that rotational cameras do not allow (since the film unrolls at the same time that the camera turns). But perhaps this feature will be automatically possible with digital cameras some day soon.

The principle is very simple: just let the turret turn as many times as needed, dodging and burning in front of the lens—with a black card, in the black-and-white or color laboratory sense of the term—to add or remove a little exposure. This is how I have been able to make all my nighttime photographs, and it's for this reason that I bought a Noblex (I had already noticed that one could balance the large contrast differences encountered with nighttime urban lighting with this method). How enjoyable it is to look at a well-exposed color transparency without having to retouch it! Positive films have a reputation for a limited range of contrast, and the Noblex has allowed me to obtain some very beautiful photographs without major overexposure. At night, in the city, differences in lighting can be very significant; anyone who has tried knows this. I have not yet succeeded in obtaining an equally beautiful result with a photographic assemblage. Noblex cameras still hold a large advantage.

Exposure

Here, the lens sweeps the scene being photographed, and projects an image through a straight slit to the film, which is held in an arc at the back of the camera. It's the passing speed of the slit that determines the exposure time. Therefore, not all the film will receive the amount of light needed to be properly exposed at the same time (keep this in mind while reading the rest of the paragraph, as it is fundamental). Thus, if one covers the lens for a few moments during exposure, only a small portion of the film will not be receiving light. And if the image requires just one rotation while the lens is periodically covered, the resultant exposure will be black in the areas in question. But if the image requires several turns in order to properly expose the film—covering the lens periodically, in certain areas, not during the entire exposure but only during one or more turns—a controlled underexposure of these same areas will be the result. It's with this principle that one can begin to play with sculpting the light. Thus, stopping down is required to extend the exposure time and to gain the time needed to calmly introduce the dodging.

To dodge film with the Noblex camera, multiple-exposure mode is required, which makes it possible to take any number of photos without advancing the film. This makes things interesting in other respects as well; one can modify the rotational speed (and thus, the exposure time) of the turret at will, during the effective exposure or between two different exposures. A number of examples come to mind: the exposure time could be relatively short (i.e., under two seconds), one having decided to make just one rotation during the exposure, limiting dodging possibilities; or one could use the multiple-exposure mode, with fractional exposures modifying the base exposure. For example, let us imagine that the light meter indicates 1/15 of a second at f11; these methods could be used to correctly expose the film:

- A single exposure at 1/15 of a second: if one dodges an area it will not receive all the light, but this will also be difficult to achieve because the turret moves quickly.

- Two exposures at 1/30 of a second each: if one dodges part of the film during one turn, it will be underexposed by one stop.

- Four exposures at 1/60 of a second: if one covers part of the film during one turn it will be underexposed by half a stop; during two turns, one stop; and during three turns, one-and-a-half stops. Thus, since the camera does not expose all the film at the same time, it will be possible to fully expose one area, underexpose another by half a stop, another by a full stop, and so on.

Using the Noblex 150, to expose longer than the slowest shutter speed (two seconds), it is necessary to repeat a base exposure time as many times as necessary; for example, for eight seconds of exposure, one can choose one second eight times, or two seconds four times, or two seconds three times and one second two times, and so on. In this way, with a sufficiently stable tripod, one can build up as many exposures as desired.

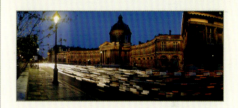

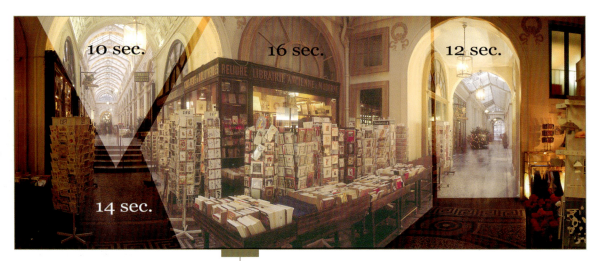

Example of an image:
Le Passage Vivienne, Paris.
Example of different exposure times used
on the same photo. This color transparency
has not been subjected to any alteration
in PhotoShop. This is the original that
one would see on a light table.

Spot-Meter Reading

The Noblex does not have a built-in light meter; rather, the Panolux mentioned earlier is attached. Although this light meter is useful in making automatic exposures, it is totally useless at night. So in the latter case, I use a hand-held spot meter instead.

The spot-meter reading is taken in three steps. First, an overall measurement of the scene determines the base exposure for the main parts of the photo. By the Seine, in Paris, a typical nighttime exposure, as stated earlier, is around 45 seconds at f11 with 100 ASA film. Following this, the areas that risk being underexposed with regard to the base exposure are metered (they will require additional exposure time). And finally, the areas that risk being overexposed will need to be dodged during the base exposure.

Once the metering is over, the exposure begins when the sky has the luminosity needed to obtain the desired density on the film. (I do not like when the sky is pitch black.) Also, keep in mind that the camera takes two minutes to make a single turn involving a two-second exposure. Thus, if the meter indicates six seconds to properly expose the sky, more than four minutes will need to pass between the beginning of the first and the third rotation. The illumination of the sky will have dimmed considerably during this time. So it is necessary to compensate for this by starting the exposure a little bit sooner.

In the example illustrated by the photo in Figure 4.44, the base exposure was 16 seconds (8 × 2 seconds) for the central area, which was the darkest. Then, according to my needs, I covered the lens in the following way as it swept past different areas over the course of several turns:

- Three turns out of eight, for an area needing 10 seconds
- Two turns out of eight, for an area needing 12 seconds
- One sole turn out of eight, for an area needing 14 seconds

Nighttime photography is an isolated case. In Paris, I often need to expose around 45 seconds at f11 with 100 ASA film, or roughly 22 turns at two seconds of exposure each in the multiple-exposure mode. If I cover part of the image during a turn, the underexposure correction brought to this area will be tiny and totally invisible (1/11th of a stop). On the other hand, if an area is very bright (which often is the case in the city), requiring only three or four turns (i.e., six or eight seconds of exposure), I need to cover it during all the other turns to avoid overexposing it. In this way, I can reduce strong contrast differences to within the limits of color transparency film, or five or six stops. During nighttime exposures, I do not rest with my hands at my sides while waiting for the minutes to pass; dodging occupies much of my time. This is always quite exciting, because I feel as though I'm making an impressionist painting!

The central disc only measures
1°. Because this is a hand-held
meter, the precision of the
measurement does not depend on
the focal length being used, since
this measurement does not
involve a percentage of the
framing with the viewfinder.

Placing the Light

Measuring light with a spot meter allows for precise measurement of the smallest areas (1°), in order to "place the light," as they say in Zone-System parlance. This is not really the case here; rather, we are deciding how to "render" certain areas, instead of just blindly relying on the shutter-speed and f-stop combination indicated by the light-meter. The metered area will result in a middle grey value – the same as a Kodak 18 percent grey card. All meters, built-in or hand-held,

function this way. It's both an advantage and an inconvenience since the light meter does not know what is being measured. Therefore, the following questions are justified:

• Has one metered a colored surface, and if so, what color?
• Has one metered a highly reflective or a very dark surface?

The meter cannot answer these questions, so one always has to interpret the metered result bearing in mind that if one uses the indicated shutter speed/f-stop combination, the area will be rendered neutral grey on the film. And it's in this way that the Zone System can be very useful and instructive:

• If the area is a middle grey value matching the light-meter reading, it will be correctly exposed.
• If the area is white or in full sun, it will be underexposed since it will be rendered neutral grey on the film.
• If the area is dark or in the shade, it will be overexposed since it will be again rendered neutral grey.

Given the latter two scenarios, it will be necessary to change the aperture or shutter speed in order to achieve the desired result. It is said that one "places the light" when one adjusts to compensate for the desired tonality of a certain area (i.e., more white or black, or more or less detail) relative to the meter reading. But only trial and error allows you to determine exactly how a particular film and light-meter will react to these kinds of exposure adjustments. The Zone System contains zones 0 through X: zone V is the intermediate zone, middle grey; zone X represents the white of the paper; and zone 0 is the most absolute black possible.

It is important to mention that this is based upon black-and-white printing, and that it is necessary to modify this system when one works, like me, with color transparency film. In this case, the white of the color transparency is reached at zone VII-2/3, and absolute black is reached at zone I or I-1/2. Color transparency film's range in contrast is much narrower than either black-and-white or color negative film, but the method of placing the light remains fundamentally the same.

A highlight area metered at f45 (remember that the base exposure is 45 seconds at f11) would be overexposed by four stops. Therefore, with color transparency film, this area would be completely white ("blocked up"). For the film to receive the right amount of exposure, dodging is required. A lot of colored information is lost beyond a stop over and under the light meter's indicated reading. The colors become washed-out or oversaturated.

I do not want the area to be blocked up, although it is okay if it loses some of its natural color. So I will place the zone between +1 and +2 stops, or between f16 and f22. (An equivalent scenario would be to underexpose one to two stops by using exposure time between 11 and 22 seconds.) And during 11 to 22 rotations, dodging (covering the area) will be required. The opposite holds true for the underexposed areas, as they will need burning-in (additional exposure time), during which the areas already properly exposed will be covered up.

Dodging

Dodging involves blocking the excess light with matte black cards similar to those used in the black-and-white darkroom. I made two cards: a small one (1/2" × 1–3/4") and a large one (4–1/2" × 4–1/2") to hide the entire lens opening of my Noblex 150. The large card must extend beyond the lens opening, to avoid light-leaks on the edges. As they are in the darkroom, the cards should be light and manageable.

Obviously, the slower the turret rotates, the simpler it will be to dodge, since it will be easier to follow its movement (up to 1/15 of a second with the Noblex 150); above this, the turret really turns too fast to dodge properly. It goes without saying that with two seconds of effective exposure, dodging is very agreeable since the turret takes two minutes to make a complete turn.

Movements

Constantly following the lens during its rotation (which depends on the angle and the surface to be covered), one constantly has to maintain a slight circular movement with the card in front of the lens to avoid either the edges of the card or a stark transition. Depending on the area to be covered, it is also necessary to back the card away from the lens as well as raise or lower it. In this way, one can dodge any area of the photo (large or small) during the time that was determined while light metering.

Once when I was making a nighttime exposure, a small area of the image needed only two seconds of exposure, or one sole rotation. Therefore, I really needed to concentrate during the succeeding 24 rotations of the 50-minute operating exposure (total effective exposure of 50 seconds) by covering this area each time the lens swept by. That day, I truly understood the advantage that the Noblex 150 has when used in this way.

Starts and Stops

Always needing to add more exposure time to the darkest areas of the photo, in small successive amounts, I thought to turn off the camera and turn it on again when a certain window was illuminated, or when a barge passed in front of some trees in the darkness, illuminating them with its searchlights. In this way, and working in darkness, I stop the lens-bearing turret just a little in front of the subject, completely covering the lens with the large card, and start the camera again when the artificial lighting illuminates the detail in question. This is how I like to photograph by the Seine and why I strongly encourage you to have a stable tripod.

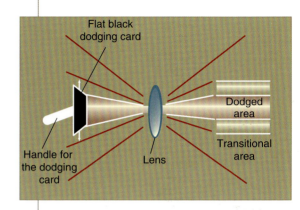

Diagram of dodging during exposure: this is based on the same principle as is used in the darkroom. In order to underexpose an area of the photograph, it is necessary to conceal it with a card while following the turret and while maintaining a slightly circular movement so as to avoid creating a noticeable area of transition. Depending on the distance separating the card from the lens, it is possible to underexpose any larger or smaller area of the photograph.

Moonrise from the Pont des Arts
Arnaud Frich

The photograph on page eight needed more than three hours of exposure! In order to make it, I had to use all the experience I had acquired in five years of using Noblex 135 and 150 cameras. This photograph was taken with a Noblex U camera, without a filter and without shifting the lens. The focus was set at 15 m, and the aperture was stopped down to f11. Fuji Provia 100 F film was used, since it has less of a problem with reciprocity failure (this is essential with this kind of camera, since one needs to avoid increasing the exposure time). The light-meter reading was taken with a Minolta spot meter (1°).

Exact location

The weather needs to be quite nice on the only day of the year where the full moon rises above the Pont Neuf, as seen from the Pont des Arts (on the right-hand side, so as to balance the composition). In other words, it took me more than a year to make this photo! First, I studied an astronomical table to find out what month the full moon was likely to rise in this direction. Then, all that remained was to determine the exact date on the calendar. Fortunately, this appeared to indicate the month of August, when weather is normally quite nice in Paris. And on the day in question, I could be found at a previously determined spot on the Pont des Arts, having arrived at sunset in order to calmly set up my equipment in advance. Indeed, the factor of time was a big part of this.

D-day

For the record, all went well—except that the streetlight in the foreground was too bright and fogged the film! (I had been worried about this.) Fogging is a major problem with this kind of camera, as explained earlier in this chapter. So the photo did not turn out, which necessitated a return—not the next day, but the next year, provided that the weather is good as well!

Fortunately, this was the case. And this time, I was prepared to reduce the streetlight's illumination, without hiding it completely, by blocking it with an opaque, white sheet of paper (as it would be overexposed, it would necessarily be invisible). To do this, I had to climb on the guardrail of the Pont des Arts, making a momentary spectacle of myself: "To fall, or not to fall." It also was necessary to reduce the intense illumination of the streetlight behind me, so as to avoid projecting an awkward shadow on the ground.

It was like that for more than three hours of exposure. The moment when the exposure begins is of the utmost importance in order to avoid having a sky that is either too dark or too light. And that evening, I wanted the moon to be a multiple exposure across a very deep blue sky. With a spot meter and a bit of experimentation, this moment is easy to find. However, it is necessary to remember that with each rotation, the effective exposure on the film will be two seconds and the subsequent rotation will start only two minutes later; thus, the illumination of the sky will have diminished. I began exposing before the moon started to rise. While waiting for it to rise above the horizon, I let the turret rotate several times at two seconds of exposure each to expose the urban landscape correctly. My base exposure time was 45 seconds, or around 22 rotations. By successive two-second exposures combined with dodging, I was able to balance the different areas of the photo by covering certain areas that, through metering, I decided had received enough light. I also benefited from the additional lights of barges, which brought out the banks and trees lining the Seine.

The string of moons

In this very beautiful urban setting, I chose to include a string of full moons. My reason for working in medium format was because here one uses a longer focal length lens than with an equivalent angle of view with 35 mm. In other words, although it is difficult to make out details on the moon with the 29 mm lens of the Noblex 135, it becomes much easier with the 50 mm lens of the Noblex 150. Thus, knowing that the moon would be large enough for my film, the rest of the difficulty lay in determining the proper exposure for the lunar details (i.e., the seas). My own experience as well as books on astronomical photography helped me here. One final problem was taking the increasing illumination of the moon as it rose above the Parisian haze and pollution into account. To do this, it was necessary to change the rotational speed of the turret – child's play with the Noblex. For aesthetic reasons, I decided to wait seven minutes between each exposure, so that the moon could move across the sky. And since the camera took two minutes to rotate, I needed to start a new rotation every five minutes afterward.

When the still-dim moon first appeared above the Pont Neuf, I opened the aperture slightly and exposed for as long as possible – never moving the camera – in order to record it on the film. However, it also was important not to expose too long, so as to avoid blurring caused by the earth's rotation. Thus, two seconds of exposure for the moon were added to the 18 previous rotations (18 × 2 seconds, or 36 seconds total). I envisioned a dozen moons, but only the first ones rising in the midst of pollution needed long exposures. When it reached a certain height, I had to reduce the exposure time to account for its natural brilliance. These last exposures were taken at 1/125 of a second at f11, which is pretty much negligible for the rest of the photo. Thus, I did not have to be too concerned about them. When the moon reached the position I wanted, I stopped taking the picture.

Changing Exposure Times

During exposure, the shutter speed can also be altered between rotations. And occasionally, one may need a very short exposure at night. This was notably the case when I made a sequential image of the moon rising above the Pont Neuf, from the Pont des Arts. When the moon appeared, it was orange and not very bright. There, the exposure time needed was two seconds. Bit by bit, as it mounted into the clear sky, it became brighter and brighter. Now, I absolutely wanted to photograph the water with the full moon. Thus, I needed to progressively reduce the exposure time in order to end at 1/125 of a second with the moon being found at the highest point in the sky. Because the exposure time was quite short in this case, I did not need to cover the rest of the photo.

I take advantage of the moments between two exposures, when the lens is turned toward the film, to change the shutter speed if that is needed.

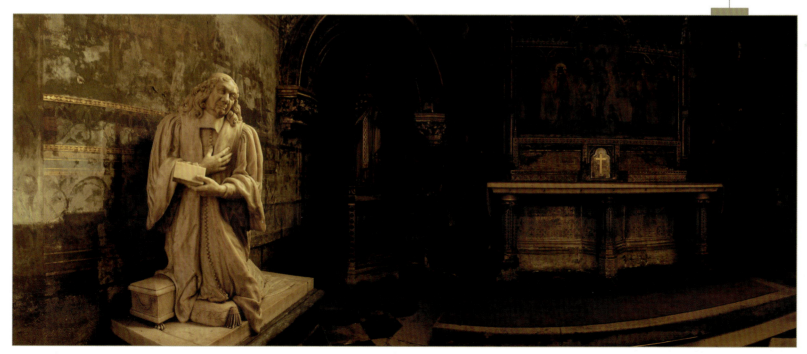

Photo by Arnaud Frich.

Joined Panoramas

The method of *joining* is starting to revolutionize panoramic photography. It is no longer necessary to have one or more specialty cameras to make high-quality panoramic photos. A conventional (non-panoramic) camera, a computer, and a joined software program are all that is needed.

Photo by Arnaud Frich.

One of the main sticking points for taking panoramas has long been the need to own a specialty camera. These types of camera, studied in the preceding chapters, generally allow for only one kind of photo to be made, even if it often is of high quality and very original. But thanks to data processing, it is now possible to obtain the same quality with a conventional camera by joining several photographs. With certain high-performing software packages, one really can imitate a panoramic photo made with cameras like the Hasselblad XPan, the Noblex, or even the Roundshot. On a technical level, sometimes it is even possible surpass certain specialty cameras, even top-of-the-line ones, thanks to shifting possibilities available when making the exposure.

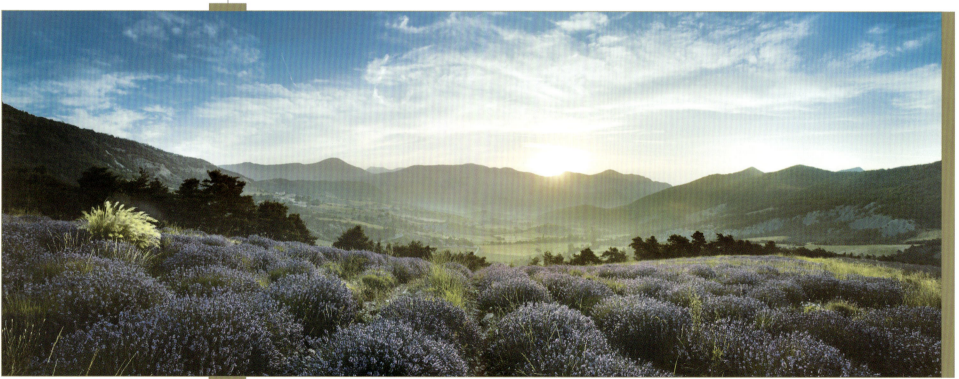

Photo by Bertrand Bodin.

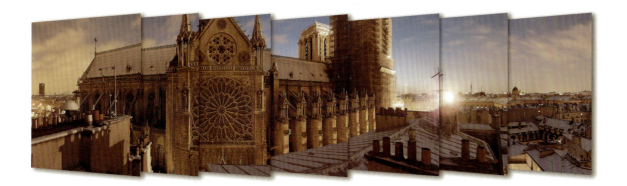

This series of images has been joined to form a veritable panoramic photograph where nothing allows you to say with certainty that it has been done this way.
Photo by Arnaud Frich.

If one uses a conventional camera – preferably digital – to make photographs that are intended to be joined, it is quite desirable to have that practical and special accessory, a panoramic viewfinder, in the camera bag. This will make the exposure of successive photos very easy and will allow one to photograph rather fleeting events as well. The preparations for taking pictures and the different steps in the joining method are presented in this chapter. The software and the joining itself will be discussed later, in the following chapter.

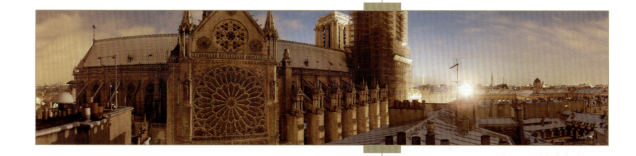

The Principle

Making joined panoramas simply involves taking numerous photos that slightly overlap, and joining them afterward with a specialty software program. The kind of image and the resultant quality very much depends on the joining software package chosen. Among the better of these, there are three kinds of assemblage and, therefore, three different visual *signatures*:

1. The mode Quick Time Virtual Reality (QTVR) presents a normal (noncurved) visual signature. The photo opens up in a window with a nonpanoramic 4:3 ratio. Using the mouse, this image becomes interactive, and one can enter it and turn 360°.

2. The flat mode, also called rectilinear or orthoscopic, allows one to join images having the same signature as a photo taken with an XPan, a Linhof 617, and so forth. The maximum angle of view is therefore around 110°. Today, few software programs allow for this type of assemblage.

3. The more common tiled mode allows you to join images having the same visual signature as a photo made with a swing lens (Noblex, Widelux, etc.) or with a rotational camera (Roundshot, Eyescan, Spheron, etc.).

If you use a digital camera with a large capacity sensor, you can join a printable panoramic image that is identical to one made from a specialty camera and conventional film. Therefore, this method is limited only by the imagination of the photographer who uses it.

Steps in the Joining Method

What follows is a résumé of various important steps in making a joined panoramic photograph.

1. Take care in choosing the point of view, the angle of view of both the camera and lens, and the focal length and placement of the critical focus desired. Preview the depth of field wanted. Placement of the critical focus most often will be set at the hyperfocal distance.

2. Once the tripod has been set up, level it along the axis of rotation, or else the photo will appear tilted.

3. Place the camera at the entrance pupil in order to verify that the lens does not tilt, unless the assemblage is done with Autopane Pro, ImageAssembler from Panavue, PT Gui, or with Stitcher. With these three software programs, tilting the camera while taking the picture is possible.

The entry pupil, often called the *nodal point*, is the ideal point of rotation for the camera during exposure.

4. Meter the light in terms of both quantity and quality: first, determine the overall exposure that all the photos will need to receive. Then, verify the difference in contrast from left to right or from interior to exterior. If possible, preview a slight correction of exposure between the images and, in certain cases, two sets of exposures for the interior and exterior. This must be done in the manual exposure mode since only this guarantees exposure regularity from one picture to the next. It is absolutely necessary to avoid having two consecutive photos with different levels of luminosity. It is equally important to choose a color temperature and avoid leaving the camera with the automatic white-balance mode turned on, as we will see a little later.

5. When taking the picture, make sure that the images superimpose by at least 20 percent and correct exposure if necessary (always in manual mode).

6. Retouch the photos after scanning them if traditional prints are used: verify that the light level, colors, and such are balanced between each shot and make any adjustments as needed. Some aesthetic retouching can also be done at this stage or at the end of the process. Finally, and this is perhaps the most important thing, correct the optical distortions that often occur with wide-angle zoom lenses and short focal lengths.

7. Join the images with a dedicated software program like Autopane Pro, ImageAssembler from Panavue, PT Gui, or with Stitcher.

8. Last-minute retouching: address these last corrections of lighting, dabbing, and so on, and determine the resolution with regard to the final result wanted (Web or print-out).

Digital or traditional, large or small format, any conventional camera will work.

Photo Equipment

In the list of necessary equipment for a joined panoramic photo, one will obviously find a nonpanoramic, conventional camera. A digital camera would be preferable, but any traditional camera will do. The larger it is, the larger the sensor or film will be, and, thus, the better the end-result will be in terms of quality. In the preceding paragraph, I mentioned that it was important to place the camera at an ideal point of rotation called the entrance pupil of the lens. Manfrotto has made and commercialized a perfectly adapted accessory for this, the QTVR 303 head. But some photographers may prefer to make a custom-built panoramic tripod head instead.

Camera

The easiest way to avoid having to develop film in addition to scanning is to own a digital camera. The larger the negative or file, the better the final result, if one wants to make large prints. Some American photographers already understand

this and therefore use 4 × 5 view-cameras in making panoramas. The manipulation of numerous film-planes makes taking the picture rather tedious, but the detail and tonality of the resulting panoramic photograph will be particularly beautiful. One thing is sure, the limiting factor is not the quality of the joining software, since these are quite adaptable and efficient.

It is strongly recommended that the camera have the following:

- A manual exposure mode or compensating system of exposure
- An effective shade for the lens (this is nearly indispensable)
- A sufficiently large memory (digital camera)
- A white-balance that can be overridden (digital camera)

Apart from these, it would also be helpful to have the following:

- A swiveling screen (digital camera)
- Resolution equal to or greater than 2 Mb of pixels (digital camera)
- A wide-angle setting of at least 35 mm without needing additional components
- A spot meter
- An attachment that allows the viewfinder to be set at the axis of the lens
- A hot-shoe (to hold the level)

The choice of the lens and focal length is the photographer's, with regard to the equipment being used. But one thing is sure, one should not hesitate from choosing or trying long focal lengths, very short wide-angle lenses, and so on. That's the interesting thing in this method: extending the playing field. However, from now on shifting (PC) lenses are off-limits, except if the joining is done with PhotoShop or Panorama Tools (see Chapter Two).

Tripod and Level

The picture-taking method just described makes a tripod necessary, which makes the framing more deliberate and precise. However, if you tend to take candid pictures, don't let the opportunity pass; shoot without a tripod.

With certain zoom lenses, the camera becomes displaced with regard to the rotational axis when the lens is set at the entrance pupil. Therefore, it is preferable to have a stable tripod in order to prevent vibration of the panoramic tripod head. As with other panoramic cameras, it will be advantageous to pick a tripod that can be set up both close to the ground and quite high, so as to vary the view a bit.

Although one can avoid placing the camera at the entrance pupil to gain a little time, it remains indispensable that the camera remain horizontal during rotation. A level is required therefore; otherwise, the joined images would give the impression of tilting to the left or right. Under these circumstances, it becomes necessary to reframe it, so that the area used will gradually shrink away in height. A simple level can do this, but a level like the one found on the base of a Manfrotto 303 head or on many other tripods is ideal. Certain levels with two perpendicular bubble housings can also be attached to the camera's hot shoe.

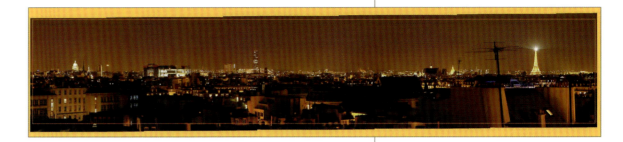

The usable image band is significantly reduced after cropping the joined image.
Photo by Arnaud Frich.

Panoramic Tripod Head

For anyone who wants to make a high-quality joined panoramic photograph, I strongly recommend placing the camera at the entrance pupil of the lens during the entire rotation; the joining software can still repair many problems and make perfect connections. When using the software programs, the largest difficulty concerns a foreground subject interrupting the flow of the horizon. I can state from experience that the problem is greatly reduced when the foreground starts at a significant distance from the camera.

The most important technical question in joined panoramic photography involves the following. The entrance pupil (to be studied in detail later) always remains the same for a given camera and lens focal length, so finding it each time is not necessary. Once it has carefully been determined, the camera is placed on the panoramic tripod head at the predetermined spot for the focal length in question, which was noted previously.

To place a camera at this ideal point of rotation, and in the vertical position (which gains the maximum in height), numerous equipment possibilities exist such as the Panosaurus head set; the most practical is undeniably the Manfrotto 303/303+/303SPH head.

> **TIP**
>
> *Because of the notches on the ball-and-socket joint of the Manfrotto QTVR head, it is easy to return the camera to the same position or one or two pixels to one side. This turns out to be very useful when doubling the number of exposures in two typical scenarios: in order to reduce sensor interference, or, a more frequent scenario, to make a second series of images when photographing an interior opening onto an exterior. First, a series that is correctly exposed for the interior is made, followed by a second series for the exterior, while making sure to rotate the ball-and-socket joint so that it stops just one or two pixels short of the next image (this noticeably helps to reduce digital image noise). All that remains is to attach the images using retouching software like PhotoShop, and then join them in an adequate software program.*

Manfrotto 303, 303+, and SPH Heads

These well-designed panoramic tripod heads are made of different parts that serve our needs perfectly. And since autumn 2003, Manfrotto has sold a new panoramic tripod head, the 303 SPH. The latter is quite suited for making 360 × 360° photos for QTVR, but it is equally good for tilting the camera to take the picture (while always being set at the entrance pupil).

1. The stand (reference no. 338), having precise controls, allows one to put the final touches on leveling the tripod. Just remember, the head needs to rotate on the vertical axis, as we observed when discussing the level.

2. The panoramic ball-and-socket head (reference no. 300N) allows one to select the angle of rotation between each picture (10° to 90°) using a graduated and notched scale. Obviously, the angle depends on the focal length of the lens. This is more convenient than it may seem, since among the other graduated stands and ball-and-socket heads that I occasionally use, like those made by Novoflex or Gitzo, this is the only one that is notched.

To join two images correctly, the software programs require an overlap of around 20 percent. Therefore, all that is needed is to set the stop at the proper notch, which depends on the focal length and horizontal angle of view of the lens. Every time that one turns the panoramic tripod head, it will automatically stop at the next notch.

The panoramic ball-and-socket head is very helpful in normal use and even indispensable at times. On several occasions, I have needed to take 360° photos from places like snow-lined Parisian rooftops or the peaks of mountains, and I could not have turned the camera otherwise because it was set at the edge of a precipice. Not being able to watch things from the viewfinder, I thus was enabled to control the angle of rotation during exposure.

Also, thanks to the notch on the ball-and-socket head, one can close the eyepiece of the viewfinder to ensure that there will not be any light-leaks; this is a real problem with cameras that have a fixed, semi-reflective mirror. (This has caused me to lose several photos due to a significant halo.)

Other strong points with panoramic tripod heads are that they have two or three perpendicular ruler settings (two for the 303 and 303+ models, and three for the 303 SPH); these aid in setting the entrance pupil of the lens exactly above the rotational axis, no matter what camera, lens, and potential degree of tilt is being used. Panoramic tripod heads are more cumbersome than a custom-designed system, but very adaptable when switching to wide-angle or telephoto lenses. One final

remark: a square helps to position the camera vertically, in order to obtain the maximum angle of view when using the 303 and 303+ models.

Custom-Built Mounts

As a less cumbersome and cheaper alternative to the QTVR Manfrotto panoramic tripod head, I had the simple idea to put two ball-and-socket joints together. This

remains less functional, because it is more tiresome to level, and it is difficult to get it to work, but it occupies much less space in the camera bag and is lighter – the only added weight is that of the second ball-and-socket joint. Additionally, this alternative can accommodate a wide range of cameras, digital or otherwise.

Mounting a camera at the entrance pupil with two superimposed ball-and-socket joints. Although less practical than a real panoramic tripod head, this system is far less bulky.

One can also build a mount on the base of a metal square found in a hardware store, or on a sliding Manfrotto stand where the entrance pupil of the lens is located exactly above the rotational axis of the ball-and-socket joint. This produces a specially designed head that is not very cumbersome. The downside is that it is necessary to make a new head for each camera. Nevertheless, this solution remains clever and economic.

Panoramic tripod head. Manfrotto 302

Panoramic tripod head. 303 SPH

Hand-Held Light Meters

If one normally rests satisfied with the camera's built-in light meter for overall light-meter readings, it nevertheless becomes necessary at times to measure contrast differences with further precision – notably interiors, sunny weather, and harsh lighting. To do this, a photographer will need to use either the spot meter in the camera, if it has one, or a hand-held spot meter, which offers more precision. A photographer who normally uses a hand-held light meter to take incident readings will also want to use a spot meter in these situations. After a reading is taken, the camera is adjusted, set in manual mode, relative to the shutter speed and aperture settings indicated by the light meter.

Although it is strongly recommended to make exposures in manual mode so that all the photos receive the same amount of light, certain software programs can balance minor light-level differences between consecutive pictures without too

much problem – a little bit like the Noblex and its Panolux light meter. If the sun is to the right, especially when the field of view taken in exceeds 150°, subjects to the left will be found in the highlights, whereas those to the right will be in shadow. But through the use of slight exposure corrections while taking the picture, it is possible compensate for this by underexposing the areas in full sunlight and overexposing shadow areas. The only limit here is that one has to strictly avoid not adjusting the exposure by more than a third of a stop between consecutive images. In this way, one gains at least two stops for the entire joined panorama.

The Minolta VI flash meter has two measuring systems: an incident meter and a spot meter. Perhaps this is the absolute weapon for the panoramic photographer?

Photo by Arnaud Frich.

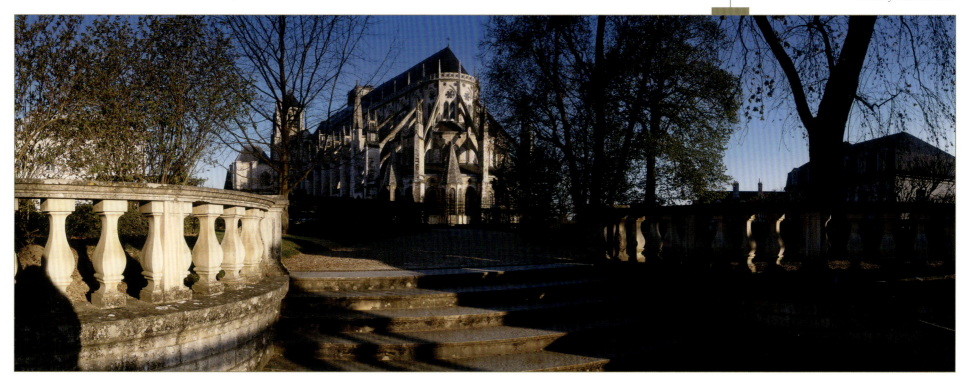

When the tripod is completely extended, a cable release is needed to avoid touching the camera.

Accessories

This equipment category is "accessory" in name only! Depending on the joining method chosen – and, thus, the kind of photograph made – the following accessories will prove to be indispensable and can help produce an image of a very high technical quality. However, since these accessories do not specifically pertain to panoramic photography, their use is more limited than in nonpanoramic photo, mainly because of the wide field being photographed.

Cable Release

If the entrance pupil of the camera is placed above the rotational axis of the ball-and-socket joint, it's because to the burden of carrying a heavy and cumbersome tripod is worth it in order to obtain the best possible quality of assemblage. With such a qualitative approach, it will be quite common to use a cable release to avoid shaking or vibrating the camera. In certain situations, it is nearly indispensable (e.g., when the tripod is fully extended or during the long exposure times needed with nocturnal pictures). It takes the form of a flexible cable, or with the more modern cameras, a cordless infrared remote control.

Filters

There is no law against using filters when taking pictures that will eventually be joined – quite the contrary! As in conventional photography, as distinguished from panoramas, filters serve to reinforce the message or vision of the photographer. Whether he or she photographs with black-and-white or color film, or with a digital camera, the photographer selects from filters (made by different manufacturers) that can color correct (color film), increase color saturation, or improve contrast (notably with black-and-white). But before referring you to the imposing literature on the subject (see the bibliography booking Appendix A), I first want to offer some advice concerning certain filters that often are used in joined panoramic photography:

1. A graded, neutral density filter will certainly be very useful for landscape panoramic photographers. In many cases, this gradient and stopping down will be enough to avoid overexposing the sensor in the highlights (i.e., the sky). But if one seeks to obtain a less realistic, artistic effect, a denser filter will be needed.

2. A polarizing filter, very practical in normal photography, should be used with caution. It represents a special case because the field of view being photographed is often wider than 100°. Normally, this filter is used to control polarized sunbeams in order to eliminate reflections from shiny surfaces, as

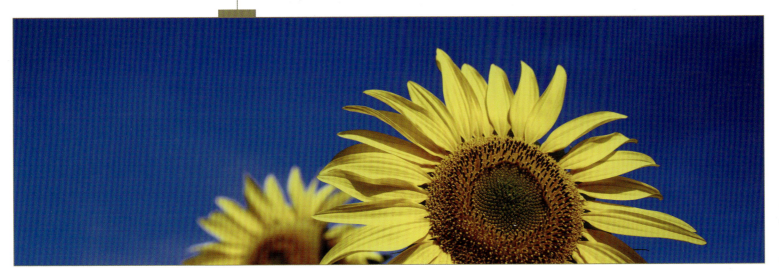

The photographer has chosen to use a polarizing filter to reinforce the contrast between the sunflower and the deep blue of the sky.

Photo by Benoît Ancelot

well as to render the blue daylight skies found in fine weather somewhat darker. Skies photographed in this way are characteristically of a saturated, dark blue, but only in the part of the sky forming a 90° angle with the sun. The filter effect is completely ineffective when aimed in the same direction as the sun and at 180°. Therefore, it will be useful in one part of the sky and ineffective elsewhere. The resultant fall-off in light will hardly be pleasing.

Flash

When aimed toward the ceiling in interior photography, a flash does not create obvious shadows that could damage the quality of the final joining, so its use can be permitted in such cases. Outside, in daylight, one also can use it to bring out a shadow. But here one needs an explanation of how to guarantee that a brought-out shadow will match the neighboring photograph. The main concern of the photographer who joins his or her photos is to have successive images where the overlapping areas are identical and match perfectly.

When making successive exposures, a good way to bring out a shadow is to avoid putting the flash on the hot-shoe and hand-hold it with a cord, aiming it in the same direction from one exposure to the next. And today, more and more remote control systems function without cords and have multiple flash features, which is very convenient. When outdoors, one also will have to contend with one of the most typical problems encountered with using a flash: its maximum reach.

Photo by Peet Simard.

Prior to Taking the Picture

While setting up, one determines the angle of view, light-level, color temperature, type of assemblage that one wants to obtain, and how many images need to be taken. Remember that depending on the software program used, one will (or will not) be able to make small exposure corrections between shots and choose a rectilinear (straight) or tiled (curved) assemblage. Also, with certain software programs like the Panavue ImageAssembler or the Realviz Stitcher, a photographer is even free to tilt the camera while taking the picture, in order to place the horizon line in a desired area, further augmenting the power of the photograph.

Framing Decisions

The higher performing software packages allow assemblages that simulate exposures taken with rectilinear, flatback cameras like the Fuji 617 and the Hasselblad XPan II, as well as exposures taken with rotational cameras like the Noblex and the Roundshot. Because of the number of photographs being taken, choosing the right kind of assemblage becomes important. In the former case, three to four photographs will make an assemblage not exceeding a 110 to 115° angle of view; in the latter case, there should be just enough photographs to cover a complete rotation.

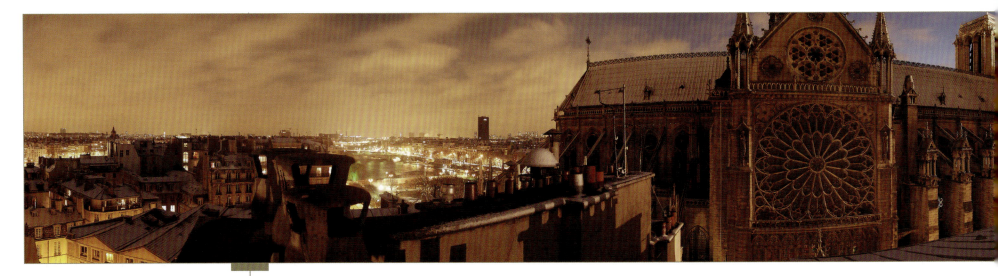

This 360° view of Paris, one of the rare ones I have made, required 22 photos! Because of the lighting conditions, it was necessary to work quickly.

Photo by Arnaud Frich.

The main strength of the higher performing software packages is that they are able to straighten vertical lines and prevent them from converging to a vanishing point if the camera has been tilted while taking the picture. Although the majority of software packages (notably, those sold with small, pocket digital cameras) demand that the horizon line be placed exactly in the middle of the joined photo, others are capable of simulating pictures taken with a shifting lens. This important compositional point in panoramic photography was discussed in Chapter Two.

Angle of View

In joined panoramic photography, the photographer determines the angle of view, by deciding to join a greater or lesser number of images. In this way, if desired, one could make a complete turn of 360°. With certain software packages it is possible to choose from two joining procedures up to 115°. Beyond this, the assemblage will inevitably be of a tiled pattern, since all the horizontal lines, with the exception of the horizon, will be curved.

Having a great deal of experience with rotational cameras, I tend to use the joining method in the same way as my Noblex – that is to say, with a 150° angle of view. Experience has taught me that when I am moved by the scene in front of me, it is rare to be as moved by that scene when it is considered as a 360° image. (However, there always are exceptions; one only has to look at the 360° photographs of France by Franck Charel, made with a Roundshot, to be proven

wrong here. But he also would be the first to admit that his photographs require a lot of touching-up.) In Paris, for example, I rarely have wanted to make joined photographs; as I mentioned before, an angle measuring around 150° is what works best for me. And, as if by coincidence, this angle approximates the field of human vision.

A common use of joined panoramic photos involves making an image that will be viewed in an interactive window on the Internet. This is a quite justifiable need to preview a complete rotation; however, the Web-surfer will still be visually confronted with a normal, 4:3 image on the screen.

Focal Length

If I have a bone to pick with swing-lens cameras (e.g., Noblex, Widelux), it is because they do not allow you to choose the focal length of the lens. On the other hand, numerous rotational cameras (e.g., Roundshot, Spheron, Eyescan) and flatback cameras (e.g., Linhof, XPan, Cambo Wide) allow a choice between quite a few lenses, sometimes shifting ones as well. One of the big advantages of joined panoramic photography is that one has even more control over the focal length being used. And because the photographer can start and stop the panorama where desired, from left to right, all that remains is to decide upon the vertical angle of view in changing the focal length. If one often orients the camera vertically, with the shortest possible lens focal length, in order to gain height when

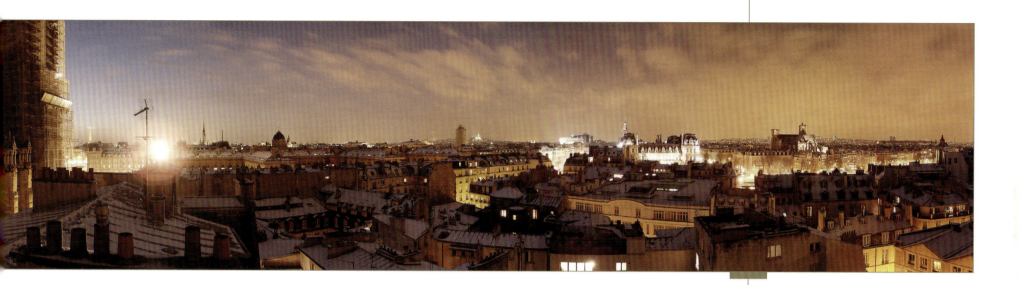

photographing entire monuments, numerous situations also exist where a longer focal length would be preferred. Using wide-angle lenses, the image quickly is dominated by large areas of sky and earth, which are often without interest. It is not always necessary to chase after the shortest focal lengths! For example, good 35 mm lens is often well-adapted for landscapes, even in the city.

Tilting the Camera

Generally, most photographers do not think to tilt the camera when making a joined photograph since it is highly advisable to keep the ball-and-socket joint level while turning it, and the lens squared in relation to the horizon. But certain software programs – unfortunately far too few of them – are capable of correcting converging lines caused by the tilting of the camera; the goal is to simulate the shifting of a lens. With the others, the horizon line will have to remain right in the middle of the joined image. If one wants to place it elsewhere for aesthetic reasons, it will be necessary to crop the image. As a result, the image will be noticeably shorter in appearance.

Software packages that accept photos only where the horizon line is perfectly centered make it impossible to use a shifting lens. Far from being joined correctly, in the latter case, the horizon line would be transformed into a succession of curved waves at each overlapping area, since it would no longer be located in the middle of the final image.

With Autopane Pro, ImageAssembler from Panavue, Stitcher 5.0 from Realviz or PT Gui, one easily obtains a flat horizon line without shifting lenses, almost anywhere

It is very easy to tilt the camera around the entrance pupil with the new Manfrotto 303 SPH head.

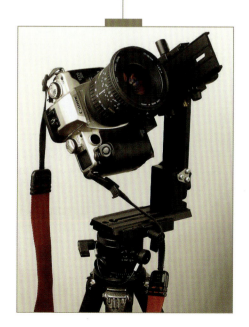

in the photo (on the condition that the horizon line remains visible in the viewfinder when taking the picture), and very straight, nonconverging vertical lines (notably, with architectural photography). This is absolutely amazing! With these software packages, the control is nearly total. For someone like me who likes to shift, this has been a wonderful discovery. In this way, the Autopane Pro instead of the Realvis Stitcher 5.0 not only allows one to avoid buying a shifting lens, but above all, to place the horizon line where desired, no matter what focal length is being used.

Leveling

If one is lucky enough to have a tripod with a level, or better still, a Manfrotto 303 head with 300 stand, leveling is very easy. In the case of a custom-built

assembly, it is necessary to make sure that the rotational axis is leveled. Here, one can use a simple level, placing it on the flat part of the horizontal axis of rotation. Then, it is necessary to verify that the camera lens is equally squared up – at least when the joined image is not going to be made with one of the rare software packages that allow for perspective correction.

Depth of Field

Due to the overlapping of the joined areas, all images need to be taken with the lens set to the same critical focus. For example, one should not focus on a foreground subject in one picture and at infinity in another. If the photographer wishes to have a maximum depth of field, he or she needs to place the critical focus at the hyperfocal distance, as is done when using a rotational camera. To control how much will be in focus, depth of field is adjusted by stopping down on the lens more or less and by focusing on the hyperfocal distance.

In addition, the size of the sensor or format affects the depth of field, as we saw in Chapter One. The panoramic photographer who seeks the largest possible depth of field therefore will want to choose a small-sized sensor or small-format camera rather than medium or large format. We also saw in Chapter One that the larger the sensor or film format is, the more it becomes necessary to use a long focal length lens to achieve an equivalent angle of view. But the longer the lens focal length is, the more one has to stop down on the lens to reach an equivalent depth of field. For example, in panoramic photography, it's quite common to stop past $f8$ with a 35 mm or digital camera, and down to $f45$ with 4×5. And once again, with digital sensors, it is difficult to obtain enough shallow depth of field when wanting to emphasize a certain plane.

How Many Images?

The number of joined images depends on the choice of focal length, orientation of the camera (horizontal or vertical), amount of overlap, and angle of view. Again, the overlapping between images will need to be around 20 percent; in other words, each image will have a usable area of about 60 percent $(100 - 2 \times 20)$. For obvious reasons, it should never go below 50 percent, but the exact amount ultimately is not all that important. Personally, when I contemplate the joined image prior to taking

the picture, I make sure that the important areas are placed in the middle of each component photograph rather than at the seams. If need be, I am happy to take one or two additional photos, especially if I anticipate a more important overlap elsewhere, between two other images. And it is not necessary that the amount of overlapping be the same. In any case, if the final image turns out to be more spread out than previously imagined, recropping it later will be very easy.

Here is a simple formula to have an idea of the number of photos to take, relative to the desired final image:

$$N = F/(60/100 \times HFV)$$
N = number of images to make
F = field of view of the panorama
HFV = horizontal field of view of the lens

The horizontal field of view is the angle of the scene embraced by the lens as measured from left to right, whether the camera is in a vertical position (i.e., for portraits) or a horizontal position (i.e., for landscapes). But be careful, since catalogues nearly always refer to the angle of view as measured along the format diagonal. A simple rule of three allows you to easily find the angle needed:

$$HFV = AV \times WF/DF.$$
HFV = horizontal field of view of the lens

AV = angle of view cited by the manufacturer, for a lens of a given focal length

WF = width of the film or sensor format
DF = diagonal of the film or sensor format

For example, in the case of a 35 mm lens for 35 mm (24 mm × 36 mm) with a diagonal measuring 43.27 mm and a corresponding diagonal angle of view measuring 62°, calculating for the horizontal field of view taken in results in the following:

$$HFV = 62 \times 24/43.27 \text{ (portrait position)}$$

or again:

$$HFV = 62 \times 36/43.27 \text{ (landscape position)}$$

Therefore,

$$HFV = 34° \text{ (portrait position)}$$

and

$$HFV = 52° \text{ (landscape position)}$$

Returning to the first formula, and still in the case of a 35 mm lens for the 35 mm film format, to make a 160° panorama with the camera in the portrait position, calculate as follows:

$$N = 160/(60/100 \times 34)$$

which would be

$$N = 7.8$$

or roughly eight images.

Photo by Bertrand Bodin.

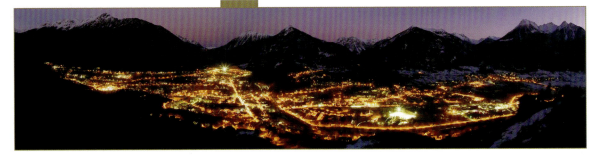

Cutaway view of a digital camera: the position of the light rays' point of convergence (i.e., the entrance pupil) changes as focal length of a zoom lens changes. Warning: with certain recent zoom lenses, the point of convergence is found at the same position for two different focal lengths (e.g., the 24 mm[-]70mm/f 2.8 Canon L).

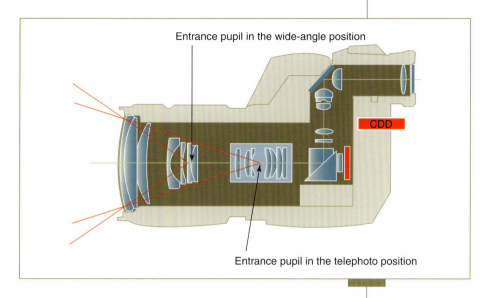

Entrance pupil in the wide-angle position

CDD

Entrance pupil in the telephoto position

Entrance Pupil

To correctly juxtapose two consecutive images in a joined panoramic photograph, they must be taken from the same point of view, or in other words, a vantage point where the perspective does not change. In this way, the foregrounds and backgrounds will superimpose in the exactly same manner between two consecutive photos, no matter what the direction of the camera. This point commonly is called the *nodal point*. Although a rotational camera can be said to turn upon the nodal point source of the lens, it turns upon another point when using the joining procedure: the entrance pupil of the lens. This is the most important technical point to remember in joined panoramic photography.

Thus, an ideal point of rotation exists in the lens, depending on its focal length – or focal lengths for a zoom lens – and the camera must turn around this point in order to achieve perfect image overlaps. But rest assured, complex calculations will not be needed to find it. In fact, it's very simple, since the operation can be performed on the LCD screens of pocket digital cameras, or better still, in a reflex camera's viewfinder.

Definition

The entrance pupil of the lens is found on the plane of the aperture-diaphragm, as viewed from the front of the lens. With a zoom lens, one can see this plane recede or advance in the lens barrel, in changing the lens focal length. Thus, in this case, the entrance pupil is not always found on the same plane, since there

can be any number of them in a zoom lens. Determining three or four of these points here will be enough.

For a given focal length, the rotational axis of the ball-and-socket joint needs to line up with the entrance pupil. Using a modified, perpendicular carriage system, discussed in the section dealing with panoramic tripod heads, it becomes necessary to shift the camera with the ball-and-socket joint until the entrance pupil is placed above the rotational axis. We will now address this in more detail.

When the lens's entrance pupil (EP) and the ball-and-socket joint's rotational axis (RA) are superimposed, the perspective does not change.

When the lens's entrance pupil (EP) and the ball-and-socket joint's rotational axis (RA) are not superimposed, the perspective changes. The entrance pupil shifts to the right in this example, changing the perspective since the point of view is not exactly the same. It's as if one had moved slightly to the right.

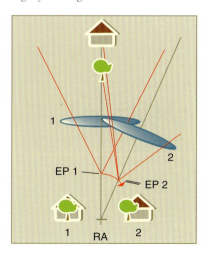

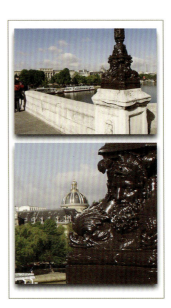

This series of photos was taken while placing the lens's entrance pupil just above the ball-and-socket joint's rotational axis. The streetlight in the foreground remains in same position relative to the dome in both exposures.

This series of photos was taken while placing the lens's entrance pupil outside of the ball-and-socket joint's rotational axis. The dome in the background shifts, since the perspective has changed.

The two series of images are to be joined with the joining software. Note that the horizon line is located in the exact middle of each photo. Therefore, this assemblage is representative of limitations encountered with all the software packages on the market.

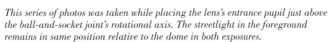

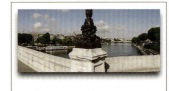

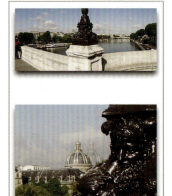

The joining is perfect and does not show any visible connections.

Here is the typical kind of flaw noticed in a joined panoramic photo where the camera did not rotate around the entrance pupil. The software has chosen to combine the foreground perfectly but displays two superimposed images in the background.

The outcome is unavoidable: the software blends the foreground and background of the two adjoining photos together. Here, I have decided to enlarge the lamppost in order to illustrate the example. And the result speaks for itself. In any case, a certain amount of retouching will need to be anticipated since photos containing foreground elements will not line up perfectly. It is obvious that had there not been a foreground element, the assemblage would not have been as difficult.

Finding the Entrance Pupil

Determining the position of the entrance pupil is easier than it appears. There are two ways to achieve this, the second being used as a verification of the result given by the first. Since it is necessary find a vantage point from which the perspective will no longer change, looking through a stationary reflex viewfinder or LCD screen will be enough. This viewfinder method is the first and simplest method. Once the entrance pupil has been situated above the rotational axis, foreground and background elements are checked against each other by turning the panoramic tripod head. Adjust slightly, until the perspective no longer changes. Thus, one finds where the entrance pupil is located for the lens or focal length in question. All that remains is to do the same check at other areas where pictures are to be taken.

The paper diagram method, which requires a piece of paper, serves to fine-tune the first method and further verify the position of the entrance pupil.

Viewfinder Method

Regardless of whether it would be with the useful Manfrotto panoramic tripod head or a homemade arrangement, the steps involved in locating the entrance pupil of a given lens focal length have been given earlier. The photos on the opposite page illustrate what is seen in the viewfinder or on the screen when determining the following:

1. Level the tripod at the chosen point of view. The rotational axis should be absolutely horizontal, whether it is a Manfrotto head or a homemade arrangement.

2. Attach the camera to the Manfrotto QTVR head or a homemade arrangement and verify that it remains level when turning 180° to 360°.

3. Shift the camera from side to side so that the optical center, seen from the front, is lined up above the rotational axis.

4. Select the focal length if using a zoom lens.

5. Find a significant foreground object or vertical line six or more feet away, and verify that intelligible far-off objects are also present.

6. Place the foreground object or vertical line on the right-hand side of the viewfinder or screen and take a close look at its position in relation to the objects in the background.

7. Turn the camera to the right in order to place the same foreground object or vertical line to the left of the viewfinder or screen.

8. Determine whether there has been any movement of background objects in relation to the foreground.

9. If movement is detected, shift the camera from right to left, or from back to front, on the ball-and-socket joint until the foreground and the background no longer change position in relation to each other. (Make sure that the alignment is like that of the photo in Figure 5.29.)

Step 1.

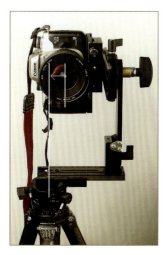 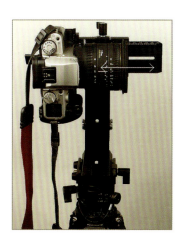

Step 3. *Step 9.*

As long as a shift between the foreground and background can be observed, the entrance pupil is not placed at the rotational axis. Therefore, it is necessary to advance or withdraw the camera support (shown in Figure 5.29) until this difference is eliminated.

Paper Diagram Method

To have a precise idea of the entrance pupil's location for a given focal length, or to confirm the result of the viewfinder method, two sheets of paper, a ruler, and a magic marker are all that is required. To begin, stop down on the lens and view it from the front: inside, you can easily see the plane where the aperture, or the entrance pupil, is located. If it is a zoom lens, you can also see how it moves back and forth in changing the focal length.

1. Place a piece of paper just in front of the lens of a given focal length. Make sure that the paper, while lying flat, is supported and raised to the diameter of the lens (see Figure 5.31).

2. Close one eye and line up the other with the edge of the paper while looking toward the aperture.

3. Move the eye along the right side, staying at the level of the paper, until you no longer see the aperture.

4. With a marking pen, mark out two points on the paper: one right next to the lens, where the remaining aperture blades can be seen, and the other on the edge of the paper where the eye is located (see Figure 5.32).

5. Do this again, on the left side of the paper.

6. Connect the points to form two lines leading from each side, then extend these lines onto another piece of paper. The entrance pupil for the focal length in question is found at the intersection. Measure the distance between the edge of the overlaid first sheet and the intersection of the two lines on the second and note where this distance is located on the lens barrel (see Figure 5.33).

Importance of the Entrance Pupil

I am often asked if it is absolutely necessary to place the entrance pupil above the rotational axis. The reply is clearly no, it's not obligatory. For me, the most important thing is to make photographs, be they technically good or not, and not to obsess about one particular technical point. However, I do not see how one can make a sequence of beautiful photographs without being concerned about the manner of taking pictures.

The further away the subjects are, as in a beautiful but distant horizon, the less of an issue the entrance pupil will be. However, placement of the rotational axis at the entrance pupil is critical in overlapping image areas where there is both a subject in the foreground and another much further away. There, a small difference in perspective will be quickly noticed.

To make a hand-held distant landscape panorama, I recommend turning around the camera rather than remaining in the same place and turning the camera around yourself. The joining software will also be less difficult to use this way.

Entrance pupil viewed from the front.

Step 1.

Step 4.

Step 6.

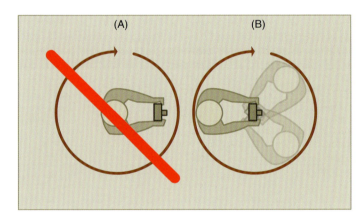

When making a hand-held photograph, turning around the camera is necessary, rather than the opposite. Seen from above, the camera seems to turn around a single point on the ground. © Realvis

This measurement needs to match the result obtained by the viewfinder method. By rechecking the information, both measured and observed, it is possible to exactly determine where the entrance pupil is located for a given focal length. (Thanks to Emmanuel Bigler and Yves Colombe for this information. I obtained it from the following Web site: www.galerie-photo.com.)

As mentioned earlier, this important axis of rotation will be located at different places on the camera, depending on the focal length and the angle of view.

If you want hand-held images that are joined very smoothly, you will practically always have to make panoramas of far-off subjects, without any foreground. Although highly efficient, the joining software is not capable of miracles!

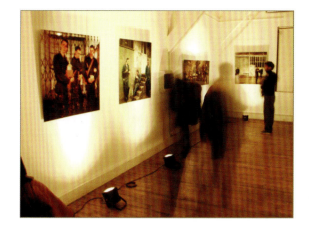 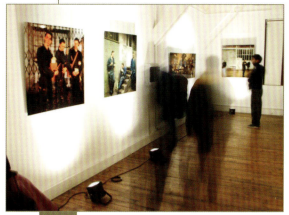

The photo on the left has been taken under artificial lighting with a white-balance reading of 6500 K (similar to daylight film). Colors are very warm and saturated. By adjusting the balance to 3500 K, the colors appear more natural.

Photos by Arnaud Frich

Light Metering

Light metering is perhaps the most difficult task in the joining method. To repeat, this is all about taking a series of photographs in which the color and luminosity differences need to be as small as possible in order to aid the assemblage. In terms of light quality, one color temperature must be selected for all the images, overriding the automatic white-balance. Then, in terms of light quantity, the metering of the light-level will depend largely on the type of assemblage chosen. And the larger the angle of view, the more difficult this will be to determine. The range in contrast between different parts of an image can be very significant when the angle is very wide, especially in nice weather since the shadow and highlight areas will not receive the same amount of light. Sometimes the entire difficulty lies in balancing these differences.

Color Temperature

There are only two categories of color transparency film, daylight and tungsten. These cover all types of lighting scenarios, apart from color negative film, which is treated as a slightly different case. Thus, the photographer does not have much of a selection, but this is not a problem that pertains specifically to panoramic photography. (As it exceeds the bounds of this book, I will not enter into further detail concerning these choices; rather, I refer you to the bibliography in Appendix A.)

On the other hand, with digital photography it is possible to accurately select the color temperature, but in no case should the white-balance be left in automatic mode since this would result in overly large color shift between component

images. It is important that an object or an important colored area be placed in one photo, rather than allow it to overlap into the following, so that the sensor can apply a color correction to an isolated image. In this way, one photo in the series could have a dominant warm or cold tonality, whereas the others would be neutral. And once the color temperature has been chosen, it will be necessary to leave metering in the manual mode for the other images as well.

I do not really care for the idea that with digital photographs one can erase the color temperature characteristics of certain illuminated areas. Therefore, I have a tendency to use my digital camera like a traditional camera by setting the color temperature to 6500K, except when the weather is really cloudy. In the latter case, I raise the level to 7500K to avoid completely removing the dominant bluish cast of the image. In the evening, after sunset, I often work at 4500K, which allows for a nice balance between twilight and artificial light. In this way, I achieve a balance between natural and artificial light that resembles color transparencies made with daylight-balanced film (Fuji Provia 100F).

It's really a new thing in color photography to be able to select the color temperature without needing a color temperature meter or a large collection of Wratten color correction filters.

Disengage the automatic white-balance and select a color temperature depending on weather conditions or your own personal taste.

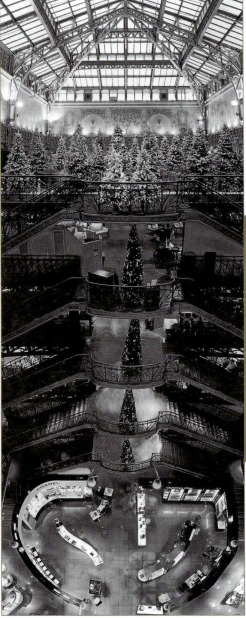

Photo by Arnaud Frich.

Determining Exposure

Two possibilities are available for determining the exposure of a series of images used in an assemblage: hand-held light meters and those that come with the camera, of which certain kinds (e.g., dot matrix measure, ESP, multizone) work quite well. Taking incident readings with a hand-held light meter, which is very reliable, is equally recommended when conditions allow it (uniform light or sunny weather). From the start, it's just about taking a general reading to obtain a couple of exposure/f-stop combinations as points of reference. Then, if conditions allow it, one measures the difference in contrast between the different areas of the panorama (from right to left or from exterior to interior). These differences increase as the angle of view widens; and to measure these, I heavily recommend using a built-in spot meter – or even better, a hand-held spot meter.

In the matrix or ESP mode, take a general reading from the start, then slightly correct the exposure between each view if this is required.

One crucial point concerning exposure with either a sensor or film is the loss of noticeable information in areas having too much or too little exposure. With a digital camera or color transparency film, the choice of the exposure depends on the highlights, which should not be too blocked-up, or overexposed. With color negative film, the opposite holds true: it's the shadows that should not be too

underexposed. Returning to digital and color transparency film, if the highlight areas are properly exposed and the shadow areas are a bit too dark, it will remain possible to fix this with the retouching software. The amount of correction depends mainly on the quality of the sensor and scanner involved: the larger the capacity of the sensor the more it will be possible to lighten underexposed areas without introducing digital noise, or interference. With negative film (color or BW), one cannot improve upon underexposure: if the information is not recorded on the film, there will be no way to invent it. On the other hand, it is theoretically possible to minimize a slight overexposure of the highlights by underdeveloping the film. But in the end, this is not very practical; if certain exposures on a roll of film require less development, still others do not. Therefore, it usually is necessary to rest content with making slight compromises during exposure, rather than profiting from subtle gains in later development.

0	+1/3	+1/3	0	+1/3	+1/3	0
f:8,0	f:5,6+2/3	f:5,6+1/3	f:5,6+1/3	f:5,6	f:4,0+12/3	f:4,0+2/3
1/125	1/125	1/125	1/125	1/125	1/125	1/125

Example of exposure corrections during rotation: a correction of 1/3 of a stop takes place between certain views.

Localized Metering – Differences in Contrast

The panoramic photographer working with assemblage is confronted with two types of exposure problems. One is the need to balance the main differences in contrast from one end to the other of the panoramic photo; the other is balancing an interior in relation to an exterior, for example when photographing a room opening onto a landscape. In this way, whenever one photographs a large expanse, as is often the case with panoramic photography, the main differences in contrast appear between the left and right areas of the image (except, perhaps, in the case of overcast or foggy weather). Typically, one area will be in the sun while the other will be in the shade. And this difference in contrast is best metered with a built-in or hand-held spot meter, since the area measured is very specific.

In joined panoramic photography, it is customary to expose all the photos at the same exposure setting in order to avoid differences in illumination in the overlapping areas. But today, software packages are capable of balancing small shifts in illumination by fusing the sky's illumination in two consecutive photos. Thus, it will be possible to make corrections of up to a third of a stop in certain pictures. The easiest example is one in which the areas from left to right range from sunlight to shade. By applying an exposure correction of a third of a stop between each image over a dozen pictures, the cumulative correction will be close to three stops. In full sun, this often will prove to be quite enough. And such corrections will not always be needed in balancing a photo.

A typical example of a panoramic photo with an interior is a bit different, since here it is more about preventing the openings (windows or doors) from being too overexposed – something that is inevitable if one wants to expose an interior properly. An easy trick consists of making two sets of pictures: one for the interior and the other for the exterior. After this, they are put together (e.g., in PhotoShop) using masks to blend them into one whole seamless image.

Using the spot meter in the camera, if it has one, makes it unnecessary to use a hand-held one. Not only will the measurement be more precise than with the automatic or program modes, but one will also be able to avoid under- or overexposing an area or areas in the image where it is necessary to hold onto information – in other words, the shadows and highlights. In this way, only overexposure with color transparency film and digital cameras and underexposure with negative film (color and black-and-white) are irreparable with the retouching software, as we remarked earlier. Therefore, it is necessary to be constantly vigilant.

Taking the Picture

Keeping the previous section in mind, one suspects that far from remaining idle at the side of the camera, the panoramic photographer choosing the joining method will actually have a lot of work to do in taking the picture. Perhaps it will be slightly correcting the exposure between photos – something that is more difficult with hand-held photography – or watching out for changing light conditions. In other cases, dodging an intense light source during one or two photos will be called for, to avoid a halo or other unsightly reflections. Also, one will have to remember to turn the camera between each picture!

Seen from above, the camera makes a rotation around the entrance pupil between two consecutive views. The angle depends on the focal length used.

Rotation

The angle of view of the final image is determined while setting up. Then, all that remains is to revolve the camera between pictures – which depends on the angle of view of the focal length used – while considering the amount of overlap needed between each image. As I have already shown in the section devoted to equipment, with a rotating Manfrotto stand (reference no. 300N) all that is needed is to turn the camera one notch after taking the picture. The positioning is done by eye, by means of a screen or a viewfinder. Sometimes I even find that aiming with the eyepiece has some advantages when the camera does not have a built-in mask. With certain cameras like the Olympus E10/E20 or the Canon EOS 1 RT, the reflex viewfinder has a semitransparent mirror; if sunlight or a spotlight enters the viewfinder, it will completely fog the photo, as I can bitterly attest from experience.

Exposure Correction

Exposure correction is a delicate step, demanding a certain amount of concentration. During light metering – especially when determining the contrast range – a decision is taken regarding exposure corrections that will result in significant differences in exposure from right to left of the image. And this, as we have seen, requires an adjustment of no more than a third of a stop between each component image.

On the other hand, I also recall that as the exposure is made in the manual mode, it is also necessary to make exposure corrections either by altering the opening of the aperture, if one wants to emphasize a constant shutter speed (e.g., in freezing motion, as is the case with a waterfall), or by changing the shutter speed, if one does not want to alter the depth of field. Once again, this is a matter of compromise – a technical or aesthetic decision.

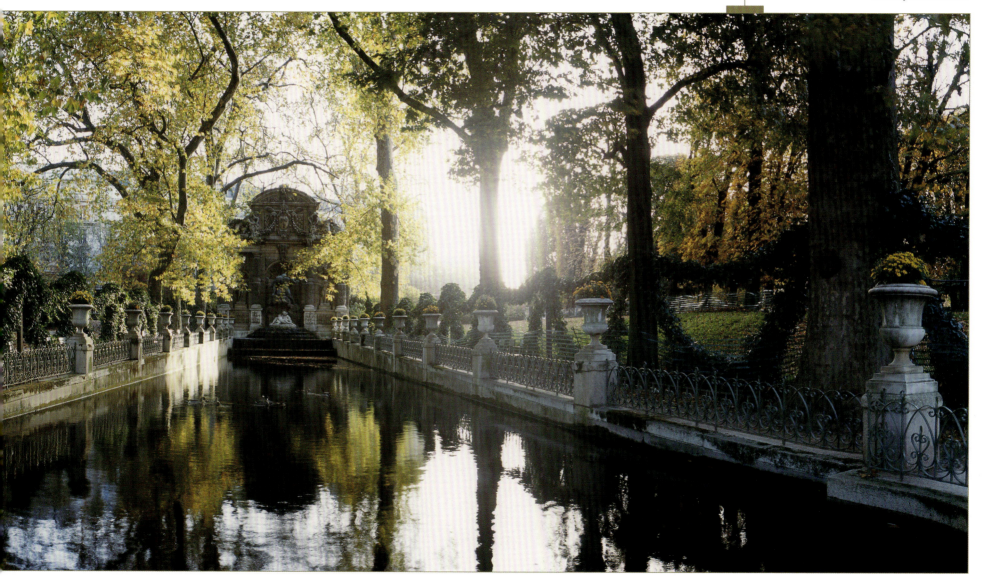

Photographic Assemblage

Rendered almost automatic because of specialty software that is becoming more and more powerful, photographic assemblage, or stitching, opens new perspectives to all panoramic photographers.

Photo by Christophe Noël.

Many ways exist to join or assemble images to make a panoramic photograph. At least one is well known to photographers since it involves retouching software programs like PhotoShop. The most creative photographers truly have arrived at amazing results! Here in particular, I am thinking about Christophe Noël and Jana Caslavska, whose photographs you will discover in this chapter.

Other more specialized software programs have several automated joining modes, some of them being among the most high-powered. Certain modes essentially serve to create images destined for the Web, in the form of small interactive photos. Others allow you to make photographs identical to those taken with specialty cameras. Three software packages actually are capable of simulating a lens shift. This is rather

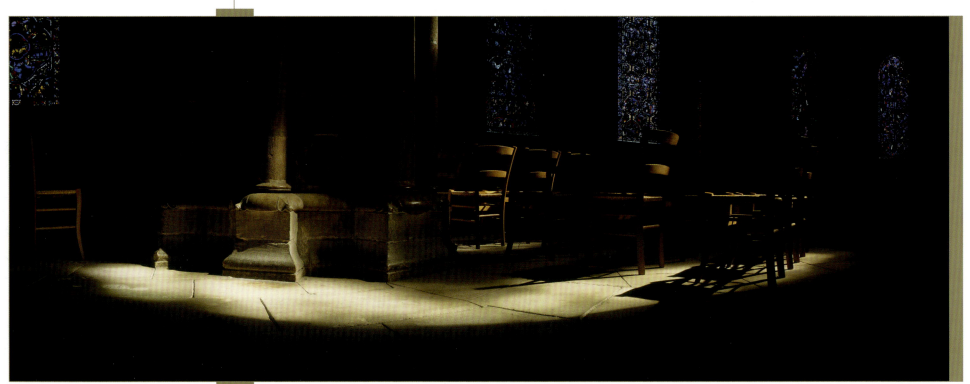

Photo by Arnaud Frich.

impressive on a technical level, but even more impressive on an aesthetic level as it allows you to make particularly successful images with a computer.

In Chapter Five, we looked at how to make the best possible images for producing a successful assemblage without visible overlapping, even when greatly enlarged. Now we will address the preparation of these images – and retouching, if needed – making an incomplete but representative list of the joining software on the market. Then, two types of assemblage will be described, featuring two of the main software programs: the tiled and rectilinear joining modes with the Panavue ImageAssembler and Realviz Stitcher.

Preparing the Photographs

Whether they come from a digital camera or a scanner, images often need to be reworked prior to being joined. Poor exposures, bad formats, a size that does not correspond to the project are all foreseeable examples. Above all, they could suffer from barrel or pincushion distortion stemming from optical problems. These faults often are noticeable with the shortest focal lengths and should be removed at all costs in order to guarantee a beautiful assemblage. Too few software programs are capable of automatically correcting them.

Light Level

Since the component photographs are all taken in manual exposure mode, they can suffer from under- or overexposure throughout the whole series, but none will theoretically receive any more or less exposure than the others. Also, it is possible to retouch them one by one at this stage, either lightening or darkening them; but it will be more practical to do this just once, after the entire image has been joined.

In order to decide on which method to use, we have to reconsider the bit-size of the digital files. If the image series is recorded at 16 bits (i.e., with the TIFF format, or the RAW format with certain cameras), light-level and color corrections must be made for all the component photographs prior to combining them, since the large majority of joining software packages accept only 8-bit images (even with TIFF). Therefore, changes must be made prior to converting a series of 16-bit images to 8-bit. As a result, they will be of much better quality, especially in the difficult areas of the image (i.e., shadows and highlights). On the other hand, if the software accepts 16-bit images, as is the case with the Stitcher 5.0 and Autopane Pro 1.3 and more recently with the ImageAssembler, version 3, it is easier to make the changes later, over the entire joined panorama.

Falling on an image. If the blacks are not dark enough, slide the left-hand cursor (1) to the right; if the overall illumination of the photo is insufficient, move the middle cursor (2) to the left; if the highlights are too dark, slide the right-hand cursor (3) to the left.

White-Balance

One of the main advantages of digital cameras over traditional cameras is the possibility of precisely and easily regulating the white-balance when taking the picture. This works really well. There are only two types of color transparency film, daylight and tungsten, but with digital cameras there are almost an infinite number because of the white-balance. Thus, it is technically possible to obtain a series of images having the same color temperature without using color conversion filters (the well-known Wratten filters).

But as is the case with the light-level, additional corrections may need to be made in front of a computer monitor if the series is still a bit too warm or cold. When the photo contains many dark and light areas, it is better to make as many changes as possible to a 16-bit image. Either the joining software accepts 16-bit images and one works over the joined image, or one makes the corrections one by one over nonjoined 16-bit images before converting them all to 8-bit.

If the photos are taken with traditional film, the problem is a little different. The film always behaves in the same way with a given type of light. Contrary to when one forgets to override the white-balance with a digital camera, here all the photos will have a similar dominating color shift if the light does not match the film's color balance. To correct this, the photographer uses an assortment of color correction filters and a color temperature meter. These are hard to manage in the field, so few photographers work with them outside of the studio. Also, some retouching will have to be anticipated here; and as was the case with adjusting light-levels, this will preferably be done at 16-bit.

Via the menu Image> Mode, it is possible to know if one should make the image in 8 or 16 bits. Here, it's a 16-bit image that converts easily into 8 bits by clicking just above.

Optical Distortions

Many wide-angle lenses introduce either barrel or pincushion distortion, these respectively referring to a bending of lines away or toward the center of the photograph. Sometimes the joining software anticipates these distortions by having a data bank (that obviously needs to be brought up to date on a regular basis) for the specific problems of many of the digital cameras on the market. In particular, this pertains to pocket digital cameras with fixed lenses. Prior to stitching, or joining, the images, one has to tell the software what camera and focal length were used in taking the picture, or else the assemblage will be of a

rather poor quality. Some software packages, such as Stitcher 5.0, can automatically gauge the distortions prior to assemblage. This function is effective when the distortions are quite noticeable, and it can eliminate an additional step in preparing the images (e.g., in PhotoShop). The gain in time and productivity is significant, since the amount of distortion can be stored in the memory after being calculated.

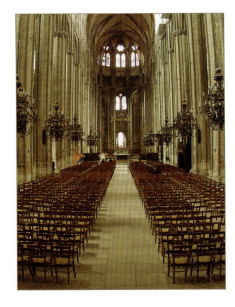

This photo made with a wide-angle lens reveals a fair amount of distortion. The lines at the edges are bowed out from the center. This is known as barrel distortion. It is absolutely necessary to eliminate this before opening the images in a joining software program.

The numerous interchangeable lenses, although of high quality, produce even more noticeable distortions – sometimes as much as certain inexpensive pocket digital cameras. Because the software does not have any information about these distortions and the proposed corrections are often too approximate, I very much prefer to correct this fault prior to opening up the images in the joining software. To do this, I use Panorama Tools; but one also could use the PhotoShop Spherization filter (although, in my opinion it is not quite as good). With the latter, I find that the corrected images lose a little bit of their initial sharpness.

Panorama Tools Correction Tool

This tool, made by an inventive German engineer named Helmut Dersch, can be hooked up with PhotoShop. It's a supplementary filter for PC, Mac, or Linux that provides very precise correction of image distortions, and more easily than the Spherization tool just mentioned.

Once this filter has been installed, it is necessary to proceed in the following way to correct image distortions:

1. After opening one of the images in the series, from the menu Filters>Panorama Tools>Correct click **OK**.

2. Check the Radial Shift option to correct the distortions. (The other options do not concern us here.)

3. Click **Options**. A total of 12 boxes will appear (four columns and three rows corresponding to the three RGB channels). Only the second and forth columns concern us here. It is necessary to fill each of these with the same numeric values. The second and fourth columns' numeric values must total 1.

If the image contains barrel distortion (lines bowed away from the center), the result of the fourth column will be greater than 1; conversely, it will be less than 1 with pincushion distortion. 1 corresponds to a 0 percent curvature. Therefore, a value of 1.012 corresponds to a correction of +1.2 percent. If the value of the fourth column is greater than 1, that of the second column needs to be negative; in this example, the value needs to equal $1 - 1.012$, which would be -0.012.

For pincushion distortion, the value must be positive in the second column and less than 1 in the fourth column; for example, +0.016 and +0.984.

In the second and fourth columns, here are the values that I found through trial and error with my Olympus E 10 digital camera in the wide-angle, 35 mm position. (My lens produces barrel distortion.)

Installing the Correct tool is very simple; start by downloading Panorama Tools from the following address: http://home.no.net/dmaurer/~ dersch/Index.htm. At the heading "Download," select Mac 2.2, Windows 2.1, or Linux. Once the ZIP folder has been opened, install the two files on your computer: one in the root directory and the other in the PhotoShop Plug-In folder.

1. For a PC, copy the file pano12.dll in the folder C:/Windows/System. For a Mac, copy the file pano12.lib in the folder System Folder Icon.

2. From the PhotoShop Plug-In that you have downloaded, copy the Correct filter in the folder Programs>Adobe>PhotoShop>external modules>filters.

3. Open up PhotoShop (the opening can be a little bit longer than normal the first time) and the filter is installed.

After a bit of practice, it will be easy to determine what values work for correcting the faults of a lens at a given focal length. Once the percentage of correction has been determined, all that remains is to apply it systematically to all the images in the series. And these amounts are stored in memory, even after closing PhotoShop.

In the same window, under the columns, check the Radial box (this is the correction that actually eliminates the distortions) and click **OK** to apply the filter. The image starts to transform; if the determined value is correct, the fault will be eliminated.

With this filter, the image keeps the same number of pixels as the neighboring image. So it is very quick and easy to use in production work. To easily find the value of the correction to apply, it is better to be interested in photographing recent buildings (or better still, graph paper), which are geometric and have straight edges, while seeking to preserve a perfect parallelism between the sensor and the building (or sheet of paper). In this way, the distortions will be seen more easily.

One other bit of advice before ending: take notes of the operations in order to speed up the work and save time in the future.

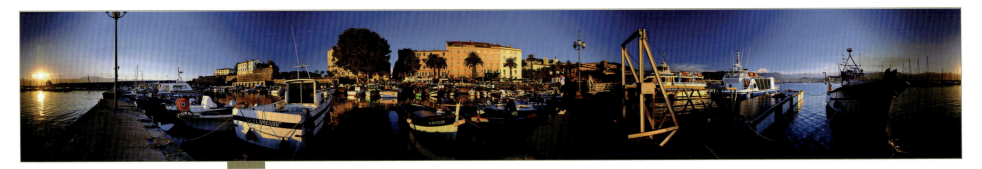

Photo by Franck Charel.

PhotoShop Spherization Filter

Corrections for optical distortions can also be achieved with the PhotoShop Spherization filter. However, it is neither adaptable nor practical in the production of a large body of joined panoramas, and the application slightly degrades the photo. Gérard Perron describes it in detail in his book *Photographie Interactive avec QuickTime VR* [*Interactive Photography with QuickTime VR*] (see bibliography in Appendix A).

Remember, assemblages often are of better quality when the correction is done outside of the joining software. In such cases, remembering to deactivate the built-in correction mode becomes necessary, or the software will introduce the opposite distortion.

Image Size and Format

All photos need to have the same number of pixels, or the software will not open them. To redefine the number, use the PhotoShop menu Image>Image Size. Define the initial resolution (e.g., 72 dpi for the Web and around 254 dpi for printing, depending on the results, the size of the print, and your personal preferences), followed by the enlarge or reduce mode. In any case, it is necessary to check the Keep proportions option so that the geometry of the individual photographs will not be changed.

The choice of the resizing calculation for the image is also important. Normally, photographers use the PhotoShop bicubic Interpolation mode. Although it is undeniably suited for enlarging images (since it creates new pixels from preexisting ones), it is far from being ideally suited for reductions, where it often is preferable to use either Closer or Bilinear mode. The range of problems for

reducing the size of an image is completely different: the image already contains all the useful information, so it becomes necessary to remove selected information in an intelligent way, to avoid degrading the image or causing it to lose sharpness.

The change in image size is done via the menu Image>Image Size in PhotoShop.

The lighter the image load, the quicker the joining software will work. Thus, it is not necessary to join the images at a high resolution in order to print the final photograph in a postcard format or publish it on the Internet. For example, if the final image is an assemblage of 10 photos containing 10 million pixels per image, the finished panorama would have around 100 million pixels. That a pretty heavy file!

The choice of image format is crucial. All the joining software packages accept JPEG or BMP files, but the same does not hold true for the TIFF format and even less so for the RAW format (the copyrighted one). Regarding the latter two files, the photographer needs to rerecord them in a format recognized by the software before opening the images. If the panoramic photographs are destined for publication on the Internet, one similarly records them onto a JPEG format at a low compression rate (i.e., the minimum required for a fine appearance on the Internet) in order to gain calculating speed in the joining step.

Retouching Tools

Retouching tools are wonderful for photographers who inevitably have to retouch their images on the computer. Incredibly effective, they almost justify the notion that one should scan all traditional photographs before printing them, if only to be able to touch them up in this way! (I have truly painful memories of retouching fiber prints with a brush.) Going beyond normal dust problems, these tools can also be used to eliminate other annoying details like halos caused by the sun or a streetlight.

Because of the Touch-Up tools included in the retouching software, removing dust and other undesirable objects is child's play.

Dust Problems

To many photographers, retouching usually means dust problems. Small digital cameras with fixed lenses have a large advantage since no dust can reach their sensors, which are hermetically sealed by a nonremovable lens. Just imagine how much touch-up work would be needed for a poster measuring 13″ × 39″ that was made from 10 35 mm slides scanned at 2,900 dpi. The antidust systems of the scanners would need to function exceptionally well! As a comparative example, it sometimes takes two hours to scan a 50 mm × 120 mm color transparency from my Noblex 150.

Interfering Objects

The Retouching tool can also be used to eliminate other bothersome details, but this is a question of personal taste. Personally, when a landscape moves me, it's due to an absence of annoying or intruding details. So in the end, there is usually very little retouching to do in this regard.

Sunlight Halos

The flare effect – halos from the sun or from any other intense light source – not only diminishes photo contrast in a noticeable fashion, but produces an equally ugly visual result. As Gérard Perron has shown in his book, these effects are often difficult to remove since they are both numerous and present in significant areas. Even if the Correction tool that comes with, say, PhotoShop 7.0 is amazingly effective, nothing guarantees that you will properly eliminate the flare effect without several hours of work. One of the most helpful solutions is covering the sun with the hand, or better still, with a small black card (like the one used in the darkroom for dodging) that one can easily erase afterward with the Retouching tool. In this way, the card is placed in a highly overexposed area of the sky (i.e., where there is no fall-off in illumination) that makes it easy to remove later by retouching. Another method mentioned in Perron's book consists of taking two photos, one with and one without the card, joining these with the retouching software, while being careful to join just the top portions of the images.

Completing all the retouching prior to the joining stage is not obligatory, since some of it can also be done on the final image. In this way, one has the advantage of standing back and viewing the entire panorama. A specific detail may not be so annoying when it is seen as part of the larger whole – especially since the whole view is the fundamental reason behind panoramic photography.

We now will consider some typical joining software packages and show how to arrange the component images to obtain a panoramic photograph. This can take from a few seconds to several minutes depending on the computer's strength and final size of the joined image. (An image destined to be poster-sized could easily go beyond 150 million bytes.)

Stitching

There are two large categories of software for joining a group of component images: retouching software like PhotoShop or Pro PaintShop and joining software proper (i.e., stitching software). They are designed for one or more specialized functions. The first type allows numerous montages, normal or artistic, but without automatic functions: it requires a bit of dexterity on the part of the photographer, and above all, time and experience. The second allows for the rapid and almost automatic joining of photographs, sometimes according to two

different joining modes that start from the same images. But unfortunately, high-powered stitching software is still not widely available. The ones that are sold with small pocket digital cameras function well but are often very limited: they know how to join only tiled (curved-line) images, with a horizon line in the middle.

What are the best-known joining methods? How does one join photographs depending on the type of result required? What software packages allow you to do this or that? These are the questions I will try to answer over the remainder of the chapter. After offering some important definitions, I will discuss some of the best joining software as well as their peculiarities. Then I will end with two technical examples taken from the most high-powered stitching packages.

The Principle

Easier than it would appear, joining involves opening prepared photos so that the stitcher can combine them in a manner that becomes more and more automatic. The stitching software compares the elements of two consecutive photos and joins them together, transforming them according to the software and the desired final result: rectilinear or tiled.

<div style="border:1px solid">

S U M M A R Y

Each software program has its own interface, but the main steps are common to all of them:

1. Opening all the images that one wants to prepare in the software program.

2. Indicating what one wants to obtain: simple panorama, tiled, rectilinear, locked, and so on.

3. Indicating what focal length lens the photos have been taken with, as well as specifying the camera. This tells the software what kind of distortions the lens has (i.e., barrel or pincushion) and what it will need to correct (this information is in its database). Usually, I find that this tool does not work that well, so I prefer to correct this problem beforehand. After all, the software already has enough to do!

</div>

These three photographs were joined in the tiled and rectilinear modes. Here, the joining of the first row serves as the line of reference.

The following explains how the job of assemblage begins. Depending on the result, all that remains is to rework the possible areas that are poorly joined, then store the final image in a specific folder.

Tiled Connections

Differing from the joining function of retouching software like PhotoShop, this dedicated software can curve horizontal lines like a rotational camera. In other words, it rounds them so that they can match up. Thus, we have a real transformation of the image, rather than a simple collage-effect introduced by the retouching software.

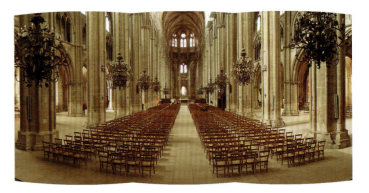

The stitching software truly has transformed the three images so that the row of chairs merges perfectly, forming a smooth curve. The images have been tiled, producing the same image as if it had been taken with a rotational camera.

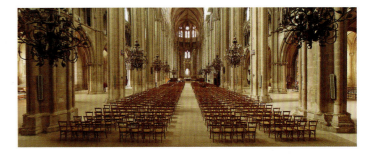

This time, the stitching software automatically merges the photos by stretching and distorting them so that the row of chairs remains straight and, in the present case, parallel to the camera back. A flatback camera would produce the same image.

Orthoscopic Connections

It is possible to obtain a distortion-free assemblage with retouching software, but this is fairly rare with specialty packages. Here, the joined image resembles a photograph taken with a wide-field specialty camera like the Linhof Technorama, or a Hasselblad XPan with a 30 mm lens. In addition, the software can fix converging vanishing points caused by the camera being tilted while taking the picture.

Photo by Jana Caslavska/chamber 5.

Creative Connections

Photographers have used – for a long time now in some cases – PhotoShop's collage possibilities to make photographic montages, and among these are some who make panoramas! Of course, these days one is able to easily join the images; but with PhotoShop, it is also possible to make some really creative montages. This remains and will remain its greatest strength. PhotoShop allows you to extend the boundaries of creativity, and panoramic photography is no exception in this regard. To show and explain all the tools of PhotoShop goes beyond the framework of this book, but in the expert's opinion section of this chapter, Christophe Noël will reveal some of its hidden potential to us.

Photo by Jana Caslavska/chamber 5.

The Workshop
Christophe Noël

I have always had dreams; photography is the first to allow me to cross this marvelous frontier between imagination and representation. Then, PhotoShop arrived: with the mouse, everything started to fall into place. My first goal is to surprise, to make something that I have never seen before, to try to be different. In a certain way, I need to be selfish, true to myself, so as not to be let down. I try to directly involve myself in my work and take part in it. I do not just seek to obtain a beautiful image: if my work is reduced to a simple illustration, I have failed. I always try to propose a subject or express a feeling, something that literally gnaws at the photographer as much as the viewer.

The photograph L'Atelier is taken from work that was commissioned by the regional Council of Seine-Saint-Denis, France, in collaboration with students from the Photography-Multimedia department of the université de Paris VIII, on the theme, Industrial Echos. I was interested in the worker mythology, proposing a group of staged images dealing with mealtime, the workplace, and so on, proposing the question of the identity of each of us in a world where the manufacture of serial objects privileges the uniform copy to the detriment of difference.

The construction of the image started with some research: looking at other images and books, consulting archives, and meeting people, in this case, workers. Next, it was necessary to combine their opinions on the chosen theme with my imagination, prejudgments, and slight personal experience as machine-shop mechanic.

Then came a time of wandering: to walk and lose oneself in the heart of abandoned industrial wastelands and old workshops. I wanted to make stagings recalling nineteenth-century tableaux vivants, like those enormous frescos that line the walls of museums. The panoramic format lent itself wonderfully to this, and the view camera was ideal for the perfect rendition of detail, an almost tactile rendering. I also like the view camera because it is heavier than the normal 35 mm, something which provides more of a feeling of making a film than a photograph. Everything takes a certain amount time, making it difficult to reconcile the imperative of delay within the framework of a commission.

Putting myself in the scene allows me to physically involve myself in what I want to call crossing the photograph; if I would have photographed someone else, the result would have been completely different. The blue overalls that I wear are mine, my blue mechanic's overalls. The self-portrait not only permits using oneself as a subject, but it also creates something that perhaps approaches performance, allowing one to live more fully at the moment when the picture is made.

The joining takes place in PhotoShop. By swinging the back of the camera, I was able to make the first part of panorama without distortion. With the last part of the image on the right, I had to pivot the camera so as to include the rest of the scene. When the time came to retouch things, I recreated certain areas of the background in PhotoShop, using the retouching tool and some blending masks to correct the distortions and vanishing points. On the final image, the machines are not exactly positioned as they were in reality, a lever and a dial have been moved; but only the builder of the machine would know this. Exposure of the figures has been achieved by marking the ground in order to avoid impossible overlaps, and the arrangement of the whole has been done in PhotoShop using the blending masks.

Henceforth, I will no longer encounter any limit to my imaginary constructions. Only time imposes constraints, since it is obviously necessary to have patience. But here is time captured by the lens and manipulated in PhotoShop: anything becomes possible, bits of ideas or fragments of dreams that will soon exist on the surface of a piece of paper.

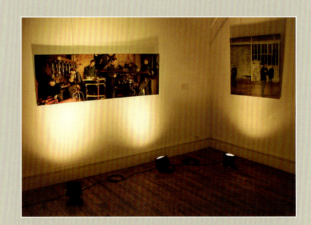

This photo also could have been made using the joining method.
Photo by Arnaud Frich.

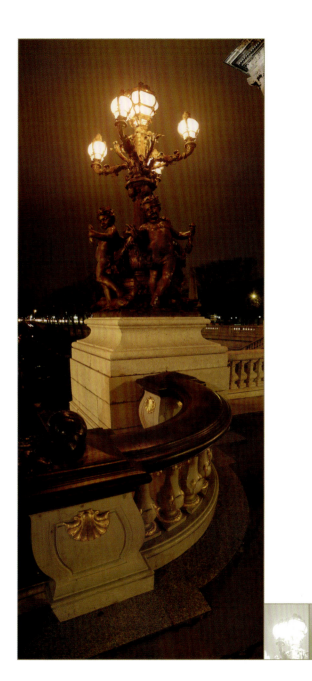

Software Programs

The range of software packages is large: some are sold with digital cameras, and others can be downloaded from the Internet, sometimes for free. The objective of this section is to present software programs that pertain to panoramas. Fundamentally, these all function on the same principle, with more or less ability. Their shared characteristic, which separates them from PhotoShop, is the automatic way in which they join images. The Internet sources listed in the appendix will allow you to complete this list.

Certain software programs join only flat panoramas, and others offer a choice between flat (straight or tiled), cubic, or cylindrical panoramas. Flat panoramas can be printed or displayed on the Internet like normal panoramic photos (i.e., using the horizontal navigation control when the image is too large for the screen, or by moving the photo in a display window with a mouse). Cubic panoramas, of which the most spectacular shape is the 360° × 180° QTVR, can be displayed only in a window with a 4:3 ratio for the size in question. Here the mouse allows you to move it in every way, as well as zoom into the image.

Realvis Stitcher

Two versions of Stitcher exist: Pro 5.0 and the scaled-down EZ version-, which is indeed easier to use since it is almost entirely automatic. Sold for both PC and Mac, these software programs are formidable tools for making quality panoramas without a specialty camera.

The Pro version is an extremely powerful tool for those who want to make interactive panoramas for the Web, as well as for high-quality and large prints, and is well known because of its 360° × 180° views in the QTVR window. The software represents the latest in present-day assemblage possibility and will be studied in further detail later in this chapter. With this version, one can obtain images with the same geometry as an XPan, a Noblex, or a Roundshot, and with even more lens-shifting capability.

Autopane Pro from Kolor.com

This new assembling software has been developed by a newly born French company and is available for a PC or a MAC; the quality makes it worth the price and it is one of my favorite assembling software programs. It allows the user to create using all kinds of assembling processes except the QTVR assembling process. The assembling options are unique and especially powerful within a polished and clear interface – PT Gui – the software that best takes care of optical distortion and has the best harmonization tool of lights. If its monitoring publisher does not convince you, perhaps its operating speed and adaptability certainly should be proof of its reliability.

Panavue ImageAssembler

Sold exclusively for PCs, Panavue ImageAssembler has all the assembling capabilities required by today's updated software except one. Unlike Stitcher, one cannot practice "authoring." However, it runs a bit slower than its immediate competitors when setting monitoring points in order to get a perfect technical assembling result. This step has to be done manually, which consequently slows down the production flow. The ImageAssembler from Panavue has been one of the first software programs on the market, and is reviewed at the end of Chapter 6.

This program remains one of my favorite joining software programs. It allows for tiled montages only, but offers the wonderful possibility of tilting the camera while taking the picture, in order to place the horizon line where it seems best. To do this, the software distorts the images being joined in order to straighten the vertical lines; in this way, it eliminates any convergence toward a vanishing point. It also can indicate curvature of the horizon line.

Making images certainly takes a little bit longer here than with other software, but the result is of the highest caliber. I am always amazed by the result obtained after each assemblage, even in high-definition. Its range of ability is absolutely astonishing since you can make flat, cylindrical, QTVR, and interactive (Java) panoramas. Like all good, present-day joining software, it accepts TIFF images (16-bit). Truly, this is an excellent tool I use on a regular basis and recommend because the trade-off between quality and price is very good. Improving on this scenario, version 3 appears to have very good new functions (e.g., storing the joining image in the PhotoShop format), but at a higher price. This software program is studied in further detail at the end of this chapter.

PT Gui

Based on the renowned algorithm method by Professor Helmut Dersch, but in a much more adequate and economical interface, this software kept improving and has become one of the best PC assembling software programs currently on the market, even though it provides less performance capability than the MAC edition. Users are often real defenders and admirers of the PT Gui software. Nevertheless its adaptability regarding the harmonization correction is not as developed as the one offered on Autopane Pro. In any event, PT Gui is a wonderful professional tool.

Panorama Factory

This software program (only for PCs) presently exists in two versions. Version 1.6 can be downloaded for free, and the more recent 3.0 version is available for a modest sum. Version 3.0 has a new interface that simplifies things for the beginning photographer; it also allows you to make secured 360° panoramas for interactive applications.

The quality of the assemblage is all for a photographer could want, even if this software does not allow one to decide where the horizon line should be placed. Another nice positive feature is that this image-joining software accepts the 8-bit TIFF format, which is fairly rare with free or inexpensive software programs.

Joining with the Realviz Stitcher

This highly adaptable software program allows you to make all kinds of assemblages, as I already have mentioned. It comes with a very well-written guide, so I do not need to discuss all the details of its operation here. Nevertheless, in this section, I will attempt to explain what is possible to achieve concerning joined panoramic photographs.

© *Realviz.*

After having joined all the images of a project (the most time-consuming part), Stitcher makes it possible to store the finished montage in multiple formats: QTVR, up to 180° × 360°; interactive Java; distortion-free layouts; bowed or spherical (tiled) layouts; cubic; and so on. Simply put, it's the most powerful and expensive stitching software program on the market.

Even though it remains less powerful for making tiled assemblages than, say, the Panavue ImageAssembler (3.5 version), it provides several options for joining images when exposure conditions have been less than ideal (e.g., balancing light-level differences, problems with joining a significant object, elimination of unwanted intrusions), as well as its own characteristic joining modes. Really an impressive array! And with the possible rare exception of Panorama Tools, it does not have any rival in the two following areas:

- The joining of several photos in order to make a distortion-free panorama, as though it had been done with a Fuji 617 equipped with a 90 mm lens (90° horizontal angle of view) or an XPan. It also has the ability to correct perspective, something these two cameras cannot do.

- The joining of numerous photos in order to make a 180° × 360° image displayed in a QTVR window. Because of the QuickTime Player display window, it is possible to make an image move completely, and in every direction (e.g., front to back, complete turns), as well as zoom in on the image. Here, the panoramic photograph is always viewable free of geometric distortion (i.e. without horizontal line curvature), and uniquely capable of conventional low-angle effects. This, I believe, is the Stitcher 5.0's most striking feature.

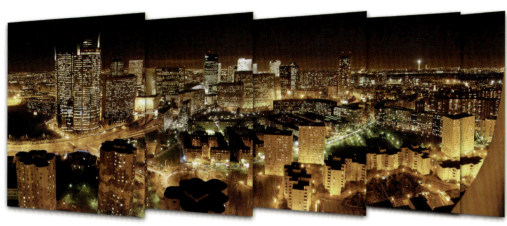

These five elevated (−12°) shots are to be joined in Stitcher. This is its main strength, since it's the only easy-to-use software that can make a rectilinear assemblage, both quickly and automatically.

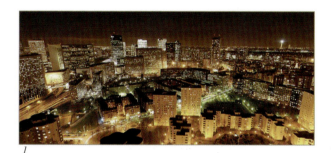

1

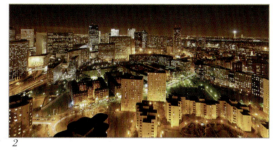

2

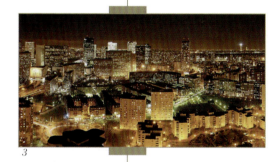

3

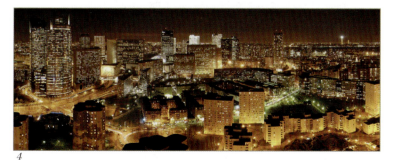

4

*Here are several of Stitcher's features, depending on the nature of the rendering: **1.** Rectilinear rendering, with vertical lines converging toward a vanishing point. **2.** The same photo, but with the vertical lines corrected. **3.** Tiled rendering, with repaired perspectives. (Note that for these three joined photos, I have not used all the photos in the series.) **4.** Because of the spherical rendering, this time I have been able to join all the images to make a photograph identical to one made with a rotational camera – in this case because I have been able to shift downward significantly, in order to place the horizon line at the upper third of the composition.*

These four renderings all have come practically from the same assemblage, in the main window. Only one or two supplementary manipulations have been needed. The gain in time is significant.

To start, the following is a small outline of the most important steps for using this software program:

1. Open the images to be joined, then choose two or three of them in order to calibrate the distortion of the lens. Contrary to many software programs, Stitcher has a good calibration tool for significant distortions. Thus, it is not always necessary to correct them later in PhotoShop.

2. Follow the assemblage for the remainder of the project by placing the images one by one in the stitching window.

3. Balance the color and light levels.

4. Align the panorama. This powerful tool is capable of straightening all perspective lines (i.e., convergence toward a vanishing point when the camera is tilted to take the picture) or of fixing problems with the horizon line.

5. Close the window if it is intended for the Web (QTVR).

6. Call up the result of the project. The software will join the images and record the panorama in a selected folder. Only then can one pick the manner of presentation (e.g., distortion-free, curved).

Menu – Calibrate Lenses: Stitcher can precisely and effectively calculate the distortions caused by the lens on the edges of the images.

Second Step: Joining

Three images of the project have now been joined in advance; from here, it is necessary to continue with the rest of the series, taking the nonjoined images from the image gallery (by the red square in the upper-right corner) one by one and dragging them into the work area above. With the mouse, the transformation tools, and the positioning accessible by the Display menu (or by keyboard shortcuts), adjust the position of the images as needed before starting the assemblage (tap Entry). The red square then changes to green on the image in the gallery.

Once the automatic assemblage has been achieved, the Equalization function can balance the areas joined in the overlapping areas. Then, it is necessary to "line-up the panorama" in order to either straighten a tilted horizon or correct the perspective of images taken with a tilted camera (i.e., making it appear as though the photograph had been made with a shifting lens). Once the tool has been activated, it helps to put some reference points along the lines that need to be vertical after correction and then to confirm this. From here, the image is ready to be stored and the software can produce the result.

Because of Stitcher's Alignment tool, it is possible to correct any kind of vertical line with a few clicks of the mouse.

Here is the Stitcher workspace when first opened. The small green or red squares (in the upper-right corner of the component images in the gallery) indicate if the images are joined or not.

First Step: Distortions

Stitcher is just about the only stitching software program with a tool for correcting optical distortions that actually works well. When you open a new project and load up a series of images (New File and File Menu>Load Up Images (Ctrl+L or Apple+L)),the images open in the lower part of the stitching window, Image Gallery.

From here, the first step consists of calibrating the lens used. This takes only a few seconds and the result of the measurement can be stored in the memory for future assemblages made with the same lens. To calibrate the lens, the software needs only two or three images. With the mouse, drag the first image into the work window just above, followed by the other two; then, roughly superimpose the areas to be joined. In the menu Tool>Strong Distortion>Calibrate, the software joins the images and calculates the distortions. Following this, one can open the property window (menu Editions>Property: Alt+Enter or Apple+Enter) and see the result.

Third Step: The Result

It's only now that one can choose the type of result wanted – size, photo export format (e.g., TIFF, JPEG) – and the folder where it will be stored. To do this, click the menu **Result>Render** (Ctrl+R or Apple+R). The configuring window that opens is divided into several parts, the first dealing with the format of the result, leaving one free to decide the following:

• Flat mode, which simulates the panoramic photograph that one intends to print; here, the image is free from distortion (i.e., like a Linhof 617 or an XPan)

• Cubic mode, which is intended only for the Web

• Spheric mode, which is to simulate a panoramic photograph taken with a rotating camera (e.g., Noblex, Roundshot); these images can be printed as well

• Cylindrical mode, also intended for the Web

Stitcher's rendering window is very comprehensive.

The Format field allows you to choose between different file-storing formats, for example, JPEG, TIFF, or PNG. Then, the options button allows you to select the amount of compression.

The second part of the configuring window, labeled Quality, shows two fields. It is usually necessary to retain the Mix 1 option of the first field. The second field concerns intensifying the images during treatment. Here, I prefer to check **None**, and to control things myself in PhotoShop according to the final destination of the image. A third part of the window is reserved for the title of the saved file and folder.

It is possible to choose the final size of the joined image without needing to take the size of the original images into account. In this way, the software effects an interpolation to enlarge the images as needed (and that explains the Sharpness function's presence in the second field). The function Preview is also very helpful for getting an idea of the joined panoramic photo. Stitcher, version 4, which has more recently appeared on the market, allows you to make a joined image

without interpolation (i.e., at a 1:1 ratio). Apparently, this has been a recurring complaint heard by the Realviz engineers.

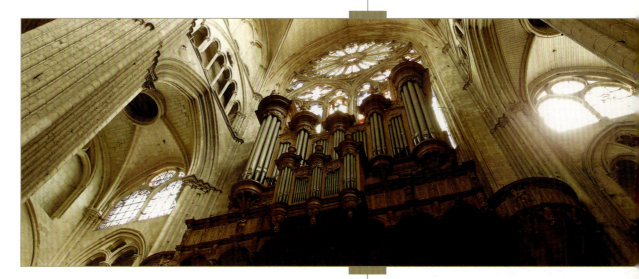

Five photos taken from a very low angle have been used to make this orthoscopic assemblage of an organ chest. The final result is equivalent to an image taken with an XPan or a 617 camera, and here it's done with a few clicks of a mouse! It also would have been possible to obtain a similar result with PhotoShop, although less easily and definitely taking much longer.

Photo by Arnaud Frich.

To start the final assemblage and store it in the selected folder, click **Result**. The series of component photographs remains accessible in the main window of the software, so you can still modify it later in order to create another project, without having to start all over again.

Joining with the Panavue ImageAssembler

© *Panavue.*

Panavue ImageAssembler is one of the most powerful software packages for assembled panoramic photographs, and my favorite to use with a PC. It works quickly and efficiently, but it takes longer to work on than, say, Stitcher or Autopano Pro. But that's the price one pays for so many unique functions! Here, one can make interactive panoramas (like extension.mov's well-known QTVR), normal photos (without being obliged to put the horizon line in the middle of the image), and assemblages constructed from scanned-in images. This software is truly the one of the most complete for making technically irreproachable, high-definition panoramas. You will not necessarily detect any difference between its images and those made with a specialty camera. In the past, one could open images with all kinds of extensions like the 8-bit TIFF, but the more recent 3.0 version, mentioned earlier, also allows one to work with all kinds of file extensions except RAW files. In either case, the memory capacity is very large.

The following is a short outline of the important steps in using this software program:

1. Be sure to correct the lens distortions before opening the images in the software (its automatic tools have left me unconvinced).

2. Prepare a Lens Wizard project in order to tell the software what focal length, angle of view, and inclination (tilt) have been used. At this stage, the software needs to have only two images from the series.

3. Then, and only then, open all the images to be viewed. Indicate both the desired result (e.g., simple panorama, closed, interactive) and the Lens Wizard project in question.

4. Finally, start the assemblage after having selected all the images. The software begins to make its decision a few seconds later. Store the final image in a dedicated folder.

5. To create a locked panorama (visible in a display window like QTVR), open the 360° image. After it has been joined, start the locking-up process.

Main screen of the Panavue ImageAssembler that appears when a new project is opened. The assemblage is made in two or three steps, depending on the type of project. 1. Lens Wizard. 2. Assemblage. 3. Locking the image in the QTVR format.

First Step: Lens Wizard

From the start, the software needs to be told what focal length was used to make the pictures and how many degrees the lens was tilted. To do this, open a new project (New Project, Ctrl+ N) and check Lens Wizard. As long as the camera has been truly leveled during exposure, only one Lens Wizard project per lens and focal length (if it's a zoom) needs to be created. But if the camera has been tilted (i.e., elevated shot or low-angle), it is necessary to create a new Lens Wizard for each viewing condition, even for the same focal length. That's the only drawback to this software; but what a pleasure to be able to place the horizon where one wants while keeping it completely horizontal! However, there is one small condition: when making the exposure, the horizon line needs to be included in the viewfinder's field of view, or the assemblage will not work.

Once Lens Wizard is checked, the window, Gathering Information, appears. Tell it how many photos are being used so that it may calculate information about the conditions of exposure – information that will be essential for the joining software later. To do this, place numbered flags at the same places for two or three consecutive photos. I definitely prefer to check the option, 2 photos in a row, to lay down eight flags instead of four. In this way, the results will be perfect, even with the most difficult of calculation projects (e.g., when the lens has been seriously tilted).

> ### NOTE
>
> *As I explain in the retouching section, I prefer to correct the optical distortions (barrel and pincushion) in PhotoShop, aided by the Panorama Tools plug-in, prior to starting a Lens Wizard project. To create a high-quality assemblage, the software needs photographs that are perfectly identical in the overlapping areas for the most important architectural details. If people, leaves on a tree, or even clouds have moved, the software will disregard them in order to balance the images.*

A small window opens with three tabbed index cards: Overview, Images, and Options. In the Options card, click **Do lens fine tuning**. Then, open the Images card and click the only active button (**Add+**) to select the folder and images that are to be used with the project. Warning: At this stage, I repeat, it is not recommended to make an assemblage, only to prepare for it. Just two images from the entire series that constitutes the final panorama will suffice. It is better to choose images with straight vertical lines along the entire height of each photo in order to facilitate flag placement and achieve an accurate calculation of the degree of lens tilt.

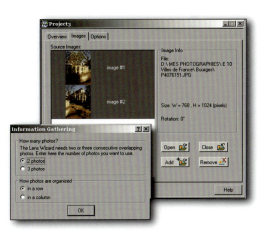

After opening a new project and choosing Lens Wizard, an Information Gathering window followed by a Project window are displayed. This last one has three tabbed index cards: Overview, Images, and Options.

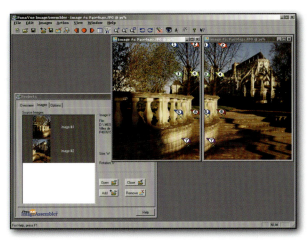

Using a loupe to assist you, place the small flags in the same locations of both photographs to connect them.

> **N O T E**
>
> *Because of the similar appearance of images, make sure you have noted the numbers of the chosen photos before opening ImageAssembler if your are in either Details or List display mode. If not, you can move to Miniatures display mode.*

Before moving on to placing the flags, click the icon of the menu, Arrange Windows. Then, place the flags one by one in the same areas of the two images being joined, using the loupe at a 200 to 300 percent magnification for more precision. A very practical way to do this consists of clicking one of the flags, followed by the Loupe+ found on the tool bar, as many times as needed: each image enlarges around the selected flag at the same time as the two photos. One changes the operation of the eight flags by placing them in groups of two. Here, it is desirable to do this in such a way that the flags 1 and 2, 3 and 4, 5 and 6, and 7 and 8 would be placed on the lines that are horizontal after the image is joined. In a similar manner, it is preferable that flags 1, 3, 5, and 7, and then 2, 4, 6, and 8 would be placed on lines that will be vertical in the final image. As a result, the degree of camera tilt can be more precisely calculated.

When you decide to create a Photo Stitching project, the software asks you to organize the photos in columns or rows.

From here, one starts the calculation by clicking the blue eye of the menu bar, or clicking **Action>Full Run**.

On the job bar below, in the right-hand corner, one can see the calculation advance. Once it has finished, a window opens up with two joined photos. Then, a second window appears with the options, New Stock Lens and Cancelled. If the assemblage looks good, click **New Stock Lens**.

The software recalls the various parameters of the calculated exposure (e.g., focal length, degree of tilt). Then, it asks you to select the type of film used (e.g., 35 mm, 6 cm × 7 cm, APS) and to title the project. In this example, I named it E10 35 mm Bourges. Finally, close the window and the project.

Second Step: Series Assemblage

This step starts by opening a new project, of which only one in a choice of five concerns us: Photo Stitching. Having selected this, the choice of a column or a row is then proposed in a new window. In most cases, click **Row.** to provide access to a new window with five tabbed index cards. (At this point, the 360° wrapping card does not concern us.) Click the card, **Options**, which contains the following three screens:

• **Stitching Options**. Provides a choice between a completely automatic assemblage and a manual mode. I have noticed that the quality of the automatic assemblage directly depends on the quality of the Lens Wizard

Among all the images of the series, I have chosen these two photos because of their vertical lines; all that remains is for me to place the flags at the same spots in both images.

The five tabbed index cards of a Photo Stitching project.

calculation and the degree of camera tilt when taking the picture. If the Lens Wizard is well calculated, something you will know only after the assemblage, auto mode works as well as manual. If not, then it is preferable to select the stitching option, Manual stitch with 2 flags. This obliges one to manually place the two flags on all the images facing each other, which will quickly lead to a 300 percent enlargement. But when one has several images to join, it is surely preferable to redo the Lens Wizard calculation than place a large number of flags.

• **Image Options**. it's better to leave this control alone and to turn off Adjust Color if the software has problems balancing the light-level and color in the joined areas. Clearly, ImageAssembler will work its wonders quite well here.

• **Projection Type**. The Spherical box must be checked, or the software will not curve the images.

On the index card, Lens Selection, check Use One of the Stock Lenses. Then, in the Stock Lenses field, select the focal length and degree of tilt prepared in the preceding Lens Wizard stage. Finally, on the index card, Images, click **Add+** to open the folder containing the images that are to be joined, and position them from left to right depending on the order of the assemblage.

Before obtaining the final result, one can quickly obtain a low-resolution version of the assemblage by clicking the blue eye of the menu bar or by scrolling down Action> Preview Run. If the general aspect of the overall image seems right with regard the balance of light and color, and if no component image has been forgotten(!), start the assemblage (Action> Full Run) and wait patiently.

Creating a QTVR Sequence

We are starting to see what the joining procedure is like for printing a high-definition panoramic photograph. If a 360° exposure has been made, it also possible to render it interactive for the Web or multimedia with ImageAssembler (which offers the possibility of saving it in the format .mov). To do this, open a new project and choose 360° Wrapping. Three new tabbed index cards appear, but only two are active:

• **Options**. Do not touch this card, except to disconnect Adjust Color if the software has trouble balancing the joined areas.

• **Images**. Click **Add+** to open the image that is to be locked (one will be able to lock only one image presenting a 360° angle of view). A frame is then placed on the image with two red flags at each end. First, enlarge the height of this grey frame. (The frame does not need to be right in the middle of the image; it can be placed wherever it is deemed to be aesthetically pleasing.) Second, place the two flags from left to right on the same detail of the image, while greatly enlarging the image. Start the assemblage (Action>Full Run) and wait again.

After joining, the three images of this project reveal traces of the tiled assembly. The Cropping tool of a good retouching software program can eliminate these.

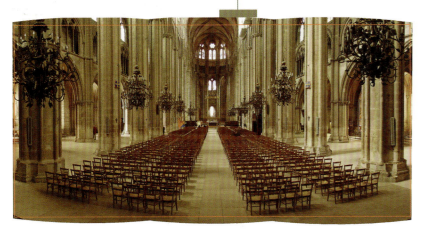

It is necessary to crop the panoramic photograph in the retouching software program, in order to eliminate any evidence of tiling, and to save it via the menu File>Save Image As. Store the completed image in a selected folder in either a TIFF or a JPEG format, depending on your preference. (Recently, it has also become possible to choose the PhotoShop extension PSD.) In this way, each image of the series will exist as a separate copy.

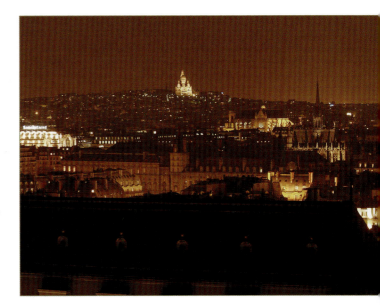

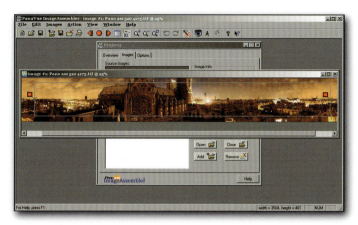

Now that the image has been cropped, locked, and glued in the right places, it is necessary to save it in QTVR (i.e., the MOV format) via the menu File>Save Image As.

It still may be necessary to retouch the image before completing the panorama, to correct some traces of joining, leveling, and so forth.

Place the red flags on the same pixels to the left and right of the panorama.

Photo by Arnaud Frich.

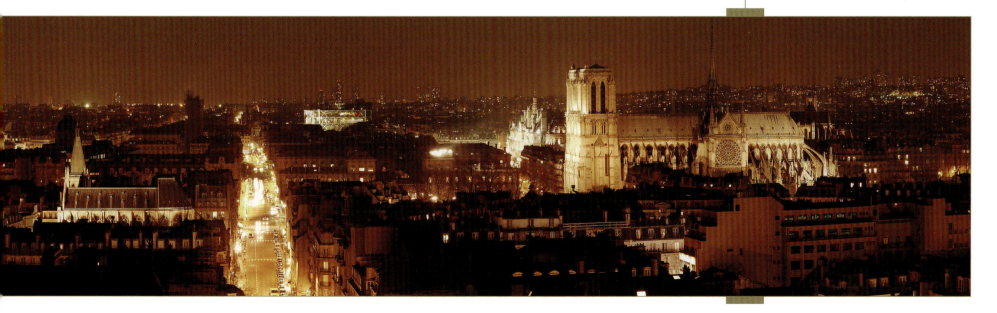

Chapter 7

After the Exposure

There are still two checks on the development of panoramic photography. One is the need to own a specialty camera, and the other concerns the presentation and archival storage of a format that is out of the ordinary. Fortunately, things are improving, especially because of digital technology.

Photo by Francois-Xavier Bouchart.

Digital technology, via the Internet and printing, offers totally new solutions to the presentation of photographic work in general, and panoramas in particular. The format lends itself quite well to being displayed on the Web, particularly because of interactive tools and the new possibility of quality ink-jet printing on a rolled-up support. To convince you of this, I need to cite only one example: printing a large format color transparency (6 cm × 17 cm) in traditional photography requires a cumbersome enlarger (5 × 7) that few amateurs can neither afford nor find enough room to install at home. Also, enlarging this color transparency beyond 8″ × 24″ is difficult, requiring three large trays for the gigantic format. With a good flatbed scanner and a color ink-jet printer, the same amateur or professional – when it's a serious matter of printing – can easily make a 13 × 39 inch print from the same transparency. This would seem to constitute a real habitual change in displaying photographs.

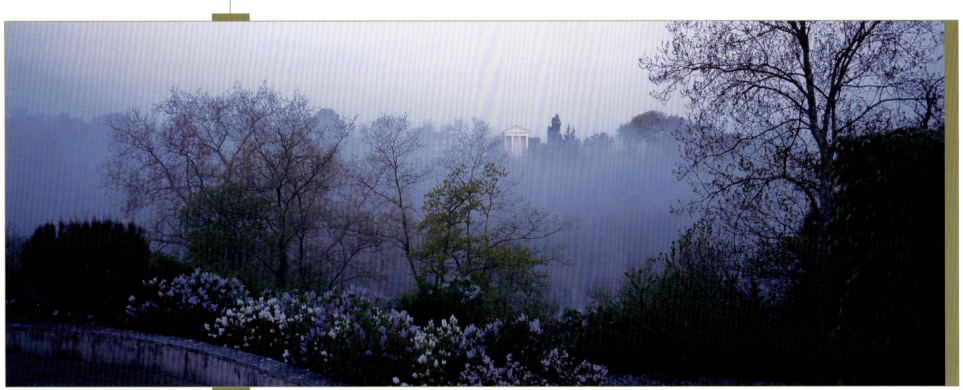

Photo by Jean-Baptiste Leroux.

To obtain large-scale traditional prints, like in this exhibit by
Christophe Noël, it is still necessary to use a professional color lab.

Traditional or Digital Prints?

No other alternative to printing in black and white or color with an enlarger existed until recently. But today, things have changed greatly since it is possible to make images with a simple ink-jet printer. This new method of printing on paper provides a unique solution to the main problems of panoramas, knowing the size of the film and the format of the sheets of paper.

Thanks to the expansion of panoramic photography with small, pocket digital cameras and their automatic joining functions, a real demand for elongated printing paper does exist on the part of the general public and professionals. Currently, only the Epson brand makes it, but everything points in the direction of the competition soon moving into this market as well.

Traditional Prints

In traditional photography, all color and black-and-white printing from negatives or positives is done with an enlarger, either at home or in a professional printing lab. Conventional formats are the norm, so traditional printing is not very easy when panoramic format photographs are requested. The more the format is elongated, the more difficult things become. A very big enlarger is needed to accommodate the length of the film, as well as a specific lens that can cover the diagonal of the negative. Making large prints requires a lot of room to work with three or four large trays. Therefore, few amateur or professional photographers move in the direction of printing large format panoramas, especially in color.

The archival storage of digital files and traditional film is a constant preoccupation for photographers. The traditional panoramic photographer is confronted with two problems: (1) to find organizing sleeves that accept the atypical film formats in question and (2) to find sleeves that do not deteriorate. In my opinion, the situation seems much more favorable when it comes to safeguarding digital files: the format of the digital images is of no real importance on a CD-ROM where the lifetime needs to be only as long as the average lifetime of the generation of CD-players.

Enlarger

At least when making cropped panoramic photographs, the film will be much wider than it is high. This forces the photographer to have an enlarger that surpasses the film in size. For example, a medium-format enlarger would be needed to enlarge photographs taken with an XPan, a Noblex 135, or a Horizon 202, since these use 35 mm films with dimensions measuring 24 mm high by 58 mm to 66 mm wide. The difference in space respectively occupied by a 35 mm and a medium-format enlarger is not that great, but it does become significant with 6 cm × 17 cm negatives, which require a 5 × 7 enlarger – a particularly large and expensive piece of equipment. It is rare to find professionals having one for their personal use, whereas medium-format enlargers are fairly common, even with amateurs. With this in mind, those wanting to persevere with traditional photography should look into the 6 × 12 format, because the size and price of a 4 × 5 enlarger is not too prohibitive and it also allows the possibility of entering into large format. And there is no better way to obtain high quality enlargements (i.e., image detail and tonal range of the material) than through traditional large-format enlarging.

A glass negative carrier for the film format or with movable blades is ideal for printing from panoramic negatives, especially large ones.

To complete this basic equipment, a lens covering the film diagonal is required. In this way, one needs an 80 mm to 90 mm enlarging lens for 24 mm × 66 mm negatives, and a 150 mm lens for the film used with a Noblex 150 (5 cm × 12 cm). A 150 mm lens can also enlarge 4 × 5 sheet film. Next (and this is not a detail to be overlooked), a negative carrier designed for the film format is needed – something that is quite rare with regard to panoramic formats – or at least a carrier equipped with sliding, movable blades that can adapt to different formats. When using blades, the negative carrier also needs to be able to sandwich the film between two sheets of anti-Newton ring glass. If not, the film risks sagging in the middle, since 35 mm and 120 film is thinner and less rigid than 4 × 5 or larger sheet films.

In most cases, professionals who use the 6 × 17 format (often color transparency film) either take their film to a professional lab or show their work on a light-table. This imposing format, being large enough to be viewed on its own, is most impressive in front of the client and does not necessarily require a loupe.

Paper

No traditional paper (fiber, RC, or color) is marketed in panoramic format sizes. Thus, a 13 × 39 inch poster format would require printing paper on a roll. Because it is expensive to develop these rolls, this is a real handicap, and caused problems for me when I had a 4 × 5 outfitted darkroom. I ended up buying some 20 × 24 inch trays that limited me to prints no longer than 20 inches. This was a bit frustrating starting from 12 cm negatives!

It is necessary to acknowledge that one of the main advantages of digital printing is that it is quite adaptable with regard paper size. Here, paper on rolls and in all sorts of standard sizes exist, perfectly suiting the needs of the panoramic photographer for a much lower cost (especially in color) than traditional printing.

Held in my hand, this panoramic print on a 20 × 24 piece of fiber paper seems small. The actual image is only about 10 inches high.

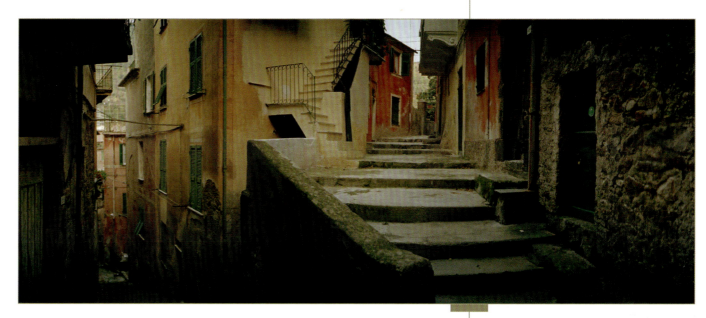

Professional Laboratories

The distinction between mass-market and professional laboratories is important. If the latter kind can realize any type of request, since they have all sizes of enlargers and paper, the same does not hold true for labs geared toward the general public. Their equipment usually comes down to automatic printing that accepts one or two formats at most. And if mass-market laboratories accept work that exceeds their competence, they subcontract it. Their machines can automatically print only a panoramic format originating from APS film.

Digital Prints

Ever since I saw a three-foot long sheet of color paper roll out of my Epson 1290 printer, I have not been able to look back. Only four years before, the largest I could print my black-and-white negatives was on 20 × 24 sheets of paper (fiber, of course).

Digital printing has revolutionized the working method. In addition to an undeniably comfortable setting, it adds an ecological dimension (satisfying the need for developing products that are less hazardous to health and the environment) and provides practical solutions for panoramic photographers. We are no longer as limited with regard to the size and color of our prints as we used to be.

Scanning the Originals

Many photographers who previously had worked only with traditional photography have now switched to digital printing. This requires them to scan all their color transparencies and negatives. And here again, digital provides some simple and fresh solutions. Confronted with the exceptional length of panoramic negatives, all that is needed is to find a scanner with a window large enough to project through. Up to around five inches in length (e.g., 6 × 12) the choice is wide-ranging; beyond this, the options are more limited.

The choice of a scanner depends on the film size and scan quality desired. Two important criteria are maximum resolution and depth analysis (often called D-max). Traditional panoramas often being of a larger size than 35 mm, it is more important to choose a scanner that offers a higher depth analysis than high resolution, since, as is the case with an enlarger, the larger the film is, the less it will need to be enlarged. Here, I need to add that as it is now possible to print very large photographs on roll paper, this requires that the machine scan at least 1600 dpi for a 5 cm × 12 cm color transparency, and even higher for, say, 24 mm × 66 mm. For example, a color transparency of the latter format, intended to be printed 20″ × 36″ at 220 dpi, would need to be scanned at around 2900 dpi.

With its transparent 12 cm × 12 cm window, this flatbed scanner can scan panoramic color transparencies measuring up to 12 cm. For this, I have made a 5 cm × 12 cm frame, which is the format size of my transparencies. The frame also lifts them up slightly, avoiding Newton rings.

Up to 2-3/4 inches long (e.g., Hasselblad XPan, Noblex 135, Horizon 202), the film can be scanned with either film or flatbed scanners equipped with a transparent back. Film scanners have a justified reputation for being better in quality. Their D-max is truly superior, and the resolutions they propose are not unrealistic (as opposed those indicated by the cheapest flatbed scanners). But since things evolve quickly with regard to digital equipment, I do not wish to enter into a possibly fruitless discussion here. No sooner is a book published than the available equipment has already evolved past it; so instead, I will simply encourage you to study the market well, prior to making a purchase. Minolta (Dimage Multipro) and Nikon (8000 and 9000) make film scanners up to 3-1/2 inches long whose reputations speaks for themselves, and the Epson Perfection series remains a safe bet for those seeking relatively inexpensive flatbed scanners.

With films up to about five inches long, usually it is possible to use a flatbed scanner. And as long as the scanner remains nonprofessional, the price will be noticeably lower than with larger-format scanners like the superb Danish Imacon series (e.g., 646, 848). These more expensive models accept films up to seven inches long, even with the bottom-of-the-line version. Flatbed scanners for the general public have also made so much progress that they are now starting to make high-quality scans as well, even with fairly large negatives.

Imacon scanners are known for the quality of their scans. They can also scan originals up to seven inches (18 cm) long, thus can scan color transparencies taken with a 6 × 17 camera.

For films longer than seven inches, which includes film from rotational cameras, no solution exists apart from professional labs that have either flatbed scanners with very large surface areas or rotating film-scanners. Also, the work will often be subcontracted outside, so here you will be further prevented from doing the scans yourself – but the results will be irreproachable.

Digital Printout

In the last two chapters, we saw that computers can provide original and innovative solutions to panoramic photography, especially with the joining method. This is also the case after taking the picture. For a few years now, color and black-and-white ink-jet printers have been appearing on the market with ever-increasing photorealistic capabilities. In lieu of a color lab, an amateur or professional can now make photographs at home, and in a small room, since the equipment is not very large.

The Epson 1290 A3+ printer, already outdated, can make prints up to around 43 inches long on roll paper.

NEWTON RINGS

On a scan, Newton rings are a problem caused by the film coming into contact with the thin glass plate of the flatbed scanner. These resemble iridescent concentric rings, like an oil stain left on the ground by a car. The same phenomenon occurs in glass negative carriers for enlargers. To eliminate them, anti-Newton ring glass is used on the side facing the light bulb of the enlarger. This is glass that has been very lightly frosted to prevent the film from sticking to it. But as anti-Newton ring glass does not yet exist for flatbed scanners, it is necessary to make sure that the film never touches the glass plate. This is not easy with long panoramic films; they tend to bow in the center from heat emanating from the glass.

The digital print provides real working flexibility. One can always debate its quality; but screen markings have become invisible, and certain fine art papers have started to appear on the market. And it is very easy to use. Now it is possible to print in color at home, without additional costs. Along with this advantage, panoramic photographers have a second: size. Certain brands offer the choice of a large range of panoramic format papers as well. This is notably the case with Epson, who has an undeniable lead in this field. Epson markets papers of different qualities and sizes for its line of printers designed for the general public (e.g., the variously sized rolls of its feature product, Glossy Premium Paper).

However, the print driver limits the length of the roll-paper print to 40 inches, most certainly to allow you to print panoramic photographs in the most common and well-known 3:1 aspect ratio. Now, if one uses the entire width of the paper (around 13 inches), this restriction leaves a margin of a half-inch at either end. I do hope that the makers of printers will go beyond this limit, since joined photography allows for 360° montages, which is far beyond the 3:1 ratio. For example, the panoramic photograph on pages 96-97 would have been around 7'8" long if it had been printed at a width of 13 inches! Finally, with regard to the brands that make paper in the standard format (4:3) only, one has to remain contented with printing one or two panoramic photographs along the length of one sheet.

The printer driver for Epson printers allow you to decide the size of the printable area up to around 13 inches wide and 43 inches long.

All professional ink-jet printers of large size work with roll paper, no matter what the support or end-result would be. Thus, one can make two foot-wide panoramic prints on the Epson 7800, without any limitation but the length of the roll itself, and four foot-wide prints with the 9800 and 10,800 models. And in 2004, Epson started selling a new professional printer, the 4800 and brand new 3800, which introduces a new width standard: 17 inches.

It is now commonly agreed that the resolution of a photographic print should be between 220 and 330 dpi when a print is designed to be seen at short distance (e.g., in a book), up to around 12" × 16". But it is not at all necessary to adhere to this dictate when making larger prints. A print extending to four feet in one dimension, viewed from a distance of around five feet, and printed at 72 dpi, will still appear very sharp, as I can testify from direct experience.

Elements of Color Management

Regardless of whether the photographs come from a scanner or an assemblage of digital photos, at times it remains necessary to correct them a little with the retouching software, adjusting color, contrast, and brightness. Something I cannot repeat enough is how useful it is, if not essential, to make these corrections on a calibrated screen (or graphic chain). In this way, they are easier to control, whether they are intended to be printed or displayed on the Internet.

A screen probe, in this case made by Monaco Optix, allows you to precisely calibrate and characterize a monitor. It is highly recommended for making reliable, retouched images.

The largest difficulty encountered at the moment of scanning or printing a photograph is preserving the color and light-level of the original as much as possible. With a noncalibrated graphic sequence, the work is done by eye, via the screen. The scanner and print driver provide a selection of menus that allow you to control various levels and colors. They are becoming better and better designed, and thus more effective, but they will never replace a true calibration by a scanner or printer that really takes print faults and characteristics into account.

Photo by Arnaud Frich.

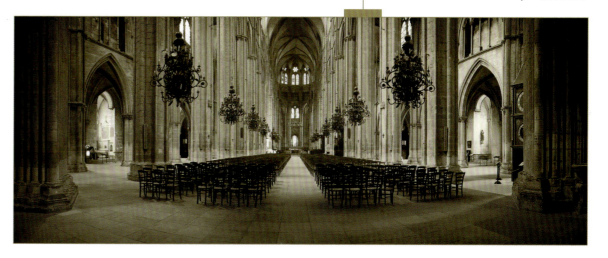

Having experimented with both methods, I by far prefer to make my scans without using optimization settings (truly a rough scan). Rather, after opening up the image in the software program, I assign an ICC profile to the scanner (in PhotoShop, menu Image>Mode>Assign Profile) depending on my needs. In this way, I find my original immediately, thus gaining a lot of time and productivity. I print my panoramic photographs the same way, basing this on the print profiles that have been created with regard to my printer, paper, and ink, as well as the print resolution I have selected. And although it is not too much of a problem to redo a 4 × 6 print in order to correct one or two details, it is completely exasperating to restart a three-foot long print from a roll of paper. In this regard, color management has allowed me to cut down on waste. Now I can start to make a large print without hesitation and profit completely from the advantages of digital printing with panoramic photography.

These transparent and opaque IT 8 test cards are used to calibrate scanners and printers, respectively. The color swatches are very precise and registered in a description file. For example, once the test card has been scanned, the profile-generating software compares the results with the colors registered in the file to make a characteristic profile for the machine in question.

ICC PROFILES

ICC profiles are small files containing the color-metric "ID card" of a machine used to reproduce colors. It provides the color-generating software with two very precise kinds of information: first, all the colors that the machine is capable of reading or reproducing (its range), and second, the way it will modify particular colors (since no equipment is exempt from certain faults). In applying an ICC profile to images coming from a given machine, color shifts are better corrected. A profile is obtained during the calibration (more exactly, during the characterization) of the machine, using a test card (the most well-known standard is the IT 8 test card) and profile-generating software, like those made by Monaco-Systems or GretagMacbeth.

Presentation of Panoramic Photos

The presentation of photographic work is the summit of creativity. The photographer has different ways to achieve this, from the most traditional to the most contemporary. In addition to books, exhibits, and slide presentations, Internet distribution must be acknowledged. The spectacular craze for this style of presentation translates into a real change, since today just about anyone can show his or her photographs across the world for free, whereas yesterday it was necessary to publish a book in order to be known by a group of initiates. This capability has profoundly reduced the size of the planet and altered the history of photography.

Distribution of Images on the Internet

The distribution of photographs on the Internet by means of an image bank, or better, one's own site, has become commonplace and cannot be ignored. This procedure is perfectly appropriate for panoramic photographs as well: either they exceed the width of the screen, and the Internet surfer uses the horizontal scroll box, or they are presented in a window of fixed dimensions where the image can be moved with a mouse.

There are three different ways to view an interactive image, but the most well-known is undeniably the Apple QuickTimeVR (QTVR). The others remain configurable and less cumbersome as they require neither downloading nor installation on the part of the Internet surfer.

Apple's QuickTime VR displayer is also compatible with PCs. More and more, this displayer is being installed in computers by default.

Anyone who has surfed on image sites without ADSL knows that their size is a serious problem. Panoramic photographers not only need to have a resolution that matches surfers' screens, but – and this is the most important point that unfortunately is often neglected – they also need to have the right color balance profile, so that every viewer can see their photographs in the best of possible conditions. Of course, every screen is different; but respecting certain adjustments and calibrations at least allows you to guarantee that the colors viewed will be the original ones. Still, I do note that Internet surfers are forgiving enough when it comes to viewing images on the Web, but this is due to the range of differences between Mac (only 8% of the international market) and PC screens.

Preparing the Images

Different from printing, here the images are distributed at a small resolution, so a high-performance scanner is not required when one wants to distribute traditional photographs. The photographer needs to meet the requirements for distributing the most faithful of images as possible, regarding color and the overall result. And the rage for ICC color and profiles is undeniable, as we will see further on.

Resolution

Although ADSL connections are spreading throughout Europe and the United States, it's still far from being the norm. In order to aid Internet surfers, the photographer needs to be careful about the size of his or her images. One way to reduce this is to choose a good resolution (in dpi) and not confuse this with definition (dimension of the image in pixels). On a standard screen, the ideal resolution is 72 dpi (dots per inch). An image with a higher resolution will not be any sharper on the screen.

Next, the photographer needs to decide on the number of pixels for the photograph. This varies depending on whether the image is to be viewed entirely, as with a normal format photograph, or partially in a window that has a zoom function (often its main attraction). Today, most screens have a definition of 600 × 800 pixels. But to avoid having the Internet surfer use the scroll bars of the browser (i.e., the scroll box), an image should not be more than around 750 pixels in size. The typical example is a little bit different if the image is distributed by an Apple, Mgi, Ptviewer, or other brands. Were it not that the size of the visual display window should not go beyond 750 pixels, the image distributed inside theoretically could have any size. But, once again, we have to account for the delivery weakness of normal Internet services (RTC).

PhotoShop Image Size menu

1. In this field, the level of image definition in pixels is selected.

2. The Resolution field is the area devoted to document size, the ideal resolution is selected, relative to the image's destination.

Choosing pixels/inch as the unit of measurement is preferred.

Size

The last and most efficient way to maintain a file size compatible with distribution on the Internet is to save the image in compression formats, like JPEG or GIF, and avoiding the TIFF format. The images need to be compressed as much as possible while finding a compromise between the memory size and quality of the distributed image. To do this, one analyzes the quality of the image to be saved on the screen and then picks a rate of compression that does not create too many artifacts.

Two menus are available in PhotoShop. The most well-known is the menu Save Under, where one chooses a JPEG compression rate from 12 different levels. Here, it is necessary to move the window a little to see the effect of compression on the image behind it. Between 1 and 4, the rate is high and the impact on the image will be significant. Starting with 5, and depending on the nature of the image, the photograph will also have an acceptable appearance. By moving the cursor from left to right, it's fairly easy to find the best compromise for each image.

There is a rule stating that there is a maximum ideal compression rate suited for each image, in a large part dependant on the number of the details and the material surface areas. A combination of both will compress much more than just a multitude of details.

The Store Under menu is the quickest for storing an image intended for the Web; I much prefer the Store for the Web menu.

The PhotoShop Store for the Web menu is the ideal menu for preparing images for the Internet. It is practical, easy to understand, and precise. Note that the Progressive box is not checked off.

ICC Profile

How do you correctly display the colors of a photograph on every screen in the world? By calibrating everything! In truth, this ideal situation does not exist. However, it is possible to strike a compromise so that the display normally would be correct, because of color management and the proper use of ICC profiles. Browsers, like the well-known Microsoft Internet Explorer, do not manage color, so they are unable to read the ICC Profile built into an image. But they can be tricked into acting like they did, with one condition: the image must be stored in sRGB (i.e., converted to this colorimetric space).

Since the arrival of PhotoShop, version 6, the Image>Mode>Convert or Name a Profile menus are essential for good color management.

The second menu, Save for the Web, provides other advantages. One, two, or four windows can be opened, in which one can observe the simultaneous transformation of the image under different JPEG compression rates, as well as at the percentage of desired enlargement. And one can choose neighboring compression rates. Especially with small images, a small area of compression can significantly change the memory size of the image. Thus, to optimize memory size over the whole image, this is the ideal menu.

The ICC, or International Color Consortium, created a standard ICC profile, the sRGB (standard Red, Green, and Blue), in the 1990s. This profile, or colorimetric space, is the lowest common denominator among all screens. In this way, any new screen is obliged to reproduce all the colors of this space. This is also the case with pocket digital cameras. When an image is stored there, it does not contain any colors considered off-scale. Thus, it will correctly display the minimum chromatic range demanded of every screen. Although the colors will be displayed faithfully enough, the image can still be either too dark or too light if the Internet surfer has adjusted his or her screen's brightness control. Regardless of whether one works with color management or not, the two examples shown in Figure 7.20 will typically be present.

PROGRESSIVE OR NOT?

Whether one stores photographs with the Store or Store for the Web menus, the Progressive option theoretically makes the image appear progressively, little by little, on the Internet surfer's screen as it is being downloaded. This avoids an overly long waiting time where nothing seems to be happening. In actual use, the opposite occurs most of the time: when one checks off this option, the image has to be downloaded completely before it can be displayed. Therefore, it is wise to make a few tests before stringing a series of images together.

When one decides to convert a given image profile to another, this menu opens.

1. Original profile

2. Color conversion engine (select ACE)

3. Destination profile sRGB

4. It is preferable to observe the image resulting from the mode of conversion on the screen and then choose the Perceptive or Relative mode.

Color management is often neglected, but it is nevertheless indispensable for working with images on the computer. It is truly the foundation of the photographer's digital darkroom.
It is not the objective of this book to explain color management entirely, but only to remove some problems that are associated with it. With this in mind, you will find several sources at the back of the book, under the Internet sites and bibliography headings.

• When color management is activated in PhotoShop (starting with version 6), on a calibrated screen, it is necessary to convert the images prior to storing them, via the menu Store for the Web, no matter what workspace has been chosen (probably Adobe 1998). If this is not done, the image will look pale, even though its saturation appeared correct in the PhotoShop work space. To convert an image for a new ICC profile, it is necessary to scroll down the menu Image>Mode>Convert Profile and choose sRGB as the final profile, Adobe ACE as the conversion motor, and the perceptive or relative mode as the conversion mode, depending on the case in question. Regarding the menu, Store for the Web, it is no longer necessary to subsequently check off the ICC Profile, partly because this adds an average of 4 K to the images (if this is negligible with a 100 K photograph, it doubles the size of a small image). And, as I mentioned earlier, it is also because the majority of Web browsers are not able to read them. Fortunately, however, they act as though their color space was sRGB by default, since it is the smallest common denominator. Thus, if an image is properly converted to sRGB (and not simply tagged in the profile by the menu Assign a Profile), its display will be correct on every monitor, on the condition that it is not too dark (the most frequent scenario).

• Without color management – either by retouching the photos configured with PhotoShop by default or with another software program that does not affect color – all that is needed is to verify that the screen is not too light or dark relative to typical screens using the Web. In this way, it is often tempting to change factory settings in order to align screen brightness with ink-jet prints from the printer (which is noncalibrated). That's a frequent pitfall. In this case, disengaging the ICC profile option is required since the images are already in sRGB.

Interactive Images

If one is disposed to write in the HTML code for Web pages, one can present any kind of panoramic photograph in an interactive way. Specific and individual solutions are diverse, requiring an entire book on the subject. Thus, I will address only a small number to suggest what is possible with panoramic images on the Web.

The simplest solutions (i.e., not requiring any competence with the HTML code on the part of the photographer) are those based on the viewers that are required to be installed on the Internet surfer's computer. These can be large enough, since the most well-known among them, Apple QTVR, which functions on all platforms, is more than 6 Mb. The MGI viewer, also fairly common, is more than 1.7 Mb. When the Internet surfer wants to view an interactive image, the viewers start up automatically. To prepare them, the photographer just needs to store them in the right format (.mov), using the joining software.

To avoid being too dependant on the presence or absence of these particular viewers, another universal alternative exists. Other viewers do not take up too much room (less than 50 K) and do not need to be installed beforehand: they start up from the Internet site visited. For the photographer, it is enough to add the file .jar (e.g., ptviewer.jar or panoapplet.jar) to the root of the site (i.e., in the same folder as the HTML pages). Then, one writes a code resembling this in the area of the HTML page where the interactive image is to appear, as shown in the following example:

<APPLET archive=ptviewer.jar code=ptviewer.class weight=600 height=300>

<PARAM name=filevalue= "photopano.jpg">

</APPLET>

A more conventional and much more universal displayer than Apple's.

Photo by David J. Osborn.

A book is a transportable and prestigious way to present your photographic work.

All panoramic photographs stored as JPEG files need to be rendered inactive. In this example, the display window has a size of 300 × 600 pixels and will open the image panophoto.jpg with the Panorama Tools viewer (ptviewer.jar). Using the mouse and some typewritten keys (+,−, etc.), the Internet surfer can turn the photo every way, as well as scroll and zoom. Customizing this code has been very well outlined and explained in the book, *La Photographie interactive avec QuickTimeVR*, by Gérard Perron.

Books and Display Cases

A book (spiral-bound shown in Figure 7.24) remains an ideal support for presenting a group of photographs. It's the most complimentary solution for images. As none specifically exist for panoramic formats, the prints will be oriented on a differently sized rectangular sheet. Under these conditions, it is possible to decide whether or not to center the photo, place it on a strip of paper, or cut a window mat. The most well-known brands are Prat and Panodia. Panodia also sells ring binders that are less prestigious but very well made.

Two types of pages are available for books or ring binders: normal pages in transparent plastic and pages in ultra-transparent polyester (for example, one finds them in the Panodia Printibook). These pages are not sealed and are perfectly neutral. The book-style presentation with pages in polyester is particularly elegant.

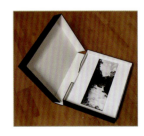

A box-style presentation also has its followers, since the removal of images from the box gives a more formal aspect to the presentation.

Another typically photographic solution consists of making a series of prints on standard-sized paper and placing them in a display box, with or without a window mat. Certain brands make boxes using acid-free materials and neutral pH glues in order to obtain museum-quality archival conditions. This is notably the case with Stouls and Serc boxes (10" × 12" and larger). Panodia also makes display cases, but they are not quite as concerned about using archival materials.

Exhibits

When I first became interested panoramic formats over 20 years ago, they were completely marginalized. Thus, it was rare to find frames for them in the nonspecialty market. However, today things are starting to change because of the development of digital photography, as well as the recent craze for Philip Plisson's panoramic photographs (in particular, his well-known image of the *Isle des Poulains*). Presently, one finds panoramic format frames in different sizes, but only in a 3:1 ratio (e.g., 8" × 24" or 12" × 36").

More and more people are buying panoramic posters, and a quite a few amateur photographers have also begun printing in this format. So it no longer has any reason to be called marginal, since it is now as easy to make as a conventional 3:2 format.

The fashion for laminated displays is also perfectly adapted to this elongated format, since the photograph, sometimes very long at the cost of not being very high, is suitably flush-mounted this way. Flush-mounting consists of bonding the borderless image on a rigid support (thick aluminum or plastic). To obtain an impeccable finish and to protect the photo, the use of an anti-UV varnish is also recommended. This framing procedure is less costly than framing under glass with a window mat. However, the latter option still has many advocates, as it can be quite beautiful, especially with the wonderful Clear-Color glass, which is totally invisible.

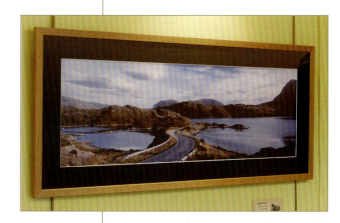

In this exhibit, Hervé Sentucq presented his series of images in traditional frames with window mats. This is traditional, but never out of fashion.

Slide Projection

The projection of large panoramic color transparencies is not possible without specially-designed projectors. But it is possible to project any kind of cropped 35 mm or 6 × 6 medium transparency, just as long the length does not exceed 36 mm and 56 mm, respectively. (Keeping the image at the center of the slide frame aids in maintaining consistency when projecting a series.) However, there is one exception: panoramic photographs from a Horizon 202 swing-lens camera, which are 58 mm long. By placing these in glass-lined, 6 × 6 slide frames, the photograph will be cropped only one millimeter on each end, which is totally negligible. Also, a medium format projector will be needed for medium-format transparencies. These are made by Hasselblad (PCP 80) and Rollei (P66A), among others; they are also sold used.

A piece of aluminum foil transforms this 35 mm photograph into a panoramic image that is ready to be projected.

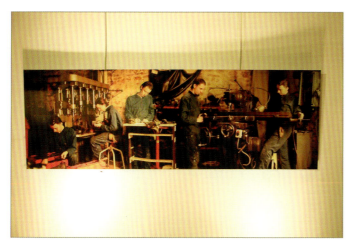

For his exhibit, Christophe Noël chose a laminated display method. This gives a streamlined quality to the presentation.

TIP

If you decide to put your slides in frames, a very simple and effective solution is to crop the original format to the panoramic format by placing a piece of aluminum foil above and/or below the slide's image. The edge is very clear-cut, does not sag, and will serve as a very sharp mask during projection. In addition, the foil melts only at a very high temperature, so it does not become misshapen and will not burn during projection!

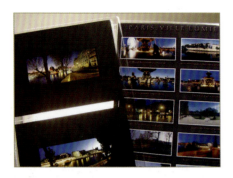

*Glassine pages are being progressively
replaced by PVC plastic pages,
which cost about the same.*

*The ultimate answer involves acid-free paper
envelopes. These are stacked in a box made from
neutral materials that guarantee excellent
conservation through the passage of time.*

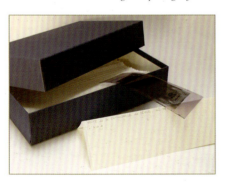

Archival Storage of Originals

Once the photographs have been made, it is necessary to safeguard their conservation over the passage of time. Thus, archival conditions are essential, whether they are negatives (color or black and white), color transparencies, or digital files. The presentation of originals is tied directly to the conditions of conservation (degradation of support, atmosphere of the room, etc.) or – something new – whether or not the digital files are obsolete.

Each type of original is a particular case. The archival constraints of a negative used only to make a print or a scan, a color transparency viewed on a light-table, or a digital file stored on a CD-ROM or DVD are very different.

Negatives

Whether black-and-white or color, negatives have only one purpose: to yield positives, either printed or scanned. So one must make sure that they are protected from dust by a protective material that does not damage them. A number of solutions are available to photographers today, from the cheapest and least protective to the ideal, acid-free solution. For the latter, there are sleeves in special acid-free paper (Serc) or different kinds of plastic.

- Glassine page/sleeves: The most economical solution, but they do not completely fulfill the ideal conditions for conservation. Chemically acidic, they eventually deteriorate the negatives they are supposed to protect.
- Plastic page/sleeves: The most typical and common of these are in PVC, and made by Panodia. They can be found in numerous formats, punched with holes for storage in a binder. Panodia also makes them in a more neutral and stable plastic, polypropylene, which is preferable.
- Acid-free paper sleeves: Made by Serc, these allow the storage of film strips (ideally, one per sleeve) in numerous format sizes: 35 mm, 120, 4 × 5, and so on. Afterward, the sleeves are stored in museum-quality, acid-free cardboard boxes.

Today, storage pages and sleeves are standardized and easily obtainable, no matter the size of the original, from 35 mm to 8 × 10 sheet film. Thus, you should

find them without too much trouble at your local store. Panoramic negatives fit standardized sleeves because the film usually is arranged in strips containing a few photos each. Thus, for example, one might cut strips of three panoramic photographs instead of six normal 35 mm photographs.

Color Transparency Film

In addition to being scanned or printed, and depending on its size, color transparency film can either be mounted in frames for projection or presented in transparent pages for viewing on a light table. Starting with the 5 cm × 12 cm format, the viewing of color transparencies is quite nice and will be even better when seen through a wide-view 4x loupe. Here, it is important to store the images in a support that allows them to be viewed without removal, so as to expose them to as little dust as possible. A number of solutions are conceivable here:

- Slide frames, with or without glass (Gepe), unfortunately are available for 35 mm and medium format (6 × 6) only. And if projecting 35 mm slides is the norm, it much rarer to do so with 6 × 6 (actual size 56 mm × 56 mm), and almost impossible with larger dimensions. By cropping (i.e., covering parts of the transparency), it is possible to project smaller panoramic format sizes using 35 mm and 6 × 6 frames; but not even transparencies taken with an XPan or a 35 mm Noblex can be projected, since they are too long (66 mm). However, as mentioned earlier, one exception does exist: images taken with a Horizon 202 swing-lens camera. These measure 24 mm × 58 mm long, so they can be put in 6 × 6 frames, but with a loss of one millimeter on each side. Still, this guarantees an original slide presentation!
- Transparent sleeves (e.g., Panodia, Prat) are the most common and practical solution for protecting color transparencies, and are also good for occasional viewing. The sleeves come in PVC and polyethylene, the latter being neutral and more stable. Slide the frame-mounted transparencies or 120 film (in its protective wrap) directly inside the sleeves.
- Black or white mounts, adhesive or nonadhesive, consist of an opaque frame with a window that is clear in front and frosted at the back. The white ones can be marked easily, but the black ones allow for better viewing on a light-box. The mounts can also be arranged in the Panodia sleeves in groups of two, three, or more. And though they are undeniably practical, they exist only in the 24 mm × 66 mm panoramic format – or in other words, for the XPan or the 35 mm Noblex (which are lucky to benefit from them since they happen to be of the same size). Other formats, including the popular 6 × 17, must be custom-made. I describe my method for doing this in the Tip described later.

I made some customized display mounts for my color transparencies, since none are sold for the Noblex 150 format (5 cm × 12 cm). In this way, I can store two transparencies in the Panodia M138 pages.

Photo by Pete Simard.

The great unknown concerning the storage of digital files is the actual life span of the supports. But an even more pressing problem is the average life of the players. Even if a CD-ROM has a life expectancy of a century, it is unlikely that there will be very many players for them in a hundred years. Thus, I believe that the real concern for the photographer of today is to be able to store his or her images on high-quality CD-ROMs or DVDs. These should be able to last until the next generation of computerized support comes along, without any alteration problems, and then allow for a smooth transition to the new technology when the necessary moment arrives. This transfer will take a certain amount of time in the case of large photo-libraries, but will guarantee the conservation of absolutely intact originals. And this, too, is a new phenomenon. Finally, it is a good idea to make two copies of each CD or DVD, storing them in two different places. Unlike traditional photographic image matrices, here it is possible to keep two digital originals; thus, one should not overlook this advantage.

Storing Digital Files

Digital files change the storage habits of photographers a bit. For once, panoramic photographs are not distinguished from normal format photographs since all end up digitally engraved on the same computerized support. Over the past 10 years, the main support was the CD-ROM, which can store 650 million bytes. These progressively are being replaced by the DVD, which allows up to 4.7 Gb, or around seven times more space. Beyond this obvious gain in size, it is necessary to add that the panoramic photographer who works with the joining method in digital creates very large files. Here, it is not an exception to create 300 Mb files, or just two photographs per CD-ROM. Thus, the DVD is not only the support of the future, but also the solution for photographers who need to store very sizeable images.

The small amount of space available on CD-ROM and DVD cases nevertheless allows small representations of images to be printed on the display card.

> ### TIP
>
> *In making my display mounts, I use black Canson paper (240 g) in the A4 format (8-1/4" × 11-3/4"), cut in half. In the middle of each resultant piece, I cut a 5 cm × 12 cm window with a utility knife, this being the format for Noblex 150 color transparencies. I further modify the width of the paper to the format of the Panodia M 138 pages, which are designed to hold two 5" × 7" images, one above the other. I leave the transparency in its protective sleeve and I glue this in turn to the Canson paper with Filmoplast ® acid-free paper adhesive. This takes a little bit of time, especially if one has a large group of images, but it's very inexpensive.*

Resources

Directory of Photographers

Benoît Ancelot

After studying carpentry, cabinetry, and interior architecture at the *école Boulle*, Benoît Ancelot turned to photography. In addition to theatrical stagings of people, his work is also oriented toward perfume and cosmetics. From camera lens to image, a symbiosis is born, which serves as a veritable revelation for him, as well as a passion and means of expression. Through the magic of his images, he succeeds in astonishing (in spite of occasionally difficult weather) by his handling of light and his respect for nature.

Benoît Ancelot usually works with a Linhof Technorama 617 camera, a VPan camera, and an Xpan.

Photos: pages 28, 37, 50, and 94

Contact : www.ancelot-benoit.nom.fr
b.ancelot@noos.fr

vincent b.

Born in 1965 in Avignon, France, vincent b. was prepared to do nothing with his life, and he continued in this way well into adulthood. Then, beginning at the age of 33, weakness forced him to make a lot of changes, as well as sire four children. Only photographing people in their normal environments at the present time, he is, along with Hikaru Ushizima, cofounder of the photographic collective *chambre 5*. This group, originally including Charles Thomas (deceased in 1999), Jana Caslavska, Ethan Lichtenfeld, Hikaru Ushizima, and vincent b., insists on making photographs in the streets. Lacking pompous ambition ("If you have a message to send, use the mail," said Godard), they seek only to surprise. This circle of friends repeatedly undertakes the riskiest kinds of collaborations, the most disorganized types of group voyages, and the most desperate kinds of experiments. They adhere to a harsh principle, the "*chambre 5* code of conduct," which allows them to do just about anything except live peacefully from idleness.

vincent b. works with a Hasselblad camera equipped with a special 24 mm × 56 mm back.

Photos: pages 50 and 55

Contact : www.chambre5.com
vincentb@chambre5.com

Bertrand Bodin

Etymologically, "to photograph" means "to write with light." This is what Bertrand Bodin, an artist of international renown, does with his images, which are there to "awaken the senses and educate ways of viewing." He captures isolated moments where nature is the main source of inspiration, and his work testifies to this.

His photographs of nature, sports, mountains, animal life, and landscapes can be discovered in his books (most recent publication: *Hautes-Alpes, des paysages*, with

text by Marianne Boilève, *éditions Libris*) and numerous postcards. They are also found in magazines, photo agencies, and advertising brochures throughout the world.

Bertrand Bodin uses the joining method with a Canon 1 DS camera and several lenses.

Photos: pages 88 and 98

Contact : www.bertrand-bodin.com

François-Xavier Bouchart

In 1970, François-Xavier Bouchart bought an old, rudimentary camera that used a technique fallen into disuse: panoramic photography with a mobile lens capable of embracing a 140° field of view (invented by Von Martens in Paris in 1846). The vision that it recreated allowed him to go beyond the fragmented 35 mm image. In addition to his work for the *Centre Georges Pompidou*, he undertook a laborious six-year project dealing with places known and frequented by the writer Marcel Proust. He claimed to be especially moved by this exceptional network of privileged and archetypal places, convinced that there was a correspondence between his own aesthetic vision and the spirit of the places mentioned in *À la recherche du temps perdu*. At the same time, this also was a recognition that these places were in the process of disappearing, because of the encroaching evolution of urbanism. His work would be exhibited and published both in France and the rest of the world. An architectural and landscape photographer, regularly publishing and exhibiting his work (including *Gares d'Europe*, *Architecture exotique en Europe*, *HLM*, *Le temps de la Ville*), François-Xavier Bouchart won the *Prix Kodak de la critique photographique* and was a member of the *agence Archipress*. He died prematurely at the age of 47.

Photos: pages 19, 69, 77, and 128

Contact : Nadine Beauthéac-Bouchart
2, rue René Panhard
75013 Paris
France-Tel.: 01 43 37 96 87
jcnc@club-internet.fr

Jana Caslavska

This young Czech born in 1966 in Pribram, in the heart of Bohemia, has been interested in images from an early age. Born into a family of miners where the father worked for more than 40 years in the metal and uranium mines of Pribram, she soon learned to comb the areas of her neighborhood in search of traces left by industry. For her fourteenth birthday, her father gave her a half-frame, vertical format camera that a friend had brought back from Germany. And it is this same camera that she still uses to tell her tales.

At the age of 20, she was so fascinated by the fine images published in the newspaper *Libération* that she started to collect them, which is what inspired her to become a photographer in France. And whether it is her series of sequential images or her fragmented panoramas, there are never any montages. She forces herself to

think about the order of images in making exposures like one uses words in a sentence. She has been a part of the collective *chambre 5* since May 2000.

Photos: page 117

Contact : www.chambre5.com/jana@chambre5.com

Franck Charel

Franck Charel was born on August 11, 1971. After obtaining a post-graduate diploma in management, he met Yann Arthus-Bertrand in 1995 and became his assistant. He remained with him throughout the project *La Terre vue du Ciel*. After five years of traveling throughout the world next to Yann, he branched out on his own as an independent photographer. He specializes in the 360° panoramic format and photographs the most beautiful French landscapes. In 2002, *GEO* magazine published his journalistic photography, which consisted of panoramas of Brittany and Corsica.

In 2003, Franck Charel published his first book with *éditions du Chêne*: *Bretagne 360°*. He uses a Roundshot Super 220 (120 film) equipped with a 50 mm lens. Franck Charel also works with more conventional formats for clients like Hennessy, Yves Rocher, and Lacoste.

Photos: pages XVIII[-]XIX, 22, 28, 62, 70, 74, and 114

Contact : 16, avenue Jean Mermoz
93460 Gournay-sur-Marne
France-Tel.: 06 20 53 71 22
www.franckcharel.com/fcharel@wanadoo.fr

Macduff Everton

Whether it is a portrait of an individual or a landscape, Macduff Everton knows how to lend meaning to a place. That's a prerequisite in his discipline; and Andy Grundberg said the following about him: "Macduff Everton reinvents travel photography in the same way that Ansel Adams reinvented nineteenth century photographs of the Great West. He captures strange and significant moments in which time and the world seem to have stopped." His work is in numerous public and private institutions like the *Bibliothèque nationale de Paris*, the Brooklyn Museum in New York, the British Museum in London, among others. Everton has exhibited his photographs in his own country and throughout the world. He has also contributed to several books on archaeology. His most recent work, *The Code of Kings: The Language of Seven Sacred Temples & Tombs*, deals with Mayan Amerindian sites.

Macduff Everton uses a Noblex 150 camera.

Photos: pages XXII[-]XXIII, 4, 12, 22, 27, 28, 77, and 133

Contact : 3905 State St., #7-213
Santa Barbara, CA 93105, USA
Tel.: (617) 898[-]0568
www.macduffeverton.com
macduff@macduffeverton.com

Arnaud Frich

Fascinated with the panoramic format since the age of 14, Arnaud Frich stopped studying science at the university level a few years ago, in order to devote himself to professional photography. He became freelance in 2001. Photographic author, instructor, and article writer in specialized magazines and journals, Arnaud Frich also runs his own Internet site where the most visited headings are, apart from his portfolio, his practical guides to color management and panoramic photographic technique.

Arnaud Frich works with a Noblex 150, the joining method, and stitching software.

Photos: cover photo and pages XX[-]XXI, 2, 6, 7, 8, 9, 14, 17, 18, 20, 21, 23, 27, 30, 32, 33, 34, 60, 65, 73, 77, 78, 79, 80, 81, 82, 84, 85, 86, 87, 89, 91, 93, 96, 100, 103, 104, 106, 110, 112, 116, 118, 119, 121, 123, 126, 127, 131, and 135

Contact : 13, rue Saint Esprit
63000 Clermont-Ferrand, France
Tel.: 00 33 6 20 03 52 45
www.arnaudfrichphoto.com
contact@arnaudfrichphoto.com

Jean-Baptiste Leroux

Jean-Baptiste Leroux was born in Touraine, a region known as "the Garden of France." He began his work on the *jardins à Courances* in the 1980s. The harmony and equilibrium of this large, classical-style park charmed him, and it's in one of the large rooms of the park's manor that he had his first exhibit, in 1985. This would be the beginning of his work on gardens and landscapes.

One exhibit, *Art du jardin*, dating to June 2003, was organized by Hachette Filipacchi in the *Parc de Saint-Cloud*, France. His next publication, *Jardins du désert*, with text by Mic Chamblas-Poton, was published by Actes Sud in 2004. Jean-Baptiste Leroux works with a Linhof Technorama 6 × 17 camera and an XPan.

Photos: page 130

Contact : Tel.: 06 07 05 95 66
jean-baptisteleroux@wanadoo.fr

Aurore de la Morinerie

Born in 1962 and practicing photography since the age of 15, Aurore de la Morinerie produced her first black-and-white journalistic panoramas (with an XPan camera) for the newspaper *Le Figaro*. This experience gave her the aspiration to present and share her work. Her primary activity, making wash drawings for book and magazine publications, allows her photography to evolve as a parallel, freely and without constraint. The series has expanded and grown richer over the years: Asia and the Orient, romantic ruins, portraits, botanical gardens, and light and abstraction. An exhibit on this last theme took place in 2004.

Photos: pages XVI[-]XVII, 41, and 45

Contact : 14, rue Rottenbourg
75012 Paris, France
Tel.: 06 12 97 48 34
aurorelm@wanadoo.fr

Christophe Noël

After studying to be a mechanic, Christophe Noël spent a year of military service on the ship Marion Dufresne, which was stationed in the Kerguelen Islands in the middle of the Indian Ocean. There, he taught himself photography and decided to change his professional orientation upon his return to the French mainland. In 2000, he entered the *centre IRIS*, Paris, to study journalistic and studio photography, and then worked as a photographic assistant for the magazine *Elle* and as a photographer for the Opale agency. In 2003, at the age of 28, he exhibited some of his work during the *mission photographique du Conseil général de Seine-Saint-Denis*, an exhibition that also was shown from March 2 to May 29, 2004 at the *Forum culturel de Blanc-Mesnil*.

At the present time, Christophe Noël is looking to find a gallery that will show his photography. He works with a 4 × 5 camera and makes his joined images using PhotoShop.

Photos pages 108 and 118

Contact : 73, boulevard Ornano
75018 Paris, France
Tel.: 01 42 55 30 31 / 06 16 99 38 06
www.photographie-multimedia.com
www.mission2003.htm
Kristophenoel@yahoo.fr

David J. Osborn

After studying fine arts (specializing in graphic design), David J. Osborn spent many years working as a photojournalist for different agencies like Reuters and the Associated Press. In 1989, he moved to Australia where he set up a studio of "institutional" photographs: portraits of the business heads, annual meetings, and so forth. Returning to Great Britain in 2001, he realized how much he had missed the beauty of the British landscape. His black-and-white panoramic photographs of the English, Scottish, and Welsh countryside, made with an Art Panorama 6 × 17, have traveled around the world.

Photos: pages XII[-]XIII, 10, 26, 38, 50, 59, and 140

Contact : Britishpanoramic
120 Dalrymple Close, London N14 4LQ
United Kingdom
Tel.: 0208 882 8958
www.britishpanoramics.com

Didier Roubinet

Ex-cameraman and documentary film-maker, incurable traveler and untiring Parisian street-comber, this certifiable eccentric has returned to his first love: capturing, in complete artistic freedom, the incredible evolution of his city and its denizens, both in color and in panorama.

Within the limits of his project and the seclusion of his studio, he presents his paradoxical work of a "young" photographer in full maturity to a growing circle of institutions, alerted photography-lovers, researchers, and collectors. Didier Roubinet works with an XPan.

Photos: pages 35 and 37

Contact : 6, rue de Kabylie
75019 Paris, France
www.movingParis.com
DRP@movingParis.com

Hervé Sentucq

Photographer-author born in 1970, Hervé Sentucq specializes in the panoramic photography of natural and urban landscapes. After studying science, he taught in secondary school before becoming a professional photographer a few years back. He is regularly on assignment in France and Scotland, two lands possessing a large number of diverse landscapes of unsuspecting beauty. His work is primarily oriented toward publication and advertising. In 2004, his book *Horizons de Normandie* was released, in joint publication with Anako. Hervé Sentucq regularly organizes exhibits, conferences, and slide shows throughout France. He uses a Fuji GXII 617 camera.

Photos: pages XIV[-]XV, 16, 17, 21, 24, 34, 36, 40, 47, 52, 54, and 56

Contact : Panoram'Art
72, rue de la Colonie, 75013 Paris
Tel.: 01 45 81 62 18 / 06 09 35 74 75
www.panoram-art.com
herve@panoram-art.com

Peet Simard

A Canadian photographer living in France for over 20 years, Peet Simard is fascinated by nature and the urban milieu, among other things. He works as a publicity photographer for large French and international companies, notably in the domains of architecture and still life. At present, he lives close to Paris with his wife and their four daughters.

Peet Simard makes panoramic photographs with an XPan and a Fuji 617 camera.

Photos: pages 57, 95, and 143

Contact : 7, avenue des Cigonges
91220 Bretigny-sur-Orge
Tel.: 01 60 85 34 75 / 06 07 37 31 84
www.parisartphoto.com
peetsimard@yahoo.com

Josef Sudek

Nicknamed "the Poet of Prague" because this city and its surroundings were the basis of his photographic work, Josef Sudek (1896-1976) is considered a master of still-life (his most famous still-lifes were taken by the window of his studio in Prague) and natural landscape photography. His photographs characteristically have an astonishingly rich tonal range. Far from the concerns of realistic representation, his work dealing with light, both diffuse and harsh, and the presence of cloud-covered skies come together to create a melancholic, romantic, and sometimes dark atmosphere.

Josef Sudek photographed Prague with 35 mm film and used a swing-lens camera.

Photos: page XI

Contact : Prague Museum of Decorative Arts
edit@upm.cz

Hikaru Ushizima

Born in 1929 in Fukuoka, southern Japan, Hikaru Ushizima quickly made a name for himself at the Tokyo Conservatory (the music college of Tokyo). A brilliant student, he was then sent to Italy for a number of years. Born into a rich and cultivated family from Alita, a small town known for its traditional pottery, he was taught Japanese traditions from a very early age. Then, after some curious wanderings that he refuses to talk about (he was the drinking buddy of the photographer Masahisa Fukase), he eagerly took up photography. Hikaru Ushizima has exhibited his square-format photographs in numerous solo and group exhibitions in Europe, the United States and Japan. He is the eldest member of the group *chambre 5*, but, as he likes to say, "not the most senile."

Ushizima shares his time between Paris and Biarritz, France, where he often stays at the *hôtel du Palais*. It was Florence, his wife, who had the idea to name the group after the number of their room. His long collaboration with his young friend vincent b. has resulted in a large number of vertical panoramas inspired by Kakemono, a Japanese painting technique on long silk or paper, which is hung vertically.

Photos: page 55

Contact : www.chambre5.com
hikaru@chambre5.com

Sources of Supplies

Equipment and Software

Panavue
ImageAssembler 3.0, assembling software

www.panavue.com

Realviz
Joining software, Stitcher 3.5, 4.0, and EZ 1.0

www.realviz.com

Panorama Factory
Joining software

www.ptgui.com

www.tawbaware.com/ptasmblr.htm

Noblex
Swing-lens cameras

www.kamera-werk-dresden.de

Cambo
View cameras and Cambo Wide DS
(4" × 5" and 6" × 12")

www.cambo.com

Fuji
Traditional films and cameras

www.fujifilm.com

Manfrotto
Tripods and 303, 303+, and 303 SPH panoramic
ball-and-socket heads

www.manfrotto.com

Kaidan
Panoramic tripod heads and accessories

www.kaidan.com

EGG Solution
Based on a 360° exposure using a circular mirror
and redirecting the image via software

www.eggsolution.com

Gitzo
Carbon or aluminum tripods

www.gitzo.com

Lowepro
Photo backpacks

www.lowepro.com

Epson
Flatbed scanners, printers, and paper cut to
panoramic format sizes

www.epson.com

Silvestri
6 × 12 panoramic cameras

www.silvestri.com

Linhof
6 × 12 and 6 × 17 cameras

www.linhof.com

Mamiya
Medium-format cameras with panoramic backs

www.mamiya.com

Hasselblad
Medium-format and XPan cameras

www.hasselblad.com

www.xpan.com

Spheron
Digital panoramic cameras

www.spheron.com

Eyescan
Traditional medium-format and digital panoramic
cameras

www.kst-dresden.de

Roundshot
Traditional and digital panoramic cameras

www.roundshot.ch

Scantech
"Le Voyageur" traditional panoramic camera and
art gallery (sells prints)

www.perso.wanadoo.fr/panorama/

Imacon
Professional scanners up to 5" × 7" and medium-
format digital backs

www.imacon.com

Gilde
6 × 12 and 6 × 17 cameras

www.gilde-camera.de

Some Internet Sites

www.arnaudfichphoto.com/guide_photo_panoramique.htm

I hoped to make this guide as complementary to the book as possible. Therefore, you will find several other resources on panoramic photo here, as well as various tutorials, like a complete guide to color management, which is found at www.arnaudfrichphoto.com/calibrage_gestion_couleurs.htm.

www.Galerie-photo.com

French-language reference site that is seriously devoted to large-format photography. Numerous articles on large-format panoramic photography and a very lively discussion group including different specialists.

www.fine-art-prod.com

Yvon Haze, a photographer who loves panoramic photography, and therefore is aware of its specific problems, makes prints for amateurs and professionals, using the best archival methods.

www.tawbaware.com/ptasmblr.htm

One of the best English-language tutorials for the Panorama Tools software.

www.adrien-dp-site.fr.st/

One the rare French-language sites offering a tutorial for Panorama Tools (under the heading, *Astuces*).

www.panoguide.com

Primary English-language source on joined panoramic photography.

Associations

AEPP

Association européenne des photographes panoramistes
Le Cercle des Panoramistes
Le Barcelone B24, 145, rue G. Janvier
34070 Montpellier
France
g.mathorel@free.fr

Our goal is obviously not to distinguish ourselves from the IAPP on reasons of principle. We simply want to allow European photographers to express themselves differently and in the framework of an organization representing our own continent. Nevertheless, it is true that this will force us to work on subjects and in conditions that are noticeably different from our colleagues in the New World and other continents.

"A manner of being and working, of seeing and doing, of learning and expressing, which is the reflection of our different cultures and which we reveal through our multiple and varied sensitivities."

IAPP

International Association of Panoramic Photographers

www.panoramicassociation.org/

American association for those who speak English. Numerous connections to panoramic photographers around the world.

Bibliography

Fine Art Books

Marcel Proust, la figure des pays, Francois-Xavier Bouchart,
editions Flammarion, 1999.

Bretagne 360°, Franck Charel,
editions du Chêne, 2003.

The Western Horizon, Macduff Everton,
Harry N. Abrams Publisher, 2000.

Alpes, ou le tarot des cimes, Jean-Baptiste Leroux,
editions du Chêne, 1998.

Écosse, Philippe Plisson,
editions du Chêne, 1998.

Chaos, Joseph Koudelka,
Phaïdon, 1999.

Prague en panoramique, Josef Sudek,
editions Odéon.

Paris en panoramique, Jarolsav Poncar,
editions Verlag, Köln, 1997.

End Time City, Michaël Ackerman,
Nathan, Delpire, Paris 1999.

David Hilliard, David Hillaird,
Editiones Universidad de Salamanca, 1999.

New Zeland Landscapes, Andris Apse,
Craig Potton Publishing, 2001.

Technical Books

La photo panoramique, Frédéric Chehu,
editions VM, Paris, 2003.

Photographie interactive avec QuickTime VR, Gérard Perron,
editions Eyrolles, Paris 2002.

Stretch, Nick Meers,
Rotovision, Suisse, 2003.

Panoramic Photography, Joseph Meehan,
Amphoto, New York, re-edited in 1996.

Photographic History

Nouvelle histoire de la photographie, under the direction of Michel Frizot,
Bordas, Paris, 1995.

Dictionnaire mondial de la photographie, des origines à nos jours,
Larousse, Paris, 1994.

Histoire de la photographie, under the direction of J.-C. Lemagny and
A. Rouillé, Bordas, Paris, 1993.

Exposure and Development

La prise de vue et le développement, Thibaut Saint-James, La
Compagnie Internationale du livre, Paris, 1987.

Le Zone Système, P-E Baïda, P. Bertholdy, M. Cégretin,
Les Cahiers de la photographie, 1993.

The Camera, The Negative, and The Print, Ansel Adams,
Little, Brown & Company, Boston, 1983.

Initiation au Zone Système, Daniel Drouard, 2002.

Noir & blanc, de la prise de vue au triage, Philippe Bachelier,
editions VM, Paris, 1998.

La pratique du moyen format, René Bouillot,
editions VM, Paris 1993.

Large Format Nature Photography,
Jack Dykinga,
Amphoto Books, New York, 2001.

Photographie en grand format,
Pierre Groulx,
editions Modulo, Canada, 2001.

Système des zones et la sensitométrie,
Michel Hébert,
editions Modulo, Canada, 2001.

Bases et applications, grand format creative, Urs Tillmanns,
SinarEdition, 1992.

Framing and Composition

Paysages en couleur, Lee Frost,
éditions VM, Paris, 1999.

Le langage de l'image, René Bouillot and Bernard Martinez,
éditions VM, Paris, 2000.

Paysages naturels, grand format créatif, Urs Tillmanns,
SinarEdition, 1994.

L'image, Michael Freeman,
éditions VM, Paris, 1988.

La photographie de paysage, Charlie White,
éditions VM, Paris.

Digital Exposure and Printing

L'impression numérique, réaliser des triages de qualité, Harald Johnson,
editions Eyrolles, Paris, 2003.

PhotoShop 7 pour les photographes
Martin Evening,
éditions Eyrolles, Paris, 2002.

PhotoShop 7, Pierre Labbe,
editions Eyrolles, Paris, 2002.

PhotoShop 7, Master class, Barry Haynes and Wendy Crumpler,
éditions Eyrolles, Paris, 2002.

PhotoShop CS pour les photographes, Martin Evening,
éditions Eyrolles, Paris, 2004.

PhotoShop CS, Pierre Labbe,
éditions Eyrolles, Paris, 2004.

Color Management

Gestion de la couleur, calibrage et profiles ICC, Gérard Niemetzky,
editions Eyrolles, Paris, 2002.

Gestions des couleurs, B. Fraser, C. Murphy, and F. Bunting,
Peachpit Press, Paris, 2003.

Photographic Credits

Cover: © Arnaud Frich, 2003

Page VIII: *Annunciation*, Lorenzo d'Andrea d'Uderigo di Credi (1458–1537), called Lorenzo di Credi, oil on wood, Louvre, © Photo RMN-H. Lewandowski

Page IX: *Preparation of the Fireworks and Decoration for the Feast Given in Navonne Square, Rome, on November 30, 1729, for the Birth of the Dauphin*, Panini Giovanni Paolo (1691–1765), oil on canvas, Louvre, © Photo RMN – Gérard Blot

Page X: *View of the Pont-Neuf, the Quays of the Louvre and the Mégisserie*, laterally-reversed view, c.1850, anonymous, daguerreotype, musée Carnavalet, © Photothèque des musées de la ville de Paris, photo: Briant

Page XI: *Fürstenberg palace*, © Prague Museum of Decorative Arts, 1950s. Photo Josef Sudek © Anna Farova

Pages XII–XIII: *Thorpeness Windmill, Suffolk*, England, © David J. Osborn, 2001

Pages XIV–XV: *Clocks*, © Hervé Sentucq, Panoram'Art, 1999 (Fuji 617, 90 mm)

Pages XVI–XVII: *Malaisie*, © Aurore de la Morinerie, 2002

Pages XVIII–XIX: *Île Rousse, Corse*, © Franck Charel

Pages XX–XXI: *Place de la Concorde*, Paris, © Arnaud Frich, 2000 (Noblex 150)

Pages XXII–XXIII: Grand Canyon, Arizona. *View from Cape Royal Near Sunset with Rainstorm and Rainbow*, © Macduff Everton, 1996

Pages 2–3: *Cathédrale de Senlis*, France, © Arnaud Frich (Noblex 150)

Page 4: *Lower Calf Creek Falls*, Grand Staircase—Escalante National Monument, Utah. First snowfall of autumn, © Macduff Everton, 1998

Page 6: (1) and (4) *La rue Montorgueil*, Paris, © Arnaud Frich; (2) and (3) *La rue Montorgueil*, Paris, © Hervé Sentucq

Page 7: (1) (2) (4) and (5) © Arnaud Frich; (3) and (6) © Hervé Sentucq; (7) © Franck Charel

Page 8: *Moonrise from the Pont des Arts*, © Arnaud Frich, 2001

Page 9: *Église Saint-Étienne-du-Mont*, Paris, © Arnaud Frich et Hervé Sentucq

Page 10: *Castle Menzies*, Perthshire, Scotland, © David J. Osborn, 2001

Page 12–13: *Yosemite*, California, Merced River & El Capitan after snow storm, © Macduff Everton, 1992

Page 14: *Apse of Notre Dame de Paris from the quai d'Orléans*, © Arnaud Frich (Noblex 150)

Page 15: Photo Arnaud Frich © Noblex

Page 16: *Maison Henri IV*, Saint-Valery-en-Caux, © Hervé Sentucq, Panoram'Art, 2002 (Fuji 617, 90 mm)

Page 17: (c) © Arnaud Frich; (d) *Moroccan door*, © Hervé Sentucq, Panoram'Art, 2003 (Fuji 617, 90 mm)

Page 18: *Apse of Saint-Eustache and rue Montorgueil*, Paris, © Arnaud Frich

Page 19: *La cathédrale de Coutances*, © François-Xavier Bouchart (Marcel Proust, la figure des pays, p.83)

Page 20: *L'Onde, Pelvoux*, France, © Arnaud Frich, 1997 (Noblex 135)

Page 21: (h) *Pont de Ménat*, Puy-de-Dôme, France, © Hervé Sentucq, Panoram'Art, 2003 (Fuji 617 + 90 mm); (b) *The West Side of Paris, Seen from the Observatory of la Sorbonne*, © Arnaud Frich, 2003 (E10, assemblage)

Page 22: (h) *Agra*, India, Taj Mahal at sunrise, © Macduff Everton, 1994; (b) *Dune du Pilat*, France © Franck Charel

Page 23: *Façade du quai de Bourbon*, Paris, © Arnaud Frich, 2000 (Noblex 150)

Page 24: *La baie du Mont-Saint-Michel*, © Hervé Sentucq, Panoram'Art, 2000 (Fuji 617, 180 mm)

Page 25: Photo Arnaud Frich © Canham

Page 26: *Waddesdon Manor*, Buckinghamshire, England, © David J. Osborn, 2001

Page 27: (h) and (c) *Aiguille du Midi, France*, © Arnaud Frich, 2000 (Noblex 150); (b) *Mono Lake*, California, © Macduff Everton, 1999

Page 28: (g) *Kamchatka Peninsula*, Siberia, Russia. Bering Sea from helicopter, © Macduff Everton, 1998; (d) © Benoît Ancelot (Linhof 617, 90 mm SA); (b) *Le port Erbalungua*, Corse, © Franck Charel

Pages 30–31: *Place des Petits-Pères Under the Rain*, Paris, © Arnaud Frich (Noblex 150)

Page 32: *Vue de Paris*, © Arnaud Frich

Page 33: *Statue Henri IV*, Pont Neuf, Paris, © Arnaud Frich, 2001

Page 34: (c) *Anamorphose*, © Arnaud Frich, 1997; (g) *L'Institut de France*, Paris, © Arnaud Frich, 2001; (d) © Hervé Sentucq, Panoram'Art (Fuji 617, 90 mm)

Page 35: *Traversée de l'Atlantique*, © Didier Roubinet (XPan, 45 mm)

Page 36: *Brèche du Diable*, Calvados, © Hervé Sentucq, Panoram'Art, 2000 (Fuji 617, 90 mm)

Page 37: (h) *La Gay pride*, © Didier Roubinet; (b) © Benoît Ancelot (VPan, 90 mm SA)

Pages 38–39: *Salisbury Cathedral*, Wiltshire, England, © David J. Osborn, 2001

Page 40: *Plage de Houlgate*, Normandie, France, © Hervé Sentucq, Panoram'Art, 1999 (Fuji 617, 90 mm)

Page 41: *Tokyo*, © Aurore de la Morinerie, 2003

Page 42: (g) Photo Arnaud Frich © Kyocera; (d) Photo Arnaud Frich © Canon; (b) © Olympus, all rights reserved

Page 43: (h) *Untitled*, © Arnaud Frich; (c) Photo Arnaud Frich © Mamiya; (b) *Basilique Saint-Jean-de-Latran*, Rome, © Arnaud Frich, 1998

Page 44: (h) Photo Arnaud Frich © Canham; (b) © Hasselblad, all rights reserved

Page 45: (h) *Hôtel Raffles*, Singapour, Malaisie, © Aurore de la Morinerie, 2002; (b) Photo Arnaud Frich © Mamiya

Page 46: Photo Arnaud Frich © Cambo

Page 47: (h.g) Photo Arnaud Frich © Horseman; (h.d) © Linhof, all rights reserved; (c) Photo Arnaud Frich © Silvestri; (b) *Forêt de Brotonne*, © Hervé Sentucq, Panoram'Art, 2000 (Fuji 617, 300 mm)

Page 48: (g) Photo Arnaud Frich © Linhof; (d) Photo Arnaud Frich © Fuji

Page 49: (h.d) © Arnaud Frich; (c.g) Photo Arnaud Frich © Gilde; (b.d) Photo Arnaud Frich © Gitzo

Page 50: (h.g) © Benoît Ancelot (Linhof 617, 72XL); (h.d) © vincent b.; (b) *Southend*, Essex, England, © David J. Osborn, 2001

Page 51: (g) © Arnaud Frich; (d) Photo Arnaud Frich © Minolta

Page 52: (h) *Dawn at Blois*, Pays de Loire, France, © Hervé Sentucq, Panoram'Art, 1998 (Fuji 617, 90 mm); (b) Photo Arnaud Frich © Fuji

Index